MARYLYN DINTENFASS

PARALLEL PARK

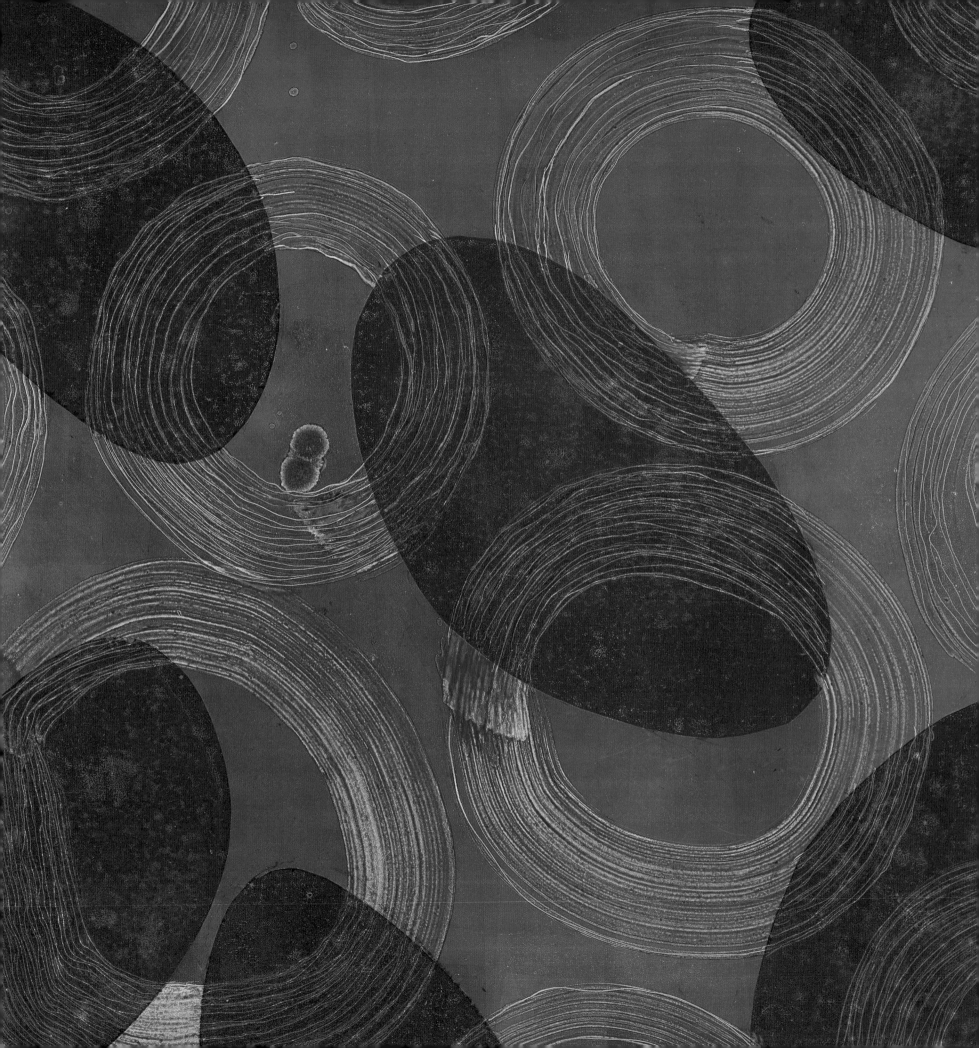

MARYLYN DINTENFASS

PARALLEL PARK

ALIZA EDELMAN

WITH CONTRIBUTIONS BY
MICHELE COHEN
RON BISHOP
BARBARA ANDERSON HILL
JENNIFER MCGREGOR
JOHN DRISCOLL

HARD PRESS EDITIONS STOCKBRIDGE, MASSACHUSETTS
IN ASSOCIATION WITH HUDSON HILLS PRESS, MANCHESTER AND NEW YORK

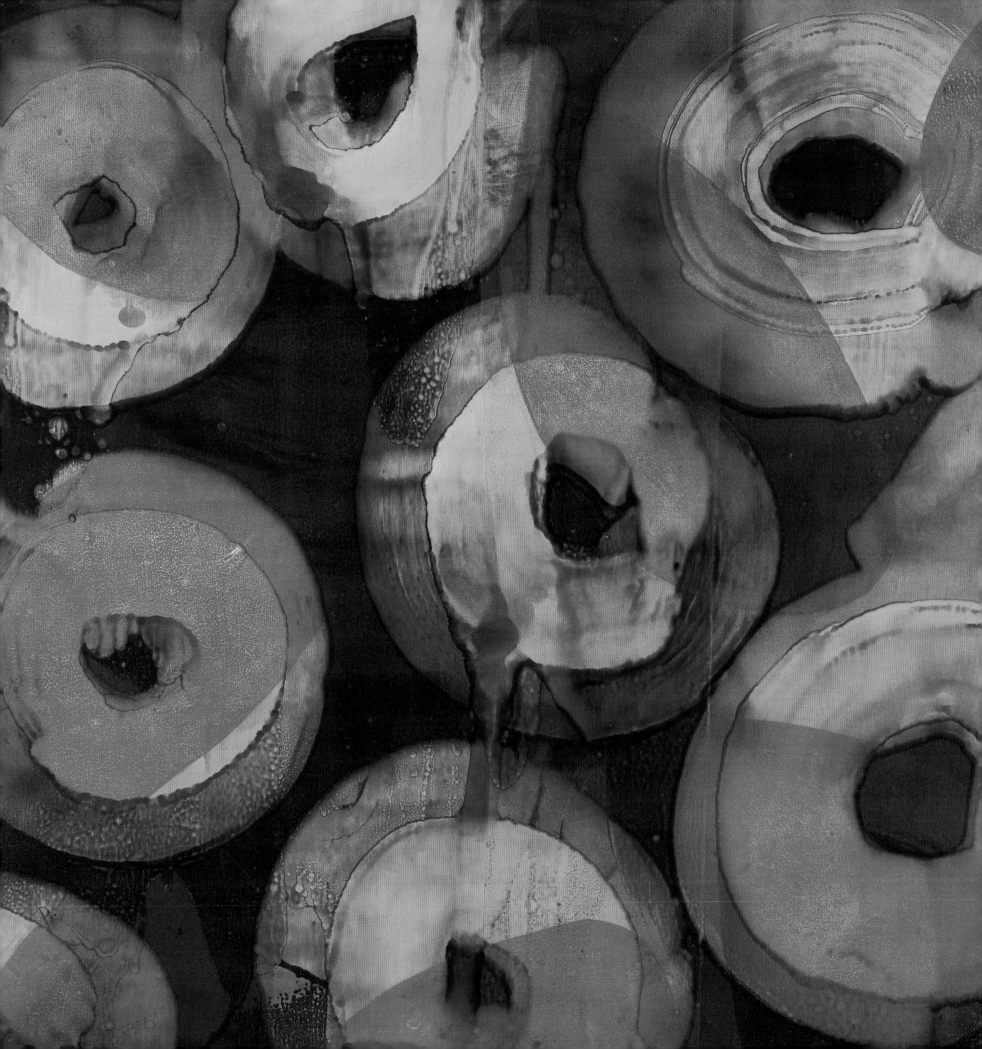

DETAIL PAGE 37

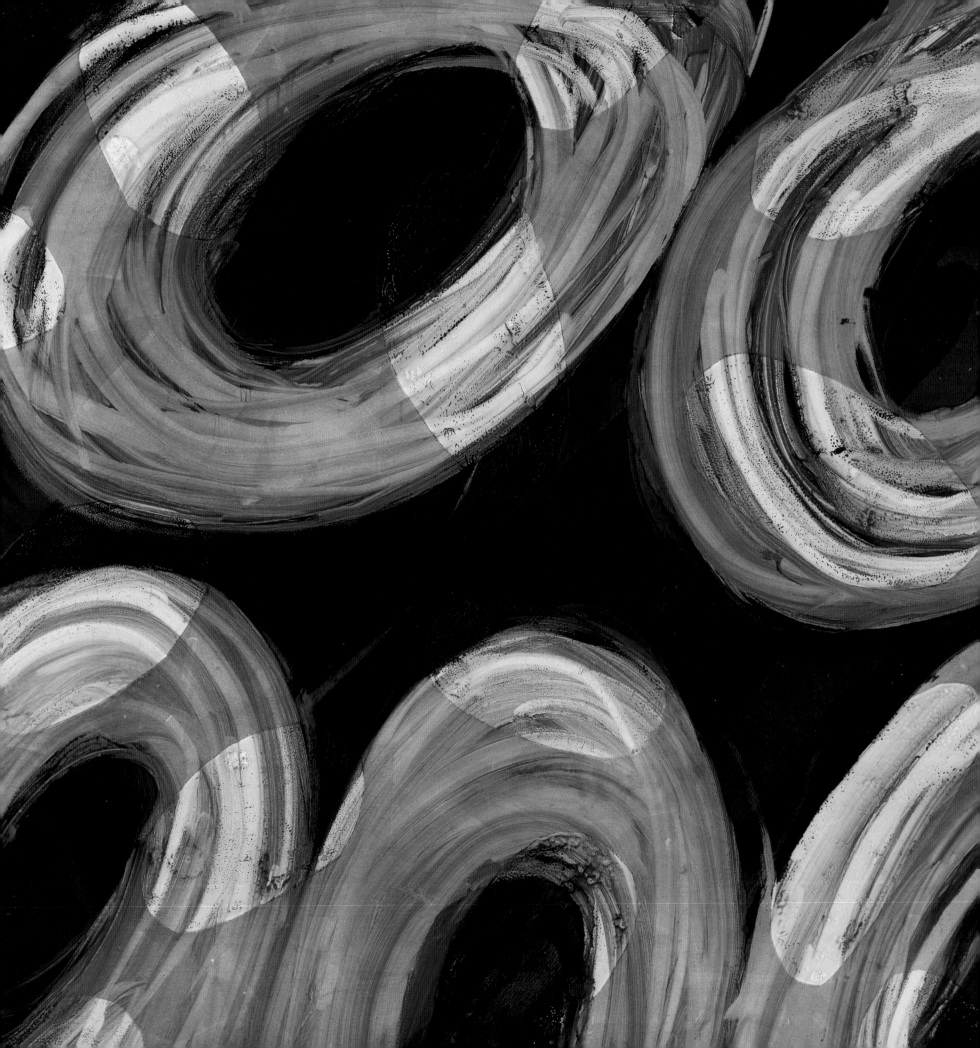

RARELY does art and architecture form the seamless bond evidenced in Fort Myers' new parking garage, a studied improvisation in form, color, and light. Marylyn Dintenfass' *Parallel Park*, like alchemy, transmutes the ordinary into the extraordinary, providing both a physical and imaginary civic gateway. A generic parking garage is now frequently mistaken for an art museum. Without other competing signifiers, the structure's neutrality allows *Parallel Park* to reference art—liberating the project from symbolic expectations often associated with public art commissioned for courthouses, schools, or hospitals. Here, the artist's brilliantly hued abstract evocations of tires, movement, and American car culture take center stage.

The essays that follow provide multiple perspectives on *Parallel Park*. Aliza Edelman contextualizes the imagery within the artist's oeuvre and the broader framework of America's love affair with the car. Barbara Hill, art consultant to the City of Fort Myers, describes the commission's history and the collaboration that formed to support it. John Driscoll's interview with public art expert Jennifer McGregor probes the qualities that distinguish *Parallel Park*, which as McGregor aptly observes, is "about transformation, transforming not only her [Dintenfass'] original art, but the building itself as well as the surrounding environment." This government commission successfully unites architecture with artistic vision and technological innovation, an operatic achievement that pushes boundaries for the artist and art in the public realm. *Parallel Park* turns limitation into opportunity.

The installation is a culmination of much of Dintenfass' work over several decades, drawing on her architectural ceramics comprised of modules and frames, color investigations, exploration of scale, and experimentation with digital media. The triangular aluminum tubing of *Parallel Park* is a three-dimensional frame for the art, a massive segmented canvas rhythmically punctuating all four sides of the building. The imagery and colors, enlarged to this heroic size, derive from a recent series of monoprints and paintings. Computers make the mechanical reproduction of the artist's hand on giant mesh sheets possible, a beguiling conflation of human and machine. In the resultant Kevlar panels saturated with pigment, the artist's stylistic markers of "progression, movement, and gesture" activate every facade of the building, which recedes behind the art.

"Everything comes alive when contradictions accumulate," writes Gaston Bachelard in the *Poetics of Space* (1964). Dintenfass' studio work, indeed, derives

INTRODUCTION

MICHELE COHEN

DETAIL PAGE 39

7

expressive power from her combination of opposites—a rational grid with gestural color, a disparate quadrant rupturing the harmony of three others. Difference sparks conversation, and the completed works seethe with energy. Reflecting on finished paintings that appear uninhibited and effortlessly luminous, Dintenfass explains, "things are not what they seem," revealing that the work actually emerges from a pre-conceived mental picture and a laborious process.

Parallel Park is no exception. Born of a need to provide ventilated sunscreens, it weds utility with high art: it endows color and form with a purpose that goes beyond aesthetics. Though stationary, it is in constant motion, seen through the eyes of moving pedestrians and motorists. The bold design and complex color relationships, coupled with shifting light and a changing sky, provide infinite visual experiences, or what Dintenfass calls "payback" for her viewers. Under the searing Floridian sun, *Parallel Park* can be both transparent and opaque, and at night, illuminated from within, it becomes a flickering lantern. A permeable membrane, it is both soft and hard, shield and aperture. Made from building blocks of color, it consists of individual panels, vertical strips, and whole facades, projecting and dipping. As a hybrid of architecture, sculpture, and painting, there is tension between surface and structure and a merging of autobiographical explorations with public space.

Like Christo and Jeanne-Claude's *Surrounded Islands* of 1983, a memory of vivid pink against the blue and green of Florida's Biscayne Bay, *Parallel Park* wraps a colorless structure in brilliant colors, patterns, light, and shadow, transfiguring a mundane civic amenity into a vision. Unlike Christo and Jeanne-Claude's temporary projects, *Parallel Park* leaves the residue of memory but lingers; it is both evanescent and permanent.

MICHELE COHEN, Ph.D., is an Assistant Professor and Director of the Trustman Art Gallery at Simmons College, Boston. She lectures widely on public art and art conservation, and recently authored the first history of New York City public school art and architecture, *Public Art for Public Schools* (The Monacelli Press, 2009).

W HEN I first had a conversation with Barbara Hill, art consultant to the city of Fort Myers, to consider exhibiting the art of Marylyn Dintenfass, I was immediately intrigued. Showing the work of a highly respected artist and at the same time supporting a community project such as Art in Public Places is a rare occurrence, and an embraceable opportunity. Thus, an exhibition by Marylyn Dintenfass was a perfect fit for the Bob Rauschenberg Gallery, and Edison State College.

Marylyn Dintenfass' art is visually alluring, richly luminous, technically accomplished, and provocative on a formal level; the work is riveting and unmistakably original. Much to her credit, Dintenfass has had seven solo museum exhibitions, has participated in numerous group shows, and has completed 26 public installations—*Parallel Park* being the most recent. Among her other site-specific installations are those for the Port Authority Bus Terminal, New York; the Superior Courthouse, Enfield, Connecticut; the Federal Financial Building, Baltimore; Ben Gurion University, Israel; and Tajimi Middle School, Japan. Additionally, Dintenfass' work is held in numerous public collections, including the Butler Institute of American Art, Youngstown, Ohio; the Detroit Institute of Art, Michigan; the Cleveland Museum of Art, Ohio; the Metropolitan Museum of Art, New York; and the Smithsonian American Art Museum, Washington, DC, to name just a few.

The current exhibition draws upon the *Parallel Park* series, which was completed over the past two years and from which are derived the panels permanently installed at the Lee County Justice Center Parking Garage here in Fort Myers. Working drawings for that project are also included in the exhibition. While these works will be on view at the Bob Rauschenberg Gallery for only a few weeks, Dintenfass' installation at the Lee County Justice Center Parking Garage will impact Fort Myers for many years to come. It also serves as a highlight marking the community's appreciation for and commitment to the arts.

It has been a great pleasure collaborating with Marylyn, her studio staff, and colleagues at Babcock Galleries in New York. Their assistance and guidance have been invaluable and contributed much to the realization of this exhibition. I wish to extend a heartfelt "thank you" to everyone who worked with us at the Bob Rauschenberg Gallery to make this exhibition a success.

FOREWORD

RON BISHOP

RON BISHOP is the Director of the Bob Rauschenberg Gallery, Edison State College, Fort Myers, Florida. In addition to organizing many individual and group exhibitions spanning the career of artist Robert Rauschenberg, he has developed several exhibitions on, among others, the artists John Cage, Merce Cunningham, and Christo and Jeanne-Claude.

(OVERLEAF) **DETAIL** PAGE 37

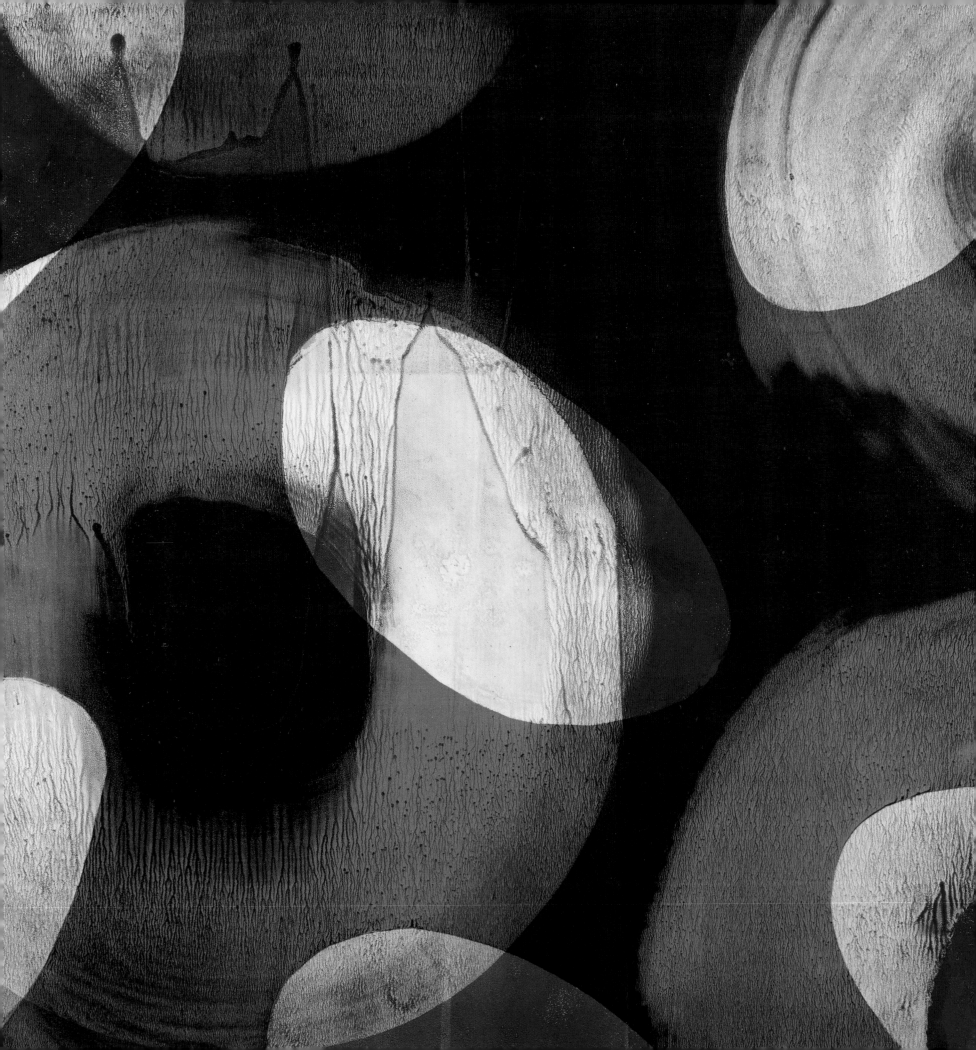

MARYLYN DINTENFASS

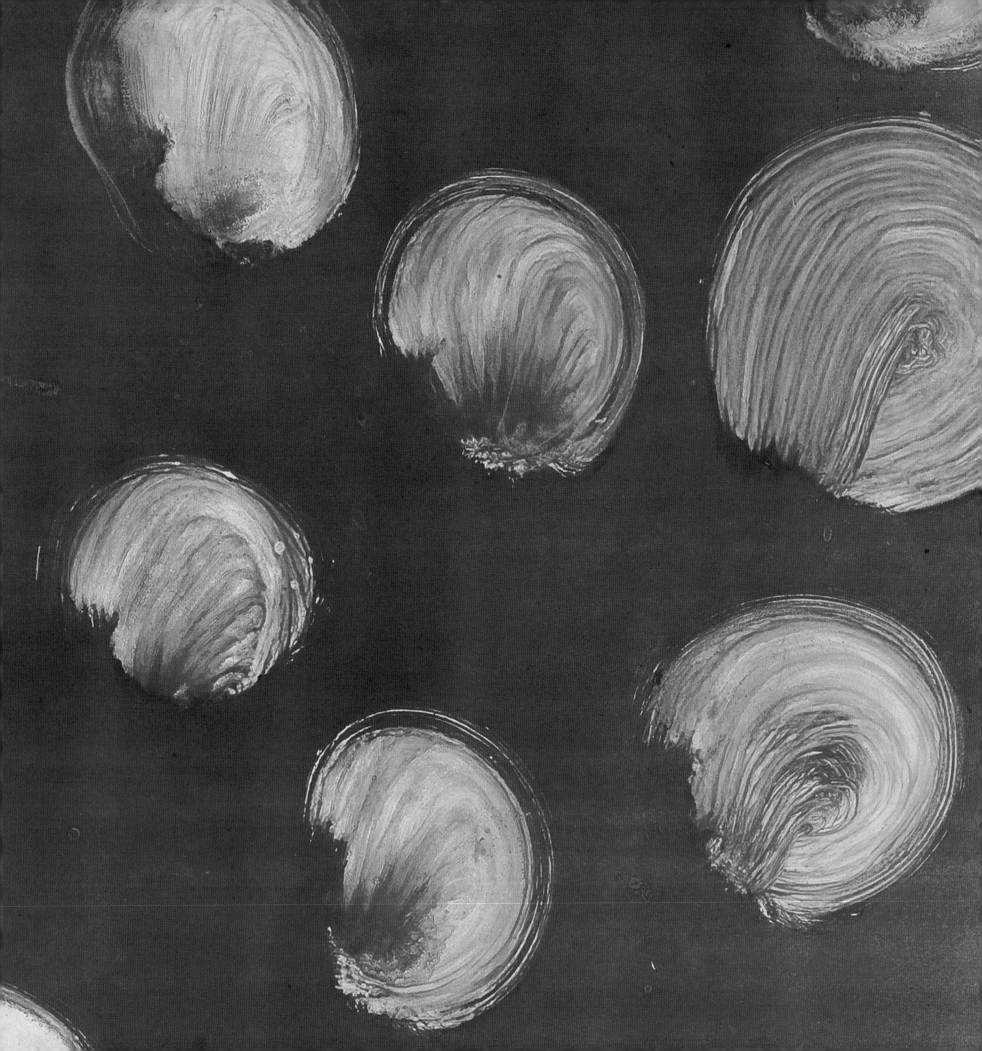

PARALLEL PARK: MARYLYN DINTENFASS' REFLECTIONS ON MOBILITY AND OTHER EXCURSIONS

ALIZA EDELMAN

"I think that cars today are almost the exact equivalent of the great Gothic cathedrals: I mean the supreme creation of an era, conceived with passion by unknown artists, and consumed in image if not in usage by a whole population which appropriates them as a purely magical object."

—Roland Barthes, "La nouvelle Citroën," *Mythologies*, 1957

THE AUTOMOBILE REPRESENTS the mythic object of the twentieth century. Its development has shaped and altered our relationships to culture, to the landscape and to the body. Infiltrating our imagination in art, literature, music, photography and film, the car, Peter Wollen offers, is "poised between the mechanical and the anatomical, the machine and the human subject."[1] Marylyn Dintenfass initiates her own critical exchange with the automobile in her large-scale installation *Parallel Park*, located in Fort Myers, Florida, and its related series of prints and paintings on view at the Bob Rauschenberg Gallery, Edison State College, Florida. This exchange is framed around the artist's veneration of the car as an object whose idealistic metaphors evoke freedom, identity and individual personality. It also negotiates— in art-historical terms—modernism's relationship to the automobile as a reflection of the urban experience and as a commentary on technology and power. Exploring the automobile as subject, Dintenfass alludes, intentionally or not, to a feminine gendered position in the spaces of modernity and visual culture.[2]

Dintenfass problematizes how we experience the artwork and the automobile as a spatially and culturally mediated object in the environment. Her oil-on-paper monotypes, conceived in advance of her site-specific installation *Parallel Park*, broadly capture the anticipation and anxiety of the postwar culture industry of the late 1950s and 1960s. *Bel Air Breeze*, *Toronado Torque*, and *Coupe de Ville Coup* command titles of cars from the Golden Age of the automobile (fig. 1). The 1955 Chevrolet Bel Air and

Fig. 1 (Opposite)
Dintenfass, *Bel Air Breeze* (detail), 2009
Oil on paper monotype, 35 x 35 in.

the 1958 Cadillac Eldorado epitomized this era's excessive designs. Long and bulbous tailfins, sexualized chrome headlights and grilles, wraparound windshields, aerodynamic hood ornaments and fantasy dashboards defined the aesthetics of the post-war American mindset. These features, Joe Kerr submits, "proved irresistible to a generation experiencing a seemingly limitless growth in purchasing power."[3] Dintenfass' larger, multipanel works in oil emulate the opulent designs and spirited colors of the Duesenberg and Stutz models, romanticized in 1920s American literature. Other works of the series relate the speed of the automobile to the postwar ascendance of rock and roll music. In *Parallel Park*—a public art project and commission for the Lee County Justice Center in Fort Myers—the artist encourages a new reading of our physical and psychological perception of mobility.

The automobile, more than most engineering or design innovations, generated in the first half of the twentieth century a new artistic vocabulary that championed the machine: the Italian Futurists promoted political manifestoes and paintings that rebelled against the old academies and glorified the myth of speed; Stuart Davis rendered his urban New York landscapes from within the isolated frame of the windshield; Sonia Delaunay designed colorful geometric garments to match automobiles; and Alexander Calder's kinetic, mechanized mobiles transposed motion as the fourth dimension.[4] Postwar examples are no less abundant but overridingly expressive of detachment, irony, death and destruction: Robert Rauschenberg's grounded tire prints; John Chamberlain's gestural, demolished automotive sculptures; James Rosenquist's billboard parodies; and Warhol's voyeuristic silkscreens of car crashes.[5] Interestingly, the feminist artist Judy Chicago attended auto-body school to master the art of spray painting and drew phallic and vaginal symbols on the masculine hood of her 1964 Corvair.[6]

Indeed, Dintenfass' abstract images can be filtered through these artistic predecessors, as well as through popular culture's screen of the postwar in such films as the anti-authoritarian *Rebel Without A Cause* (1955); the unbridled journey of *Easy Rider* (1969); and the "cruising" cliques in *American Graffiti* (1973). While Dintenfass also engages the social landscape to unearth her symbols or signs, they are clearly invested with personal meaning. This essay introduces the means by which Dintenfass employs an abstract language—both geometric and subjective—to explore her subject. Moreover, this language or lexicon uses forms of modular construction and architecture that are articulated repeatedly throughout her career.

As the car is an object of desire, it is also interchangeable as a site of meaning in Dintenfass' vernacular iconography—travel, candy, music, flowers and beauty. Like her other obsessions, the images of *Parallel Park* disclose over time the illusive nature of her constructed, vigorous surfaces.[7]

MOBILIZING SPACE

In Dintenfass' *Parallel Park* and in her previous series on candy and confections, titled *Good & Plenty Juicy*, the artist embeds the subject in a social and cultural matrix (fig. 2). The car, above all, is historically associated with a complex set of gender markers. The American woman, as Deborah Clarke argues, is "both car and driver,

Fig. 2
Dintenfass, *Good & Plenty Fruity*, 2009
Oil on panel, 60 x 60 in.

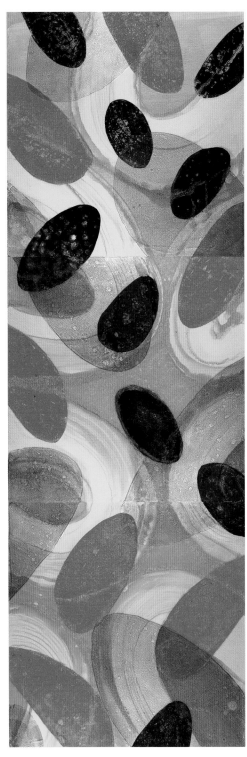

Fig. 3
Dintenfass, *This Side of Paradise*, 2010
Oil on panel, 102 x 34 in.

both object and subject of automotive culture."[8] Women and mass culture are historically unified in the industrial era as anthropomorphic, sexualized commodities and as symbols of consumption.[9] In 1912, for example, the Ford Motor Company, based in Detroit, released a now classic pamphlet directed to women, "The Woman and the Ford," to exploit the benefits of driving: "It's a woman's day. . . . She shares the responsibilities—and demands the opportunities and pleasure of the new order. No longer a 'shut in,' she reaches for an ever wider sphere of action—that she may be more the woman."[10] This advertisement relates the shifting social context of modern women, who in the 1920s and 1930s were known collectively as the New Woman. Significant exchanges among mass marketing, widespread ownership of automobiles and the contemporaneous success of the suffrage movement altered women's status and position.[11] In the postwar 1950s, motivational research for the automobile industry compared convertibles to mistresses and sedans to wives.[12]

In one group of paintings, Dintenfass broadly entertains the Jazz Age, an exceptional moment in American literary history after World War I, when the automobile permeated social representations of youthful and nihilistic modern experience. Appropriating the title of F. Scott Fitzgerald's debut novel *This Side of Paradise* (1920) for her expansive painting (fig. 3), Dintenfass releases across three large panels the directional and confrontational force of movement: elliptical, oblong wheels navigate the surface to merge with interstitial passages and spherical forms. The painting's vertical direction highlights Fitzgerald's social classification of his cast of characters in relation to their cars, from the more prosaic Ford Model T to the magnificent spectacle of the red Stutz Bearcat. For Fitzgerald, ritual courtships too are filtered through

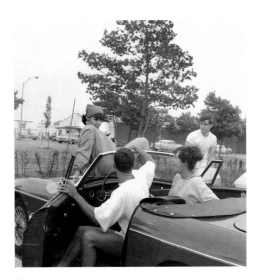

Fig. 4
Marylyn Dintenfass posing on the hood of a 1962
MGB, with her husband Gary Katz and friends.
Photograph, 1964.

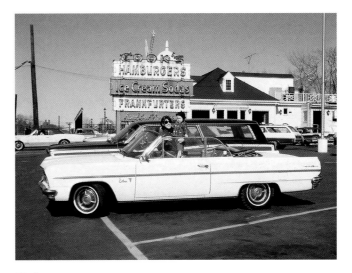

Fig. 5
Marylyn Dintenfass holding her son, Robert, in her 1964 Oldsmobile Cutlass
Convertible F85. Photograph, 1967.

automotive descriptions—aristocratic men are "terrible speeds" and hardened women "chrome-bright."[13] Dintenfass' sporty red and yellow colors, familiar with the racing Stutz Bearcat, communicate the emotional thrust of automobiles, while her painting's textural surface controls and restrains planar space: lustrous bodily sheen, burnished, enameled and vitreous, is contrasted with matte and marbled streaks.

Reflecting on the critical role played by the car in her own life, Dintenfass recounts her upbringing in the 1950s and early 1960s on Long Island, when she challenged the traditional image of a young woman by racing cars. Even then, she intuitively connected to the automobile as a subjective representation of "one's identity and personality."[14] Subsequently, Dintenfass registered for her driver's license on the first day that she was eligible to drive. While coveting the refined Volvo P1800, her first car was a beloved Volkswagen Beetle convertible, which she eventually crashed, sustaining a scar on her head. Two photographs of Dintenfass from the 1960s distinguish the public and private spaces of women and automobility: one playfully engaged in car culture—posing as object—the other captured in the classic family portrait (figs. 4–5). Pursuing art, the car performed as a practical and metaphorical vehicle of liberation and mobility, from the domestic realm to another sphere—one that was public, artistic, and masculine.

Dintenfass' *Eldorado Lartigued* (fig. 6), a monotype from the *Parallel Park* series, spotlights the singular speed of the wheel to distill a fixed moment in time and space. Comparable to the earliest photographic investigations in sequential motion by Eadweard Muybridge—also an interest of the artist—or the timed chronophotography by physiologist Etienne-Jules Marey, here Dintenfass cleverly references the early twentieth-century French photographer Jacques-Henri Lartigue. Challenged to capture a racecar on the track in his photograph *The Grand Prix of the A.C.F* of 1912 (fig. 7), Lartigue's foreshortened wheels and blurry forms underscore the inadequate timing of the camera to maintain pace with the vehicle. Dintenfass' *Eldorado Lartigued* (General Motor's chief designer, Harley Earl, transformed auto history with his Cadillac, including the Eldorado

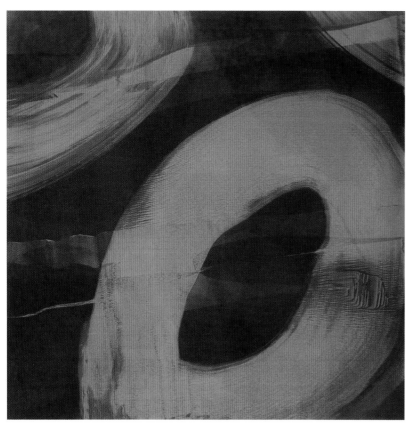

Fig. 6
Dintenfass, *Eldorado Lartigued*, 2009
Oil on paper monotype, 35 x 35 in.

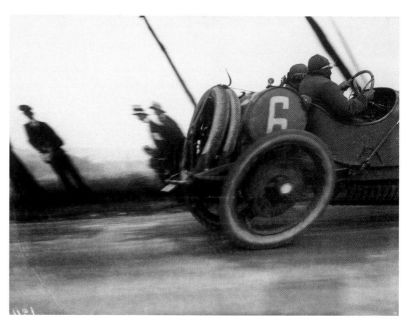

Fig. 7
Jacques-Henri Lartigue, *Grand Prix of the Automobile Club of France, Course at Dieppe*, 1912. Gelatin silver print, 10 x 13½ in. (25.4 x 34.3 cm). The Museum of Modern Art, New York, NY. Gift of the photographer (28.1963). Photograph by Jacques-Henri Lartigue / © Ministère de la Culture-France / AAJHL / Digital Image © The Museum of Modern Art / Licensed by SCALA / Art Resource, NY

models) conveys speed as surface markings—explosive streaks and black and red tire marks rupture the frame. In *Solstice* (fig. 8), the orange-red orifices have cylindrical weight at the same time that the gestural trace across the vertical plane, an afterimage, reinforces the surface tension. As in her other series, Dintenfass intends these images to be read sequentially and discursively, anticipating the next work. This formative idea of a narrative structure—rooted in photography and film—is found in her early ceramic investigations, such as *Fourth Progression* and *Diagonal Curve* of 1984. These installations serve as exceptional examples of temporality and shifting planar movement, as if in multiple exposure, through the repetitive construction of identical, porcelain clay shapes or modules (fig. 9).[15]

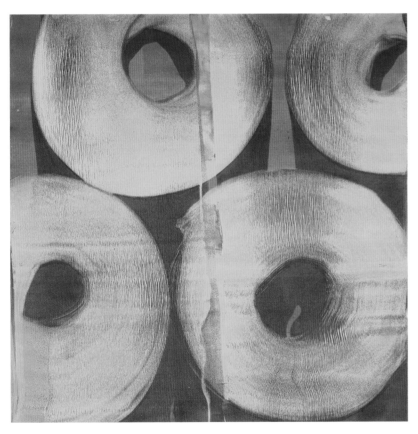

Fig. 8
Dintenfass, *Solstice*, 2009
Oil on paper monotype, 35 x 35 in.
Private Collection

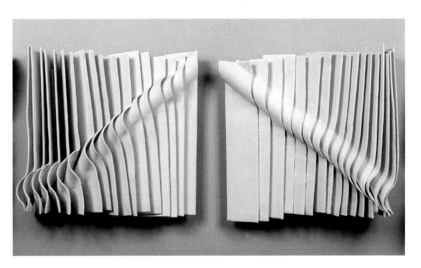

Fig. 9
Dintenfass, *Diagonal Curve* (detail), 1984
Ceramic, epoxy and plywood, 26 x 104 x 5 in.
Kaiser Permanente, Dallas, TX

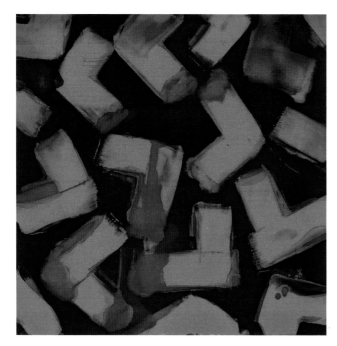

Fig. 10
Dintenfass, *Electra Lux*, 2009. Oil on paper monotype, 35 x 35 in.

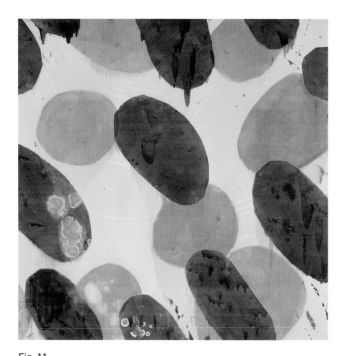

Fig. 11
Dintenfass, *Riviera*, 2009. Oil on paper monotype, 35 x 35 in.

Tracing modernism's fractured sites through speed and color, Dintenfass' prints disclose a subtle, uncomfortable narrative in the constructed surface. In striking opposition to the elongated dimensions of the wheel in *Eldorado Lartigued*, the monotype *Electra Lux* (GM's Buick Electra and Electra 225 were luxury cars) compartmentalizes saturated red and magenta L-shapes within the confines of the frame (fig. 10). Viable associations to congestion, aggression and urban gridlock, or even the common parked car, are present; more dynamic contrasts are the slackened, unconstrained edges with heavily applied areas of paint. The spatial organization of *Riviera* (fig. 11) combines the urgency of overlapping, colliding biomorphic forms and a fluid, centripetal brushwork in a softer yellow background. Here, as in the other images, an impression of emancipation conflicts with unforeseen restraint.

MOTIVATIN' SPEED

Intending to capture the pleasure and purpose of driving, Dintenfass uncovers in her most recent paintings the complementary forms of music and automobiles, and in an ancillary excursion explores the revolutionary collision in postwar culture of rock 'n' roll and cars. While the automobile has been a mainstay of musical lyrics since its technological inception—replacing the rail songs prominent in the Blues— the historical alliance of the electric guitar, the hybrid rhythms of rock and roll and the glorious dimensions of new auto designs produced an undeniable sound in postwar youth culture.[16] Elvis' countless customized Cadillacs symbolized financial and popular status. The masculine culture of the rock music industry, moreover, aligned the technological apparatus of the automobile to the female form, filling the radio waves with melodies on chasing girls, cruising and longing for sexual fulfillment.[17]

Chuck Berry, the pivotal musician of this era, inspired the act of motoring and the pursuit of the girl in his transformative car songs and 1955 hit *Maybellene*. Berry's utilitarian V-8 Ford is "motivatin' over the hill" in search of the fast-moving, social-climbing and unattainable Cadillac Coupe de Ville, Maybellene. This act of motoring, Warren Belasco notes, is all about "the inherent pleasure of moving" as a "surrogate for human relationships."[18] Belasco contends that "'Maybellene' actually concerns two types of movement: the horizontal spatial mobility of the road and the vertical of consumption."[19] Rock and roll's mobility—like F. Scott Fitzgerald's heroines and social climbers—charts femininity and car models.

Dintenfass' large oil painting *No Particular Place To Go* (fig. 12) amplifies the rambling lyrics and gritty chords of Berry's cruising song of 1964.[20] The planar surface of her painting takes on the appearance of the road's abrasive, coarse asphalt across the dark stretch of five panels. The circular thrust of tires and wheels is awkwardly transposed and

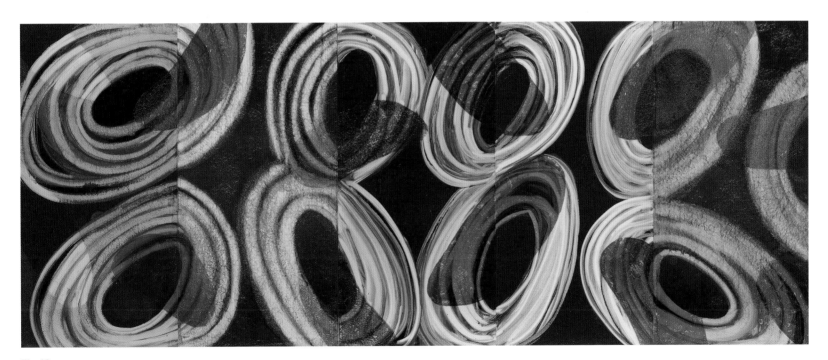

Fig. 12
Dintenfass, *No Particular Place to Go*, 2010. Oil on panel, 34 x 85 in.

oriented, not unlike Berry's thwarted chorus, "with no particular place to go."[21] The song's protagonist, "riding along in my automobile" and listening to the radio, cannot at last unfasten his girl's safety belt. For this series, Dintenfass' narrative structure defines mobility and speed not merely as positions in space, but as a temporal process that records a lifespan of events in the automobile. Her spatial grids propel and restrain her subject—counteracting horizontal motion through punctuated grooves—just as Berry's grainy voice and off-key guitar distort sound's texture.[22] Sean Cubitt offers that it is the voice of the musical artist that carries "the 'narrative' structure of the melody [as] an erotic function, to provide a point of identification through which to engage and mobilize the subject's desire."[23] Dintenfass' driving soundtrack transmits her painterly experience of transgression and gestural control.

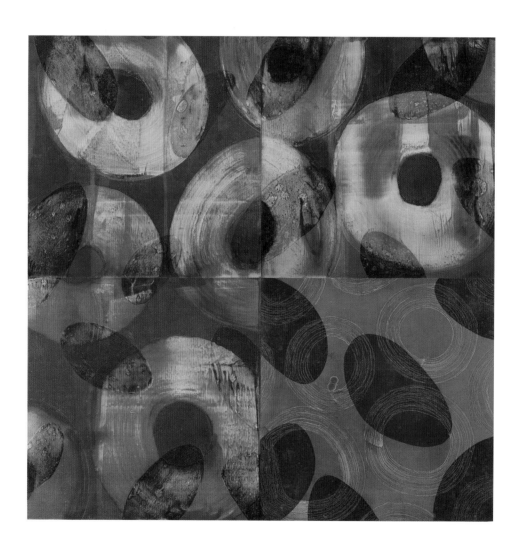

Fig. 13
Dintenfass, *Baby You Can Drive My Car—Yes I'm Gonna Be A Star*, 2010. Oil on panel, 68 x 68 in.

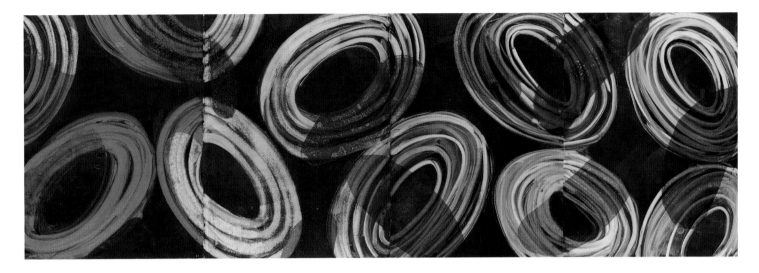

Fig. 14
Dintenfass, *Dashboard Lights On Paradise Night*, 2010
Oil on paper, 30 x 88 in.

Dintenfass carves speed through four panels in *Baby You Can Drive My Car— Yes, I'm Gonna Be A Star* (fig. 13), the title a refrain from the Beatles' 1965 song *Drive My Car*, released on the *Rubber Soul* album. Dilated shapes unfurl through the discordant fourth quadrant to obliterate her grid format and read as a uniform, narrative whole.[24] Not unlike the lyrics' glib repartee between a rising star/actress and her prospective driver/chauffeur, Dintenfass' painting initiates a dialogue among individual sections. In this conversation, however, the fourth panel is both present and absent, just as by the song's end the girl reveals that no car yet exists, but there's still the possibility of love—"Beep, beep, yea."

Perhaps no other image proposes reckless speed, whining ignitions, and consummate sexuality more strongly than Dintenfass' *Dashboard Lights on Paradise Night* (fig. 14). A sweeping riff on Meat Loaf's epic journey on young love—*Paradise By the Dashboard Lights* from his 1977 album, *Bat Out of Hell*—Dintenfass merges the car's electrified control panels and succession of spinning wheels. Constructing a lascivious and raw material surface, her colors and shapes—fervent yellows, reds, and oranges— grind and buffet against each other and the framed edges. Meat Loaf's totalizing drama, a story in sections about early lust, promise, fulfillment and despair, epitomizes his disruptive musical approach and sudden, stylistic changes.[25] What Lawrence Grossberg calls the "ever-changing structures of desire," rock and roll "functions to provide strategies for escaping, denying, celebrating [and] finding pleasure in . . . a post-modern world."[26] Similarly, Dintenfass constructs her subject through the fragmented intonations of rock and roll and her personal lexicon of symbols.

INFRASTRUCTURE AND THE GRID

Like many postwar artists maturing in the 1960s—in part acknowledging or dismissing the existentialism of Abstract Expressionism and the commercialism of Pop—Dintenfass turned to contemporary theories on the grid advanced by artists Frank Stella and Sol LeWitt, among others.[27] Her approach to spatial organization is an extension of Neoplasticism's formal construction of the grid and Minimalism's postmodern revision of it. The grid, as explored by Rosalind Krauss, rejects a narrative progression at the same time that it advances it. Analyzing this primal conflict, Krauss interprets the grid's potential for endless repetitions of the same conflict. The grid thus becomes a "mapping of the space inside the frame onto itself."[28] Throughout her career, Dintenfass has invested her material surface with a self-imposed and self-referential system of framing the edge, thus determining an internal structure that controls the appearance of spatial and gestural illusionism. Her early ceramic installation *Quadrille* from 1978 (fig. 15) illustrates the rational, modular repetition of sixteen quadrangles. The structural frame of each unit is challenged, however, by irregular layers and folds of clay that disrupt the grid. Offering her perspective that "containment and structure create creativity" and that "paintings are constructed as objects," Dintenfass traces her lineage to the ideas on systems, structuralism and literalism circulating in the 1960s.[29] Taking cues from other disciplines, many artists interpreting the grid turned to new philosophies in linguistics and anthropology to define structural models and meaning in society.[30]

The geometric, symmetrical plans of Frank Stella's paintings are also intended to control cues to depth and render an impenetrable surface. The use of commercial paints and application techniques produces a hard and somewhat reflective surface, to define the image as a literal object (fig. 16).[31] For both Dintenfass and Stella (who, in fact, memorialized a Spanish race-car driver in his *Marquis de Portago* of 1960), the visual code or meaning is located on the painting's surface.[32] Krauss has summarized painting as "not so

Fig. 15
Dintenfass, *Quadrille*, 1978
Ceramic, epoxy and plywood, 72 x 72 x 3 in.
Benton & Bowles, Inc., New York

Fig. 16
Frank Stella, *Fez*, 1964. Fluorescent alkyd on canvas, 77 x 77 in.
(195.58 x 195.58 cm). Albright-Knox Art Gallery, Buffalo, NY. Gift of
Seymour H. Knox, Jr., 1964. Albright-Knox Art Gallery / Art Resource,
NY / © 2010 Frank Stella / Artists Rights Society (ARS), New York

much an icon as a meditation on the logic of the icon, on how such a form might have come into being as a vehicle of cultural meaning."[33] Likewise, Dintenfass' paintings are constructed as interchangeable units that assemble and then reassemble her object-meaning. For her present approach, in *Parallel Park*, the object is the automobile, but next time the artist may equally consider fashion or beauty.

Yet Dintenfass' planar surfaces and masculine structures resist abstraction's objectivity. Adapting Sol LeWitt's compulsive lattice and cubic systems—his "grammar"—for her large painting *Transmit LeWitt* (2006), she reframes the relationship between horizontal and vertical bands, playfully asserting the tension between rigorous logic and unfettered line (figs. 17–18).[34] Bold and discordant colors, alternating patterns of acid green and fiery red, further counter any holistic effect. Lilly Wei aptly defines Dintenfass' use of color as "the record of the construction of the painting in which each layer is visible."[35] Color—modernism's antidote to structure—challenges the existence of a direct correlation in language through its subjective qualities and "resistance to signification."[36] Applying an additional strategy, Dintenfass embodies color as a corporeal effect without sacrificing rigorous geometry. Asserting that "color is concrete," Dintenfass also proclaims its dualistic potential: "It has body and substance; it's tactile."[37] She physically identifies this compositional color conflict as a "dysfunctional" process analogous to a family's psychological need for space and intervention.

This conflict both encourages and destabilizes a narrative reading of her work. While Sol LeWitt offers, "there is the idea, which is always unstated," Dintenfass proposes something more unsettled, "things are *not* what they seem."[38] In this sense, she privileges the viewer to encounter what she calls an "inside/outside experience," or the opportunity to map the psychic space in her work.[39] Furthermore, by revealing the potential for both "*concrete* and subjective implications," Dintenfass' approach may be compared to a broader set of strategies on identity taken by female artists working within modes from Geometric Abstraction to Post-Minimalism.[40]

Fig. 17
Sol LeWitt, *Cubic-Modular Wall Structure, Black*, 1966. Painted wood, 43½ x 43½ x 9⅜ in. (110.3 x 110.2 x 23.7 cm). The Museum of Modern Art, New York, NY. Gift of Alicia Legg (390.1986). Digital Image © The Museum of Modern Art / Licensed by SCALA / Art Resource, NY / © 2010 The LeWitt Estate / Artists Rights Society (ARS), New York

Fig. 18
Dintenfass, *Transmit LeWitt*, 2006
Oil on panel, 48 x 48 in.

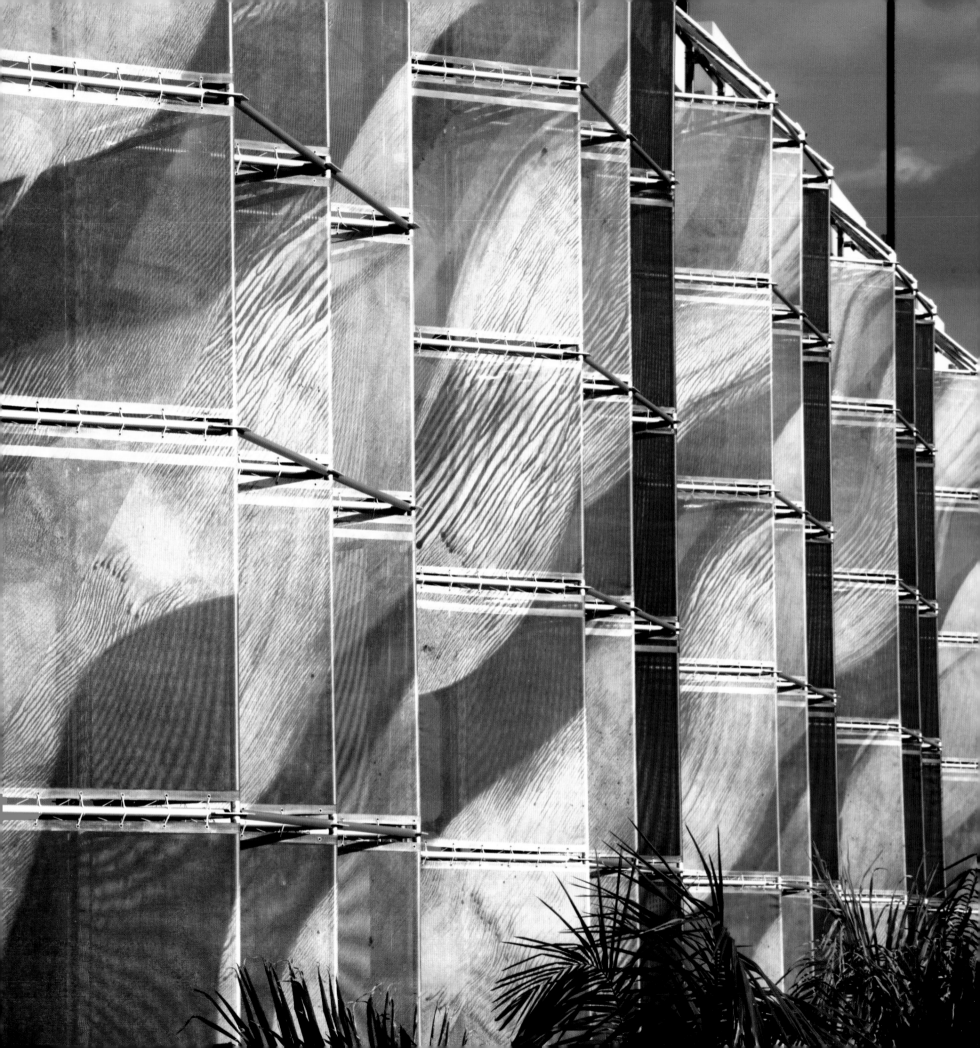

PARALLEL PARK

The postwar French philosopher Roland Barthes extolled the supreme beauty of the Citroën D.S., *la Déesse* or the Goddess, when it was first displayed in Paris—the car was an object originating from the heaven of Metropolis, a world beyond nature, with bodywork, lines, and upholstery so lavish that behind the wheel one "pretends to drive with one's whole body."[41] Dintenfass' commission and installation *Parallel Park* can be understood as a logical extension of her interest in the automobile and as a broader investigation of the dimensional nature of her subject (fig. 19). Her transformation of the ubiquitous garage— a parking lot and repository of cars—to an ultimate destination and art site establishes *Parallel Park* as an "interdisciplinary space" in the landscape.[42] Like Barthes' glorified myth of the Citroën, the viewer participates in a physical and temporal relationship with the artwork that synthesizes the object, the corporeal and the architectural.

Exhibiting her artwork on a monumental scale, Dintenfass encourages the viewer to experience *Parallel Park* as a mutable object in space and time—a true reflection of our physical extension from the automobile and the "urban-aesthetic."[43] The scale of each monotype is altered dramatically: eight images, enlarged digitally to approximately five stories in height—33 feet high by 23 feet wide—are distributed among 23 unified panels to enclose a free-standing garage. The panels— a porous, weather-resistant resin material—serve as the garage's structural facade to permit the circulation of air and light. Additionally, each large panel, comprised of individual units, is stretched for tensile strength through a system of bars and rods. Throughout her career, Dintenfass' approach to installations has consistently explored architectural metaphors and incorporated elements of the "girder, post, beam, window and bridge."[44] For example, *Parallax* and *Diagonal Frieze* (figs. 20–21) reflect architecture's abstract and interdisciplinary potential. Repetitive, interlocking units or organic, undulating

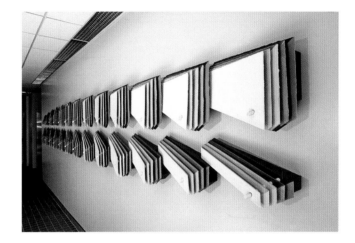

Fig. 20
Dintenfass, *Parallax*, 1983. Ceramic, metallic oxides, epoxy and plywood, 36 x 240 x 6 in. IBM, San Jose, CA.

Detail, *Parallax*

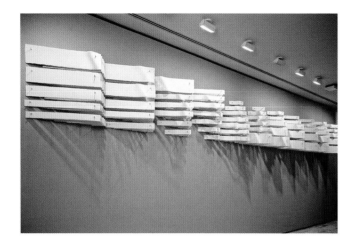

Fig. 21
Dintenfass, *Diagonal Frieze*, 1986. Ceramic and steel, 36 x 396 x 18 in.
State of Connecticut Superior Courthouse, Enfield

Detail, *Diagonal Frieze*

bands of porcelain are supported off the wall through tubes and rods that individually pierce each element but maintain a unified sculpture on the horizon.

Defining the influence of the machine on modern architecture, the French architect and theorist Le Corbusier sought to examine new relationships between the site and the landscape—the scenography. In his text *Vers une architecture* (*Towards a New Architecture*), he proposed the idealistic correlation between the automobile and the height of Greek architecture—the Parthenon.[45] Dintenfass is less utopian in her approach to *Parallel Park*, but she also frames our encounter with the automobile through sensorial experience and the local setting—the low-level buildings in downtown Fort Myers. The expanse of panels circulating the garage's perimeter recall the rhythmic progression of colonnades, pediments, and friezes in ancient Greek temples. They correspondingly display the potential for a narrative structure. Like her paintings and installations of modular grids, however, *Parallel Park* implies counter-directional movement. On the north facade of the entrance, for example, the panel *Fleetwood Would* progresses into *Eldorado Lartigued*; on the opposite, south facade *Electra Lux* shifts into *Solstice* (figs. 22–23). The image *Fleetwood Would* (the Cadillac Fleetwood optioned as a convertible) transposes infinite and vertical vectors to induce the effects of sound or the vibration of speed—measurable as wavelength—alongside the elliptical force in *Eldorado Lartigued*. Analogous to her individual prints, the expansive panels of *Parallel Park* display an oscillatory process that gives the impression of individual panels slipping under each other, or even that counteracts their rectilinear form.

In Florida, of course, color and light are a primary component of temporal experience. With *Parallel Park*, light's empirical nature changes the impression of chromatic density across the geometrical surface—at times transparent, translucent or solid. This impact of color depends on the direction of the sun combined with the viewer's stationary or active position. As in Dintenfass' *Imprint*

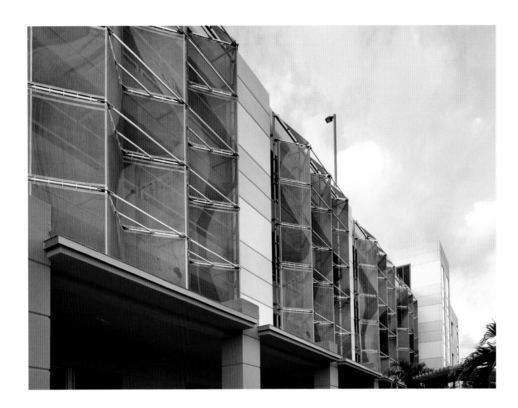

Fig. 22
Dintenfass, *Parallel Park*, 2010
Detail, north facade, *Fleetwood Would* and
Eldorado Lartigued

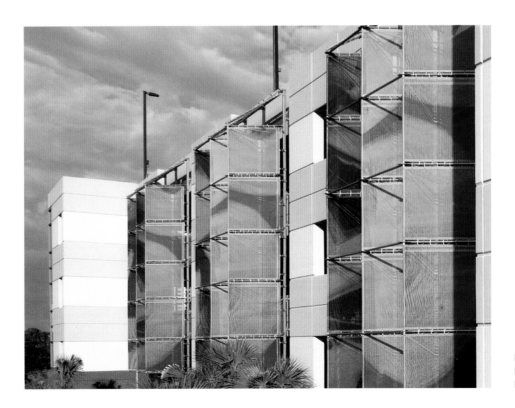

Fig. 23
Dintenfass, *Parallel Park*, 2010
Detail, south facade, *Electra Lux* and *Solstice*

Fig. 24
Dintenfass, *Imprint Fresco*, 1985. Ceramic, metallic oxides, plywood, acrylic paint, steel, fiberglass mesh and marine epoxy, 192 x 336 x 9 in. Installation, Port Authority of New York and New Jersey, Bus Terminal, 42nd Street, New York

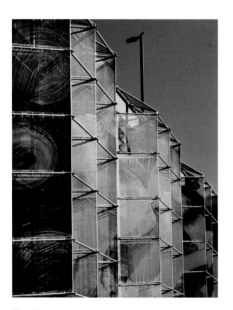

Fig. 25
Dintenfass, *Parallel Park*, 2010
Detail, west facade, *Bel Air Breeze*, *Caprice Caprice*, and *Electra Lux*

Fig. 26 (Opposite)
Dintenfass, *Parallel Park*, 2010
Detail, west facade, *Caprice Caprice*

Fresco (fig. 24), a polychrome and ceramic installation, the artist continually investigates the process through which surfaces interact with light and color. Characteristic of Byzantine mosaics and frescoes—many of which Dintenfass observed during influential trips to Italy—the viewer thus inhabits the ephemeral nature of color. When viewing *Parallel Park*—due to optical alterations of light and color, combined with scale—one fills in the fabric's holes to read the image and obtain the holistic effect. When approached from the west, the aquamarine, nautical atmosphere of *Bel Air Breeze* is juxtaposed with the sunlit, chartreuse expanse of *Caprice Caprice* (figs. 25–26). Evident here is Dintenfass' admiration of Mark Rothko and Richard Diebenkorn—artists whose particular sensibility of light and delineation of color navigate their geometric surfaces and landscapes.

Parallel Park exhibits a postmodern sensibility in its cumulative production of space. It can be read either as a progression of fractured pictorial experiences or as a collective object. By engaging the car window as an internal framing device, Dintenfass' constructions are oriented as landscapes in the city. Establishing a dialogue with postmodernism's complex approach to historical references and ornament—promoted by architect Robert Venturi's influential texts—*Parallel Park* plays on the vernacular use of iconography and symbols in unexpected ways. Venturi's *Learning from Las Vegas* (1972) endorsed the infrastructure and urban planning that support the automobile as a valuable component of architecture.[46] On the road or highway, however, the driver simulates a process of "self-abstraction," described by Cotton Seiler as the ability to divest oneself in space and time from other enclosed cars.[47] This negotiation between autonomy and invisibility shapes Dintenfass' inside/outside and public/private experience of mobility.

From one vantage point, therefore, the monumental scale of *Parallel Park* identifies our historical desire to mythologize the automobile as a symbol of mobility and progress. However, the analysis of Dintenfass' oeuvre advocates another, dialectical reading of the mapping of space through multiple positions—structural and temporal; narrative and corporeal. Moreover, Dintenfass' *spaces* are generally unfixed and unsettled, suggestive of readings that assert a feminine and gendered viewing position.[48] Arguably then, *Parallel Park* also stimulates a contextual dialogue regarding our experience of space, and encourages new and significant ideas on the future of the automobile in society: its effect on climate change, for example, or the present need for technological advances in oil consumption. Ultimately, Dintenfass' *Parallel Park* successfully translates her artistic approach into a compelling and provocative site.

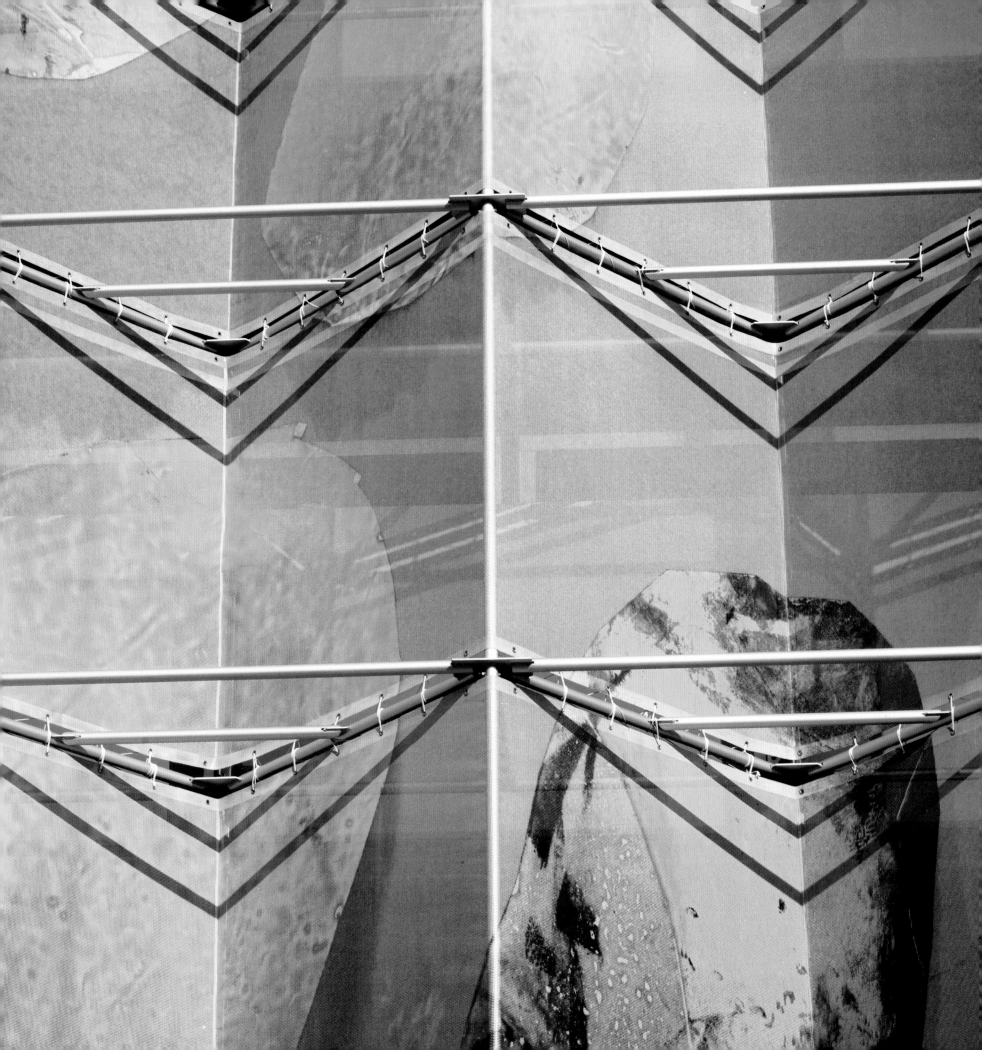

ALIZA EDELMAN, Ph.D., writes extensively on gender and social identity in modern and contemporary art. In addition to her research on the Modern Woman and Abstract Expressionism, her scholarship focuses at present on artistic relationships and exchange among North and South American women artists, including her recent contribution to *Constructive Spirit: Abstract Art in South and North America, 1920s–50s* (Newark Museum, NJ, 2010). She has worked in the curatorial department of The Jewish Museum, New York, and has lectured on Contemporary Art at Rutgers University, NJ.

1. Peter Wollen, "Cars and Culture," in *Autopia: Cars and Culture*, ed. Wollen and Joe Kerr (London: Reaktion Books, 2002), 17; see also Gerald Silk et al., *The Automobile and Culture*, exh. cat., Museum of Contemporary Art, Los Angeles (New York: Harry N. Abrams, 1984).

2. See Griselda Pollock, *Vision and Difference: Femininity, Feminism, and the Histories of Art* (New York: Routledge, 2003).

3. Joe Kerr, "Trouble in Motor City," in *Autopia*, 132. See also Karal Ann Marling, *As Seen on TV: The Visual Culture of Everyday Life in the 1950s* (Cambridge, Mass: Harvard University Press, 1994).

4. Many American artists, for example, John Storrs, mythologized the machine and technology in chrome and stainless-steel constructions displayed at the 1939 New York World's Fair. See Dickran Tashjian, "Engineering a New Art," in *The Machine Age in America, 1918–1941*, ed. Richard Guy Wilson, exh. cat. (New York: Brooklyn Museum in association with Harry N. Abrams, 1986), 264.

5. See Anne Massey's account of the British Pop artist Richard Hamilton and The Independent Group's exhibition in 1960 titled *The Man, Machine, and Motion* (ICA, London), in *The Independent Group: Modernism and Mass Culture in Britain, 1945–1959* (Oxford: Manchester University Press, 1995). See also Matthew Baigell's essay on loss and entropy in art after Abstract Expressionism in "American Art Around 1960 and the Loss of Self," in *Artist and Identity in Twentieth-Century America* (New York: Cambridge University Press, 2001), 154–66.

6. Judy Chicago, *Through the Flower: My Struggle as a Woman Artist* (Garden City, NY: Doubleday, 1975), 36.

7. See Lisa Tickner, "Feminism, Art History, and Sex Differences," *Genders*, no. 3 (Fall 1988): 96–97.

8. Deborah Clarke, *Driving Women: Fiction and Automobile Culture in Twentieth-Century America* (Baltimore: Johns Hopkins University Press, 2007), 2–3.

9. See Andreas Huyssen, *After the Great Divide: Modernism, Mass Culture, Postmodernism* (Bloomington: Indiana University Press, 1986), 47.

10. Quoted in Clarke, *Driving Women*, 15.

11. Laura Behling, "'The Woman at the Wheel': Marketing Ideal Womanhood, 1915–1934," *Journal of American Culture* 20, no. 3 (Fall 1997): 13–14. See also Cecilia Tichi, *Shifting Gears: Technology, Literature, and Culture in Modernist America* (Chapel Hill: University of North Carolina Press, 1987).

12. See Ernest Dichter, *The Strategy of Desire* (1960; reprint, New Brunswick, NJ: Transaction, 2002), 36. See also Mona Hadler, "Pontiac Hood Ornaments: Chief of the Sixes," in *Society for Commercial Archeology* 28, no. 1 (Spring 2010): 6–15.

13. F. Scott Fitzgerald, *This Side of Paradise* (New York: Charles Scribner's Sons, 1920). See also Peter J. Ling, "Sex and the Automobile in the Jazz Age," *History Today* 39 (November 1989): 18–24.

14. Marylyn Dintenfass, interview with the author, October 10, 2010.

15. See April Kingsley's important essay on the challenges of ceramics in "Marylyn Dintenfass," *American Ceramics* 2, no. 2 (Spring 1983): 16–21.

16. See E. L. Widmer's seminal essay "Crossroads: The Automobile, Rock and Roll and Democracy," in *Autopia*, 65–74. See also John A. Heitmann, *The Automobile and American Life* (Jefferson, NC: McFarland, 2009), 156–57.

17. See Diana Railton, "The Gendered Carnival of Pop," *Popular Music* 20, no. 3 (October 2001): 321–31. See also Sheila Whiteley, *Women and Popular Music: Sexuality, Identity, and Subjectivity* (New York and London: Routledge, 2000).

18. Warren Belasco, "Motivatin' with Chuck Berry and Frederick Jackson Turner," in *The Automobile and American Culture*, ed. David L. Lewis and Lawrence Goldstein (Ann Arbor: University of Michigan Press, 1980), 266–67. See also Richard A. Peterson, "Why 1955? Explaining the Advent of Rock Music," *Popular Music* 9, no. 1 (January 1990): 97–116.

19. Belasco, "Motivatin' with Chuck Berry and Frederick Jackson Turner," 268.

20. See John L. Wright, "Croonin' About Cruisin'," in *The Popular Culture Reader*, ed. Jack Nachbar, Deborah Weiser, and Wright (Bowling Green, OH: Bowling Green University Press, 1978), 109–17.

21. See Patrick Field, "No Particular Place to Go," in *Autopia*, 64.

22. My thanks to musician Steve Count for his demonstration of Berry's persistent off-key guitar sound. See Sean Cubitt, "'Maybellene': Meaning and the Listening Subject," *Popular Music* 4 (1984): 212.

23. Ibid., 215.

24. Dintenfass, interview with the author, November 16, 2010.

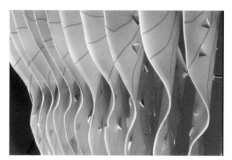

25. See Gerri Hirshey, "Pink Cadillacs, Little Red Corvettes, Paradise by the Dashboard Light," *Rolling Stone*, no. 840 (May 2000): 87–114.

26. Lawrence Grossberg, "Another Boring Day in Paradise: Rock and Roll and the Empowerment of Everyday Life," *Popular Music* 4 (1984): 237, 239.

27. Dintenfass, interview with the author, October 10, 2010. Dintenfass grants her formative influence to early professors and colleagues at Queens College in the early to mid-1960s, including constructivist painter John Ferren, who taught color theory; art historian Barbara Rose and her then husband, artist Frank Stella, who arranged salon-style gatherings for students; and Larry Poons and Andy Warhol. As the chair of the Arts Study Group at Queens College, Dintenfass organized Poons' and Warhol's visit to the department, and was impressed by their concept of making art "on one's own terms" without academic training. See "A Conversation: Marylyn Dintenfass with John Driscoll," in *Marylyn Dintenfass: Paintings* (Manchester, VT: Hudson Hills Press, 2007), 43, 126.

28. See Rosalind Krauss' seminal essay, "Grids," in *The Originality of the Avant-Garde and Other Modernist Myths* (Cambridge, MA: MIT Press, 1996), 12–13, 19.

29. Dintenfass, interview with the author, October 2, 2010. See also "A Conversation," in *Marylyn Dintenfass: Paintings*, 27.

30. French anthropologist Claude Lévi-Strauss' influential text *Structural Anthropology*, published in 1963, determined the debate on Structuralism and Poststructuralism.

31. See Michael Auping, *Abstraction, Geometry, Painting: Selected Geometric Abstract Painting Since 1945*, exh. cat. (New York: Harry N. Abrams in association with the Albright Knox-Art Gallery, 1989), 71.

32. In 1976, Frank Stella received a BMW Art Car, an opportunity he used to paint the car in his Minimalist vein; a recurring project, the BMW Art Car was given recently to Olafur Eliasson, who discussed his theories on the automobile's interaction in society in *Olafur Eliasson: Your Mobile Expectations; BMW H2R Project*, exh. cat., Pinakothek der Moderne, Munich (Baden: Lars Müller, 2008).

33. Krauss, "Overcoming the Limits of Matter: On Revising Minimalism," in *American Art of the 1960s*, Studies in Modern Art 1 (New York: The Museum of Modern Art, 1991), 128.

34. On issues of language and modularity, see Sol LeWitt, "Paragraphs on Conceptual Art," *Artforum* 5, no. 10 (June 1967): 79.

35. Lilly Wei, "Painting in the Here and Now," in *Marylyn Dintenfass: Paintings*, 21.

36. See Ann Eden Gibson, "Color and Difference in Abstract Painting: The Ultimate Case of Monochrome," in *The Feminism and Visual Culture Reader*, ed. Amelia Jones (London: Routledge, 2003), 194. See also Molly Nesbit's discussion of color's resistance to language in "On Colour," in *Olafur Eliasson: Your Mobile Expectations*, 242.

37. Dintenfass, interview with the author, October 2, 2010. See also "A Conversation," in *Marylyn Dintenfass: Paintings*, 30.

38. See Lucy Lippard, *Sol LeWitt*, exh. cat. (New York: Museum of Modern Art, 1978), 24. "The idea itself," LeWitt wrote, "even if not made visible, is as much a work of art as any finished product." See LeWitt, "Paragraphs on Conceptual Art," 83.

39. Dintenfass, "A Conversation," in *Marylyn Dintenfass: Paintings*, 30.

40. Donald B. Kuspit, "Authoritarian Abstraction," *Journal of Aesthetics and Art Criticism* 36, no. 1 (Autumn 1977): 34. See also Lynn Zelavansky, *Sense and Sensibility: Women Artists and Minimalism in the Nineties* (New York: Museum of Modern Art, 1994).

41. Roland Barthes, "The New Citroën," in *Mythologies*, trans. Annette Lavers (New York: Hill and Wang, 1972), 86–87.

42. See Rosalyn Deutsche's critical essays on public art and politics in *Evictions: Art and Spatial Politics* (Chicago: Graham Foundation for Advanced Studies in the Fine Arts; Cambridge, MA: MIT Press, 1996), 5. See also Miwon Kwon, *One Place After Another: Site-Specific Art and Locational Identity* (Cambridge, MA: MIT Press, 2002).

43. Ibid.

44. Dintenfass, "Working Large Scale: Portfolio," *Ceramics Monthly* 34, no. 5 (1986): 34.

45. Le Corbusier, *Towards a New Architecture*, trans. Frederick Etchells (1931; reprint, New York: Dover Publications, 1986), 129–31.

46. Robert Venturi, Denise Scott Brown, and Steven Izenour, *Learning from Las Vegas: The Forgotten Symbolism of Architectural Form* (Cambridge, MA: MIT Press, 2001).

47. Cotton Seiler, *Republic of Drivers: A Cultural History of Automobility in America* (Chicago: University of Chicago Press, 2008), 139–140.

48. See Deutsche, "Men in Space," in *Evictions*, 195–202.

DETAILS CERAMIC INSTALLATIONS, 1978–1987

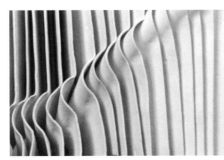

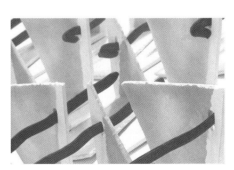

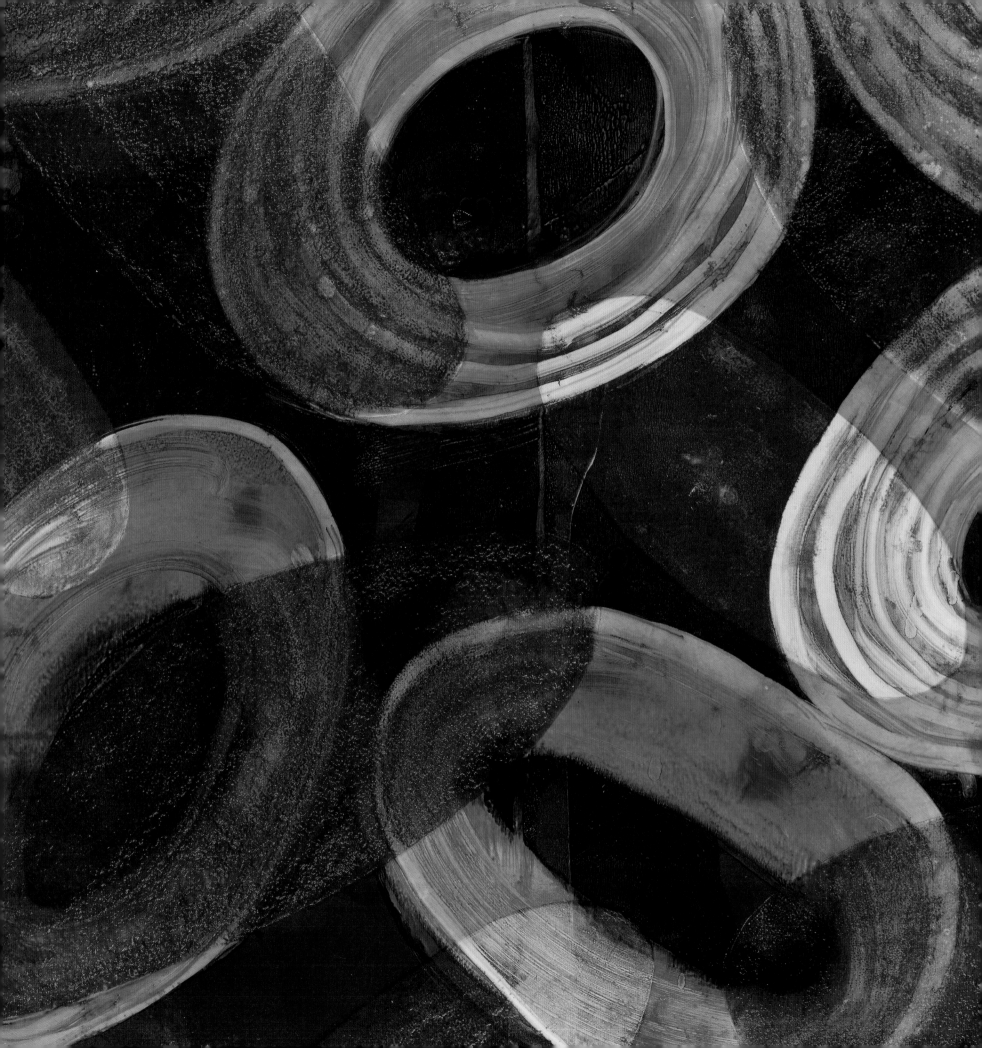

PARALLEL PARK EXHIBITION

BOB RAUSCHENBERG GALLERY, FORT MYERS, FLORIDA

WHEELS WHINING, CLUTCH CRYING, HONEY WE GONNA FLY 2010 OIL ON PANEL 68 x 68 INCHES

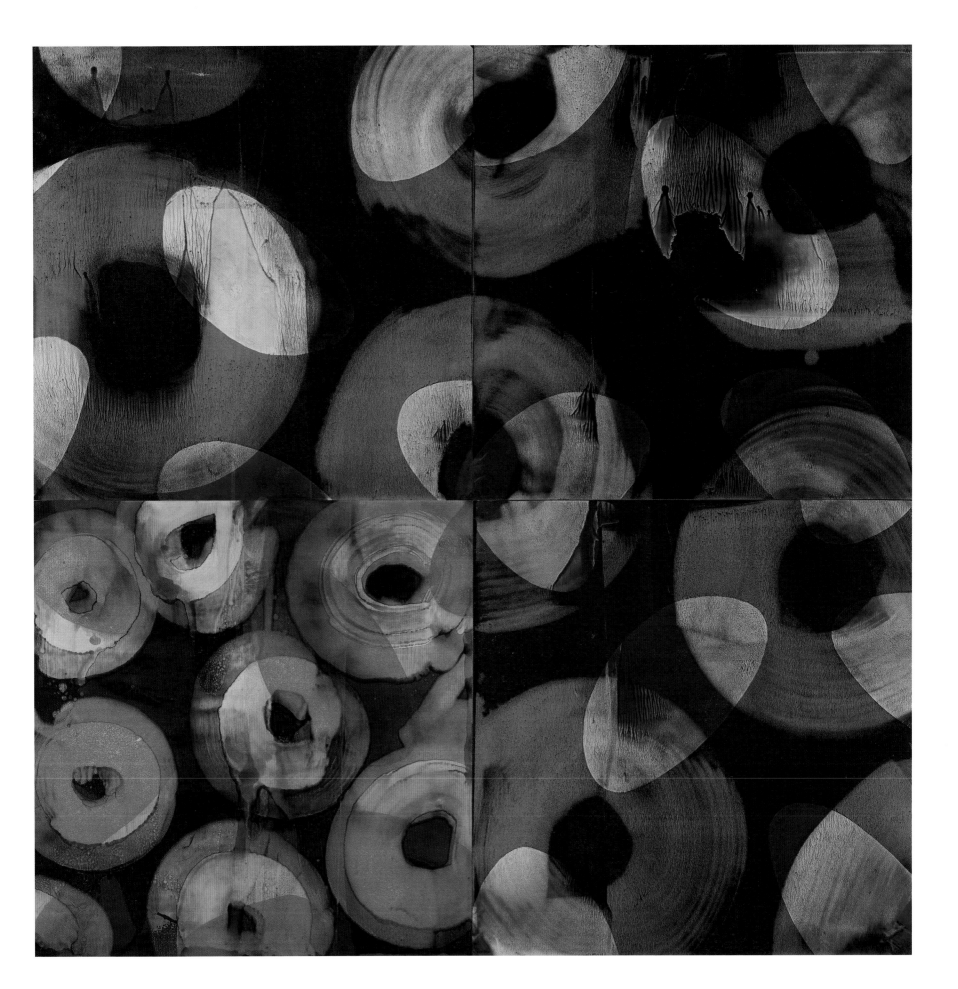

STICKSHIFT, KNEES, AND THIGHS 2010 OIL ON PANEL 68 x 68 INCHES

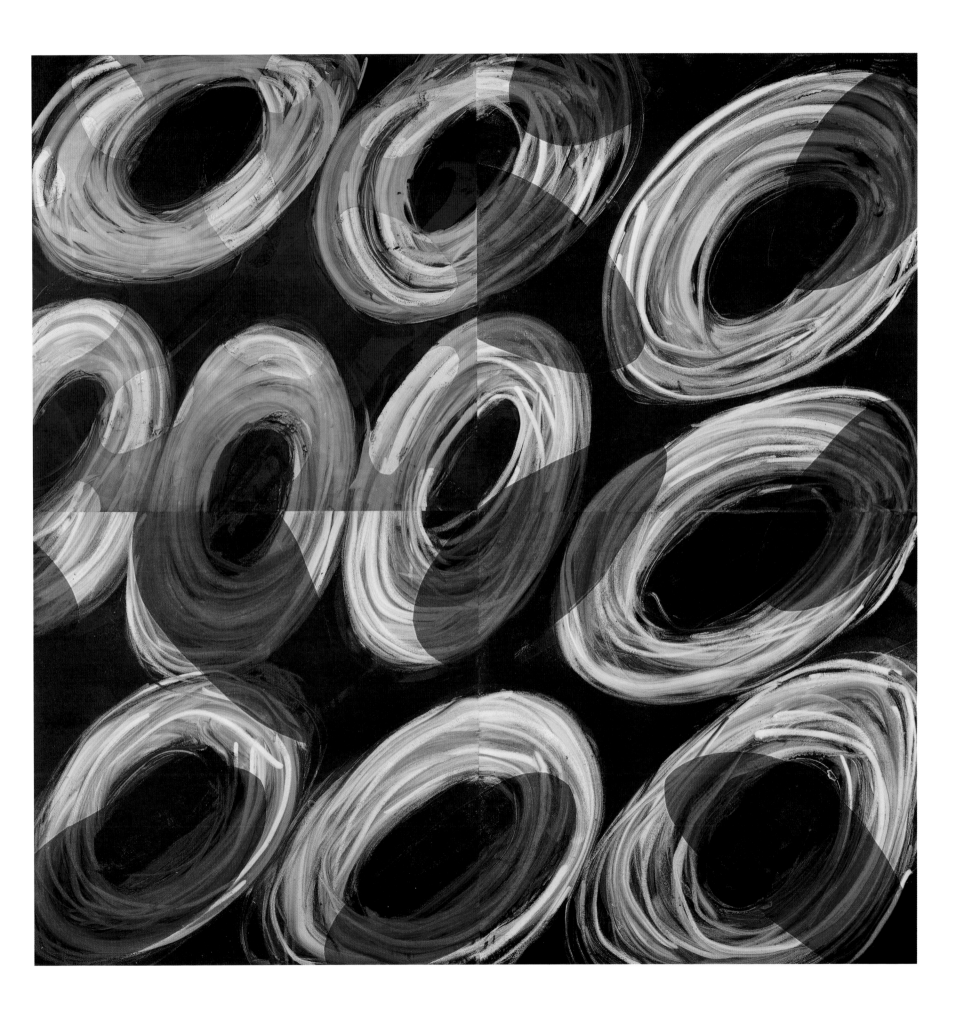

YOUR CHROME HEART SHINING 2010 OIL ON PANEL 30 x 30 INCHES

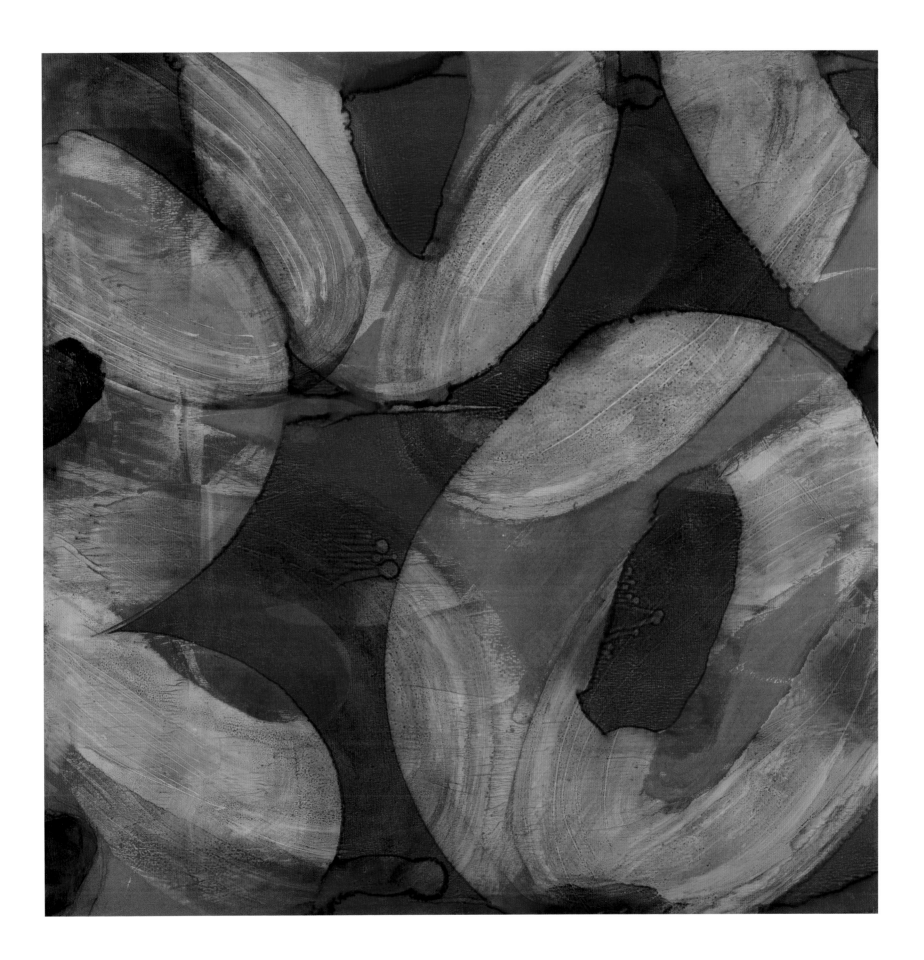

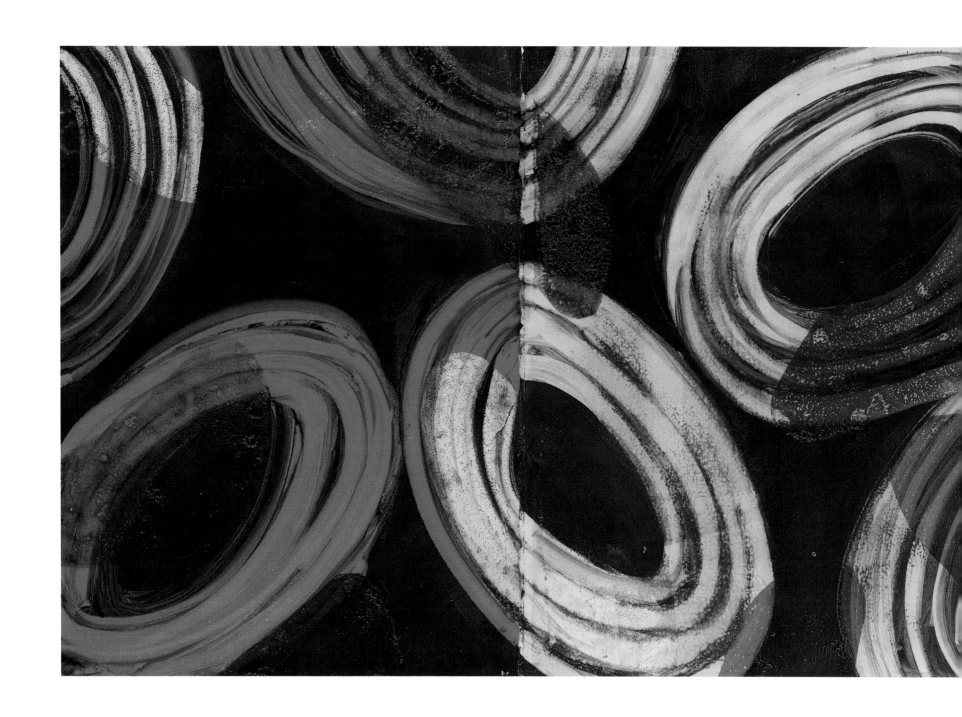

DASHBOARD LIGHTS ON PARADISE NIGHT 2010 OIL ON PAPER 30 x 88 INCHES

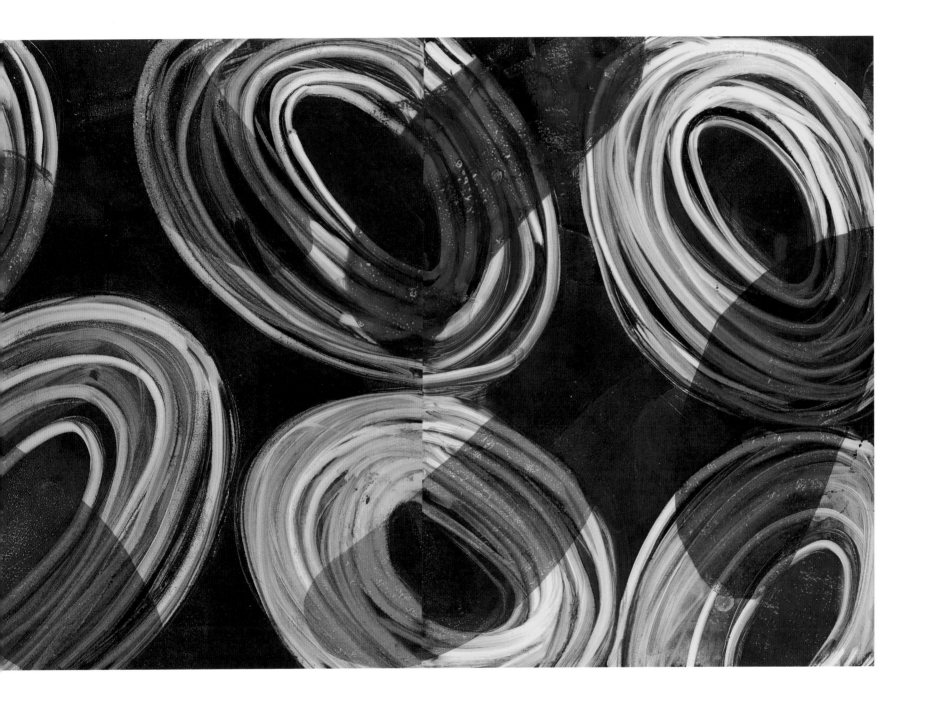

BABY YOU CAN DRIVE MY CAR—YES, I'M GONNA BE A STAR 2010 OIL ON PANEL 68 x 68 INCHES

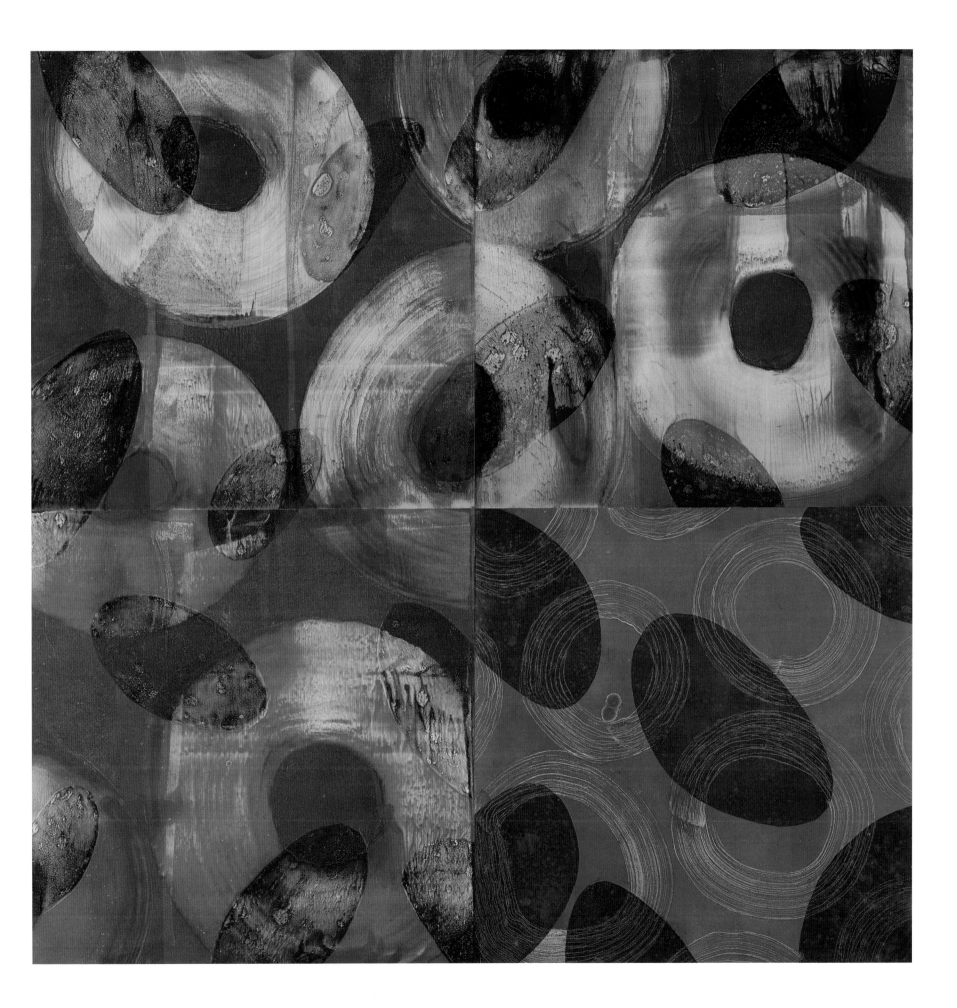

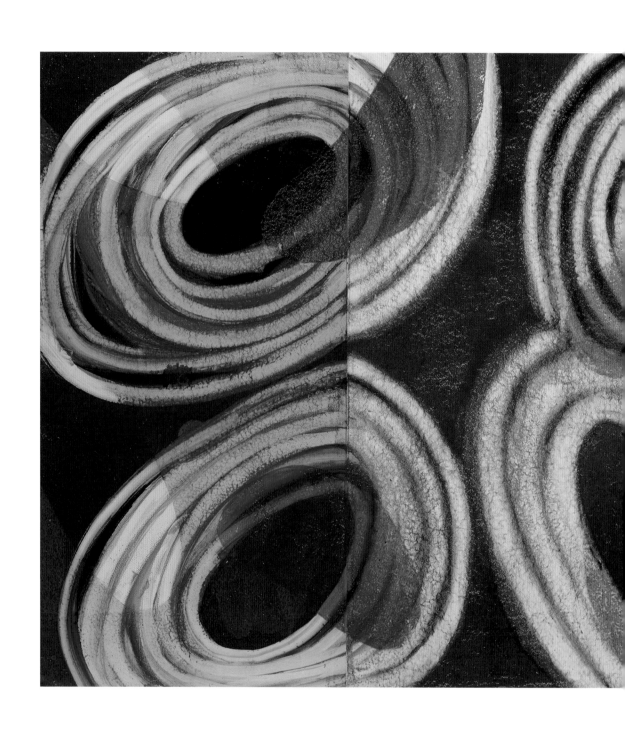

NO PARTICULAR PLACE TO GO 2010 OIL ON PANEL 34 x 85 INCHES

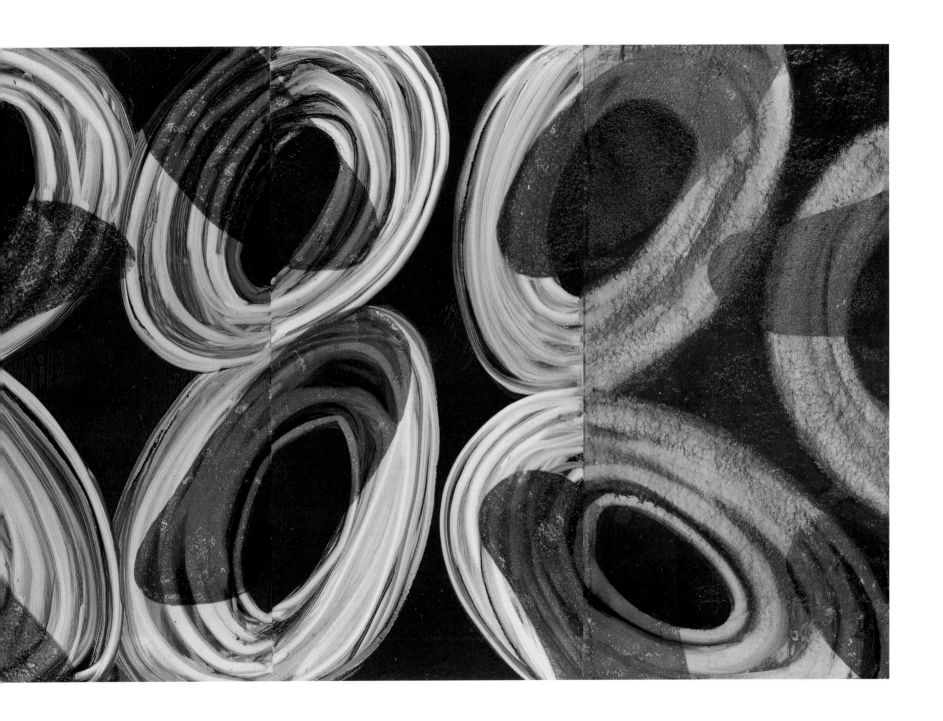

THIS SIDE OF PARADISE 2010 OIL ON PANEL 102 x 34 INCHES

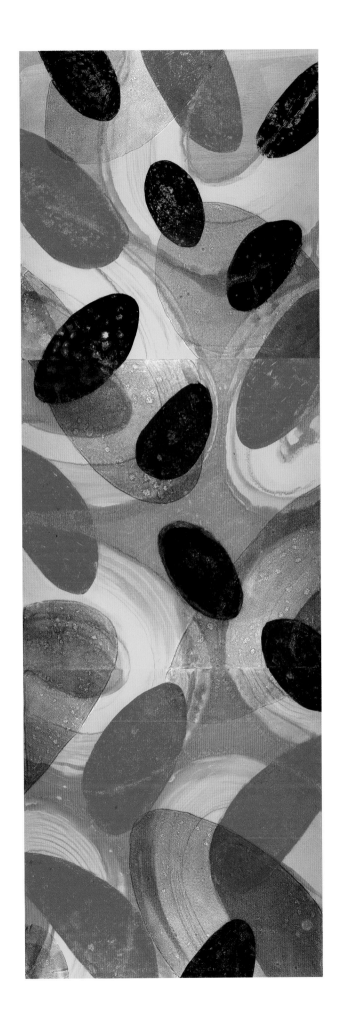

MAYBELLENE IN A COUP DE VILLE 2010 OIL ON PANEL 80 x 80 INCHES

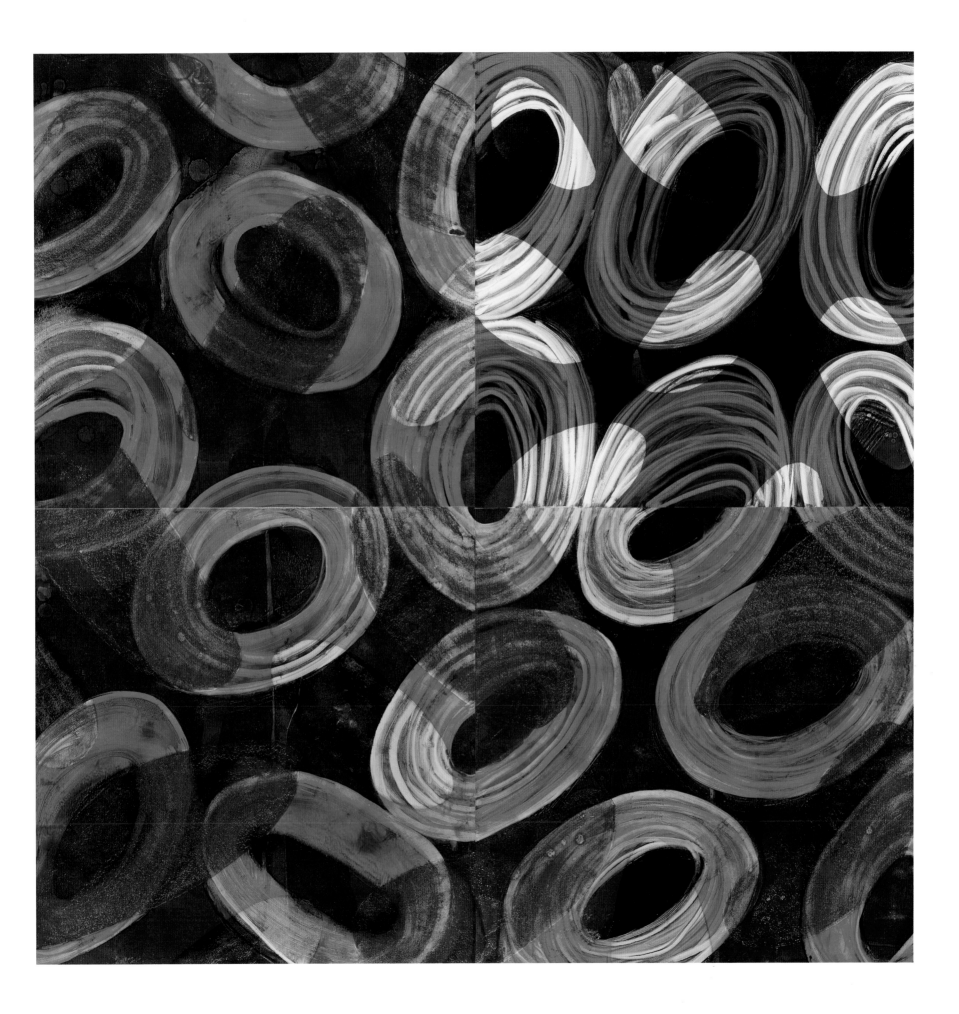

FIREBIRD SWEET 2009 OIL ON PAPER, MONOTYPE 35 x 35 INCHES

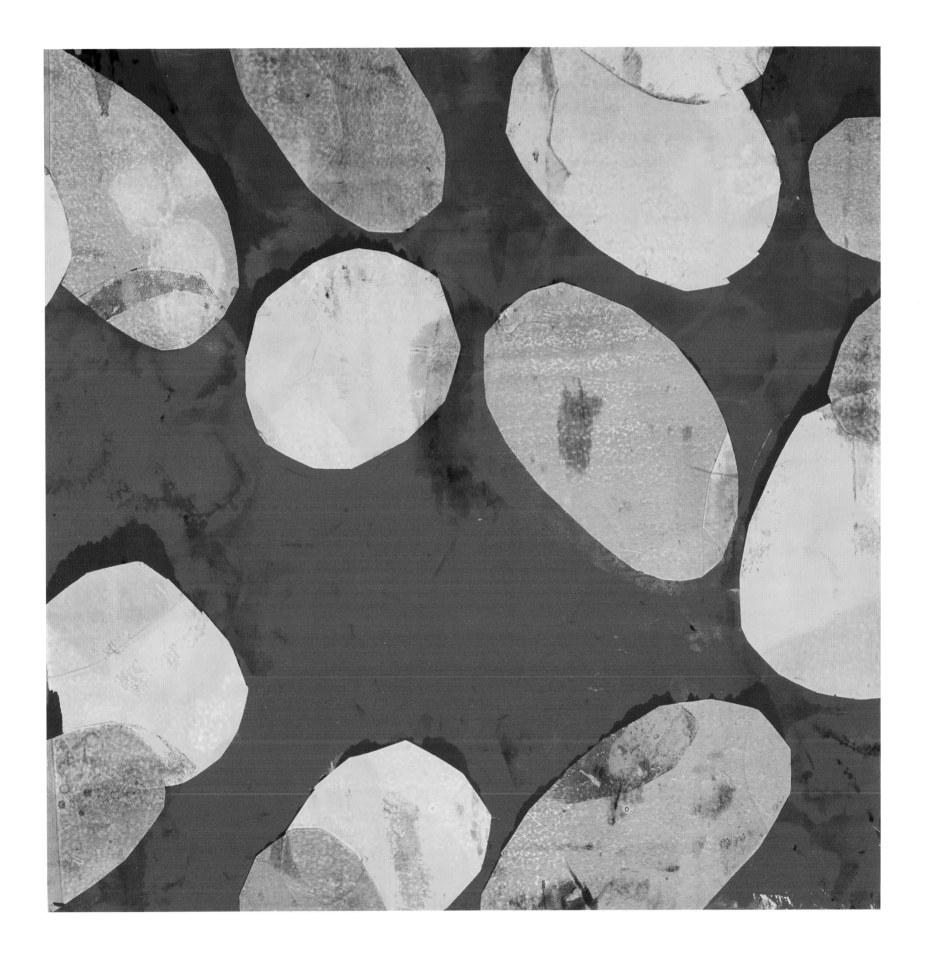

SKYLARK 2009 OIL ON PAPER, MONOTYPE 35 x 35 INCHES

COUPE DE VILLE COUP 2009 OIL ON PAPER, MONOTYPE 35 x 35 INCHES, PRIVATE COLLECTION

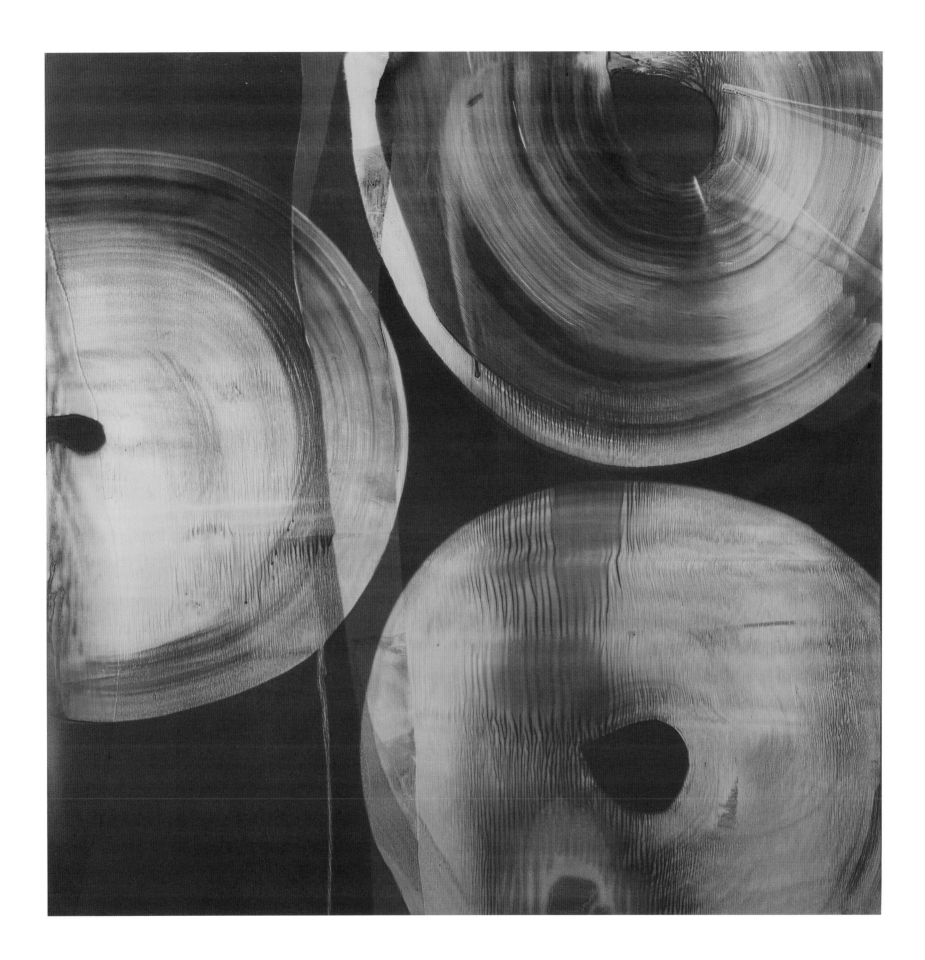

DAYTONA 2009 OIL ON PAPER, MONOTYPE 35 x 35 INCHES, PRIVATE COLLECTION

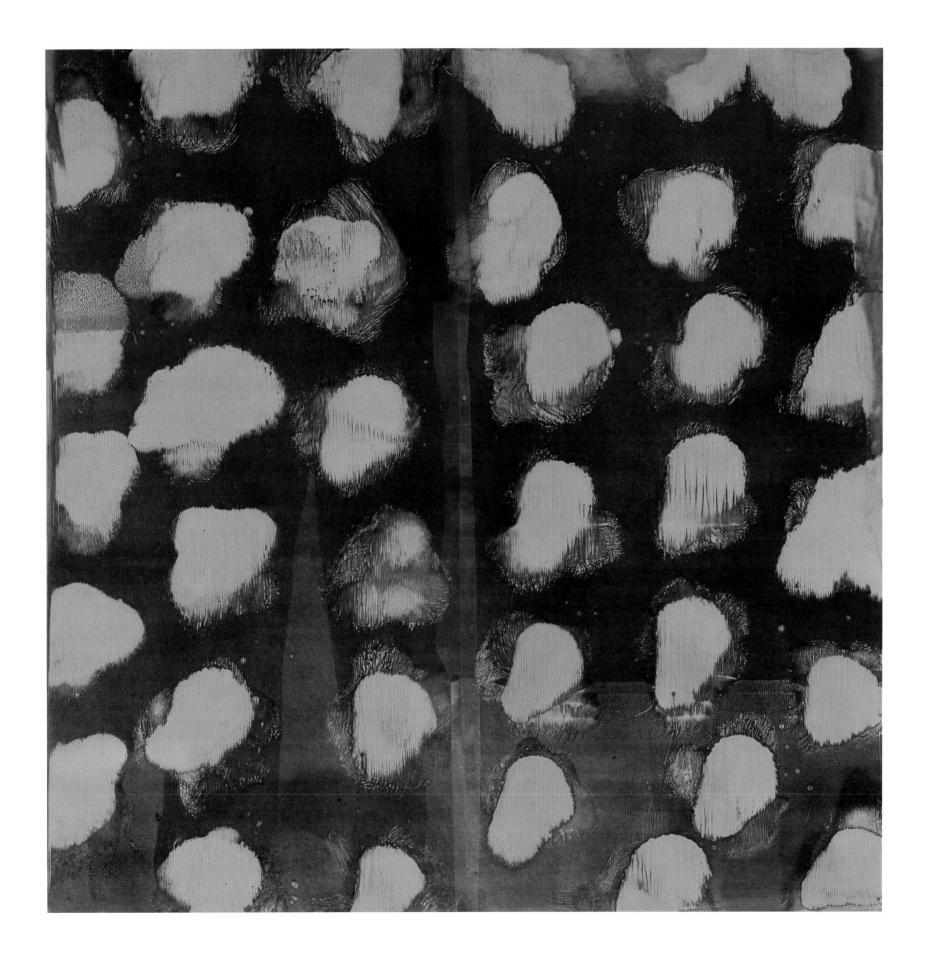

RIVIERA 2009 OIL ON PAPER, MONOTYPE 35 x 35 INCHES

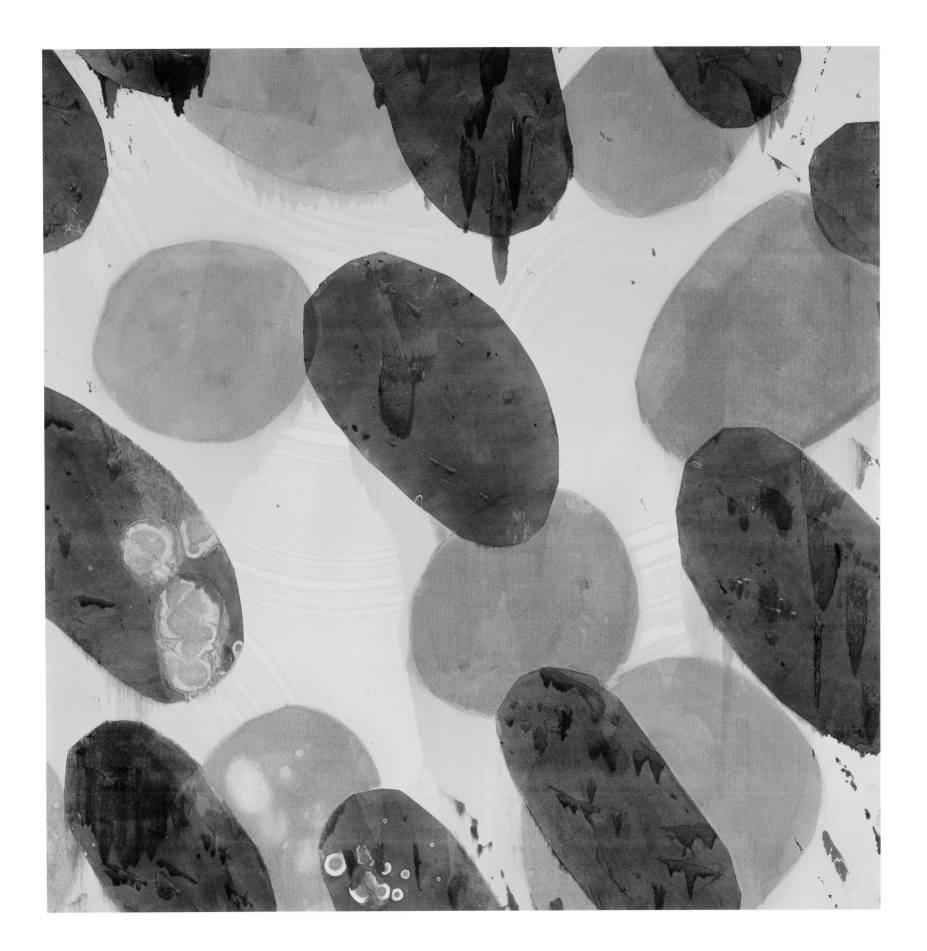

FAIRLANE FLOW 2009 OIL ON PAPER, MONOTYPE 35 x 35 INCHES, PRIVATE COLLECTION

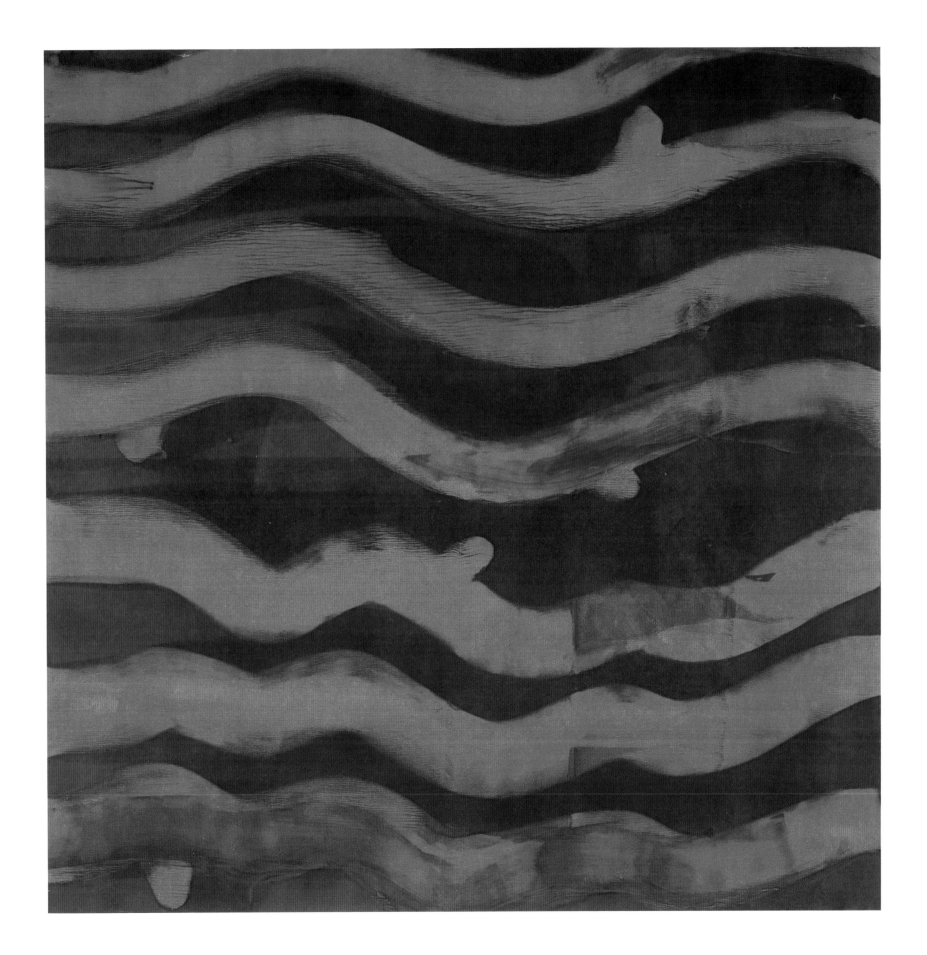

GALAXIE XL 2009 OIL ON PAPER, MONOTYPE 35 x 35 INCHES, PRIVATE COLLECTION

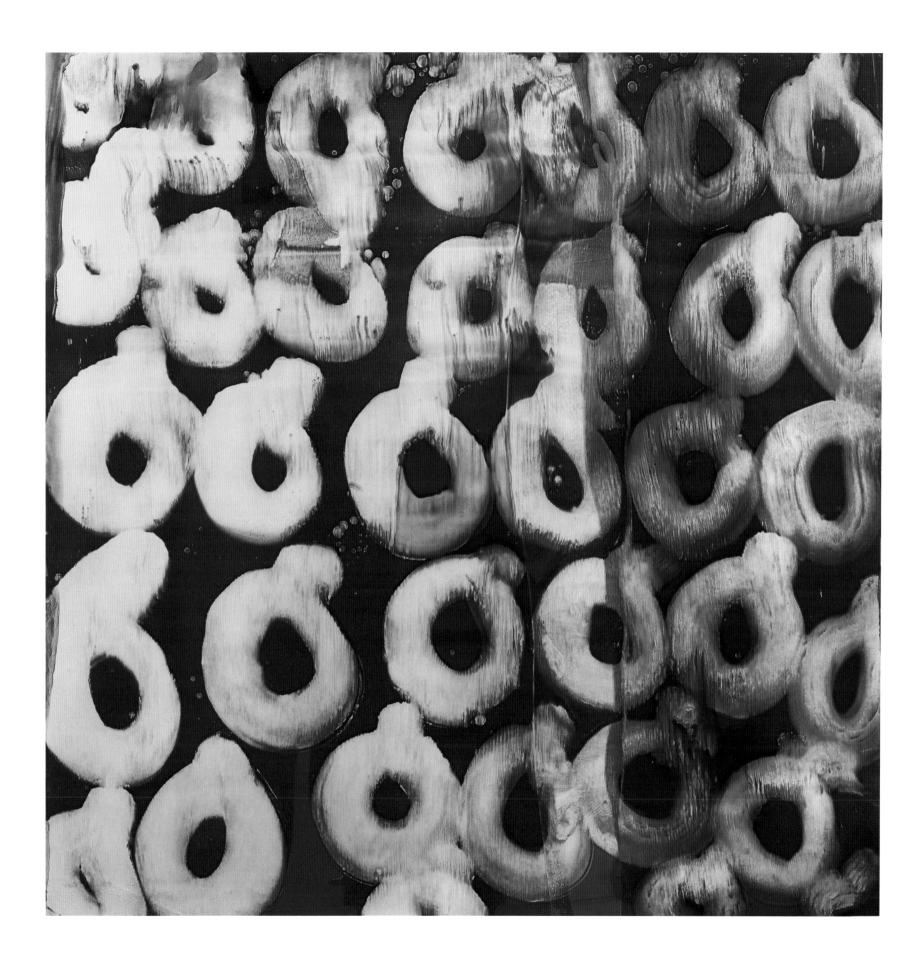

MONTEREY MERCURY 2009 OIL ON PAPER, MONOTYPE 35 x 35 INCHES

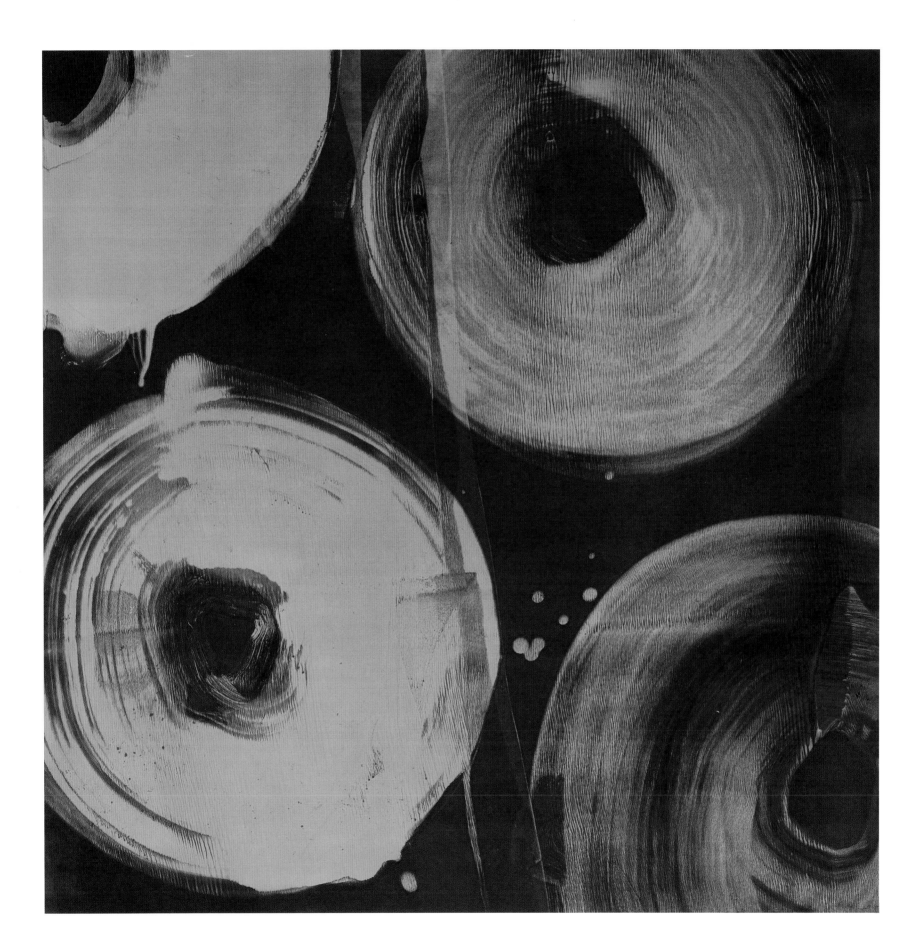

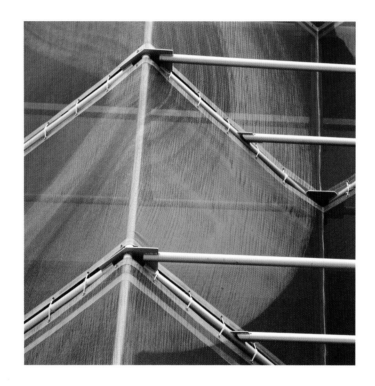

PARALLEL PARK DETAIL OF NORTH FACADE

FLEETWOOD WOULD 2009 OIL ON PAPER, MONOTYPE 35 x 35 INCHES

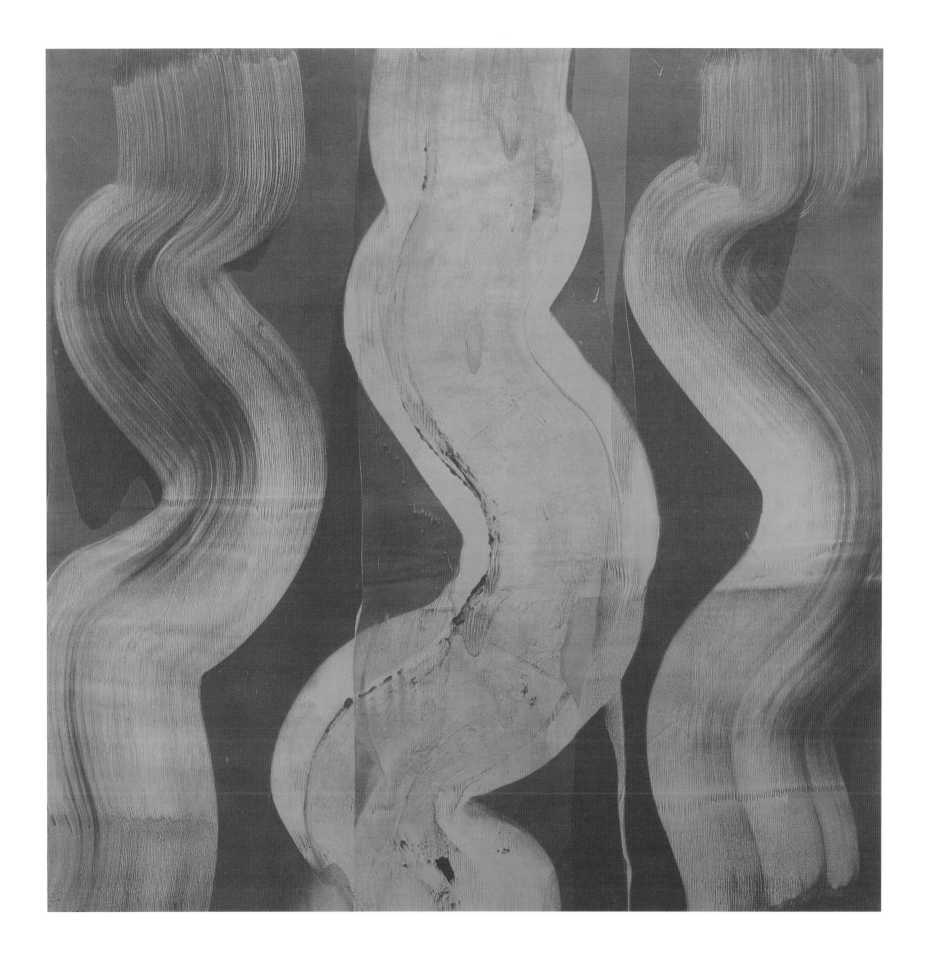

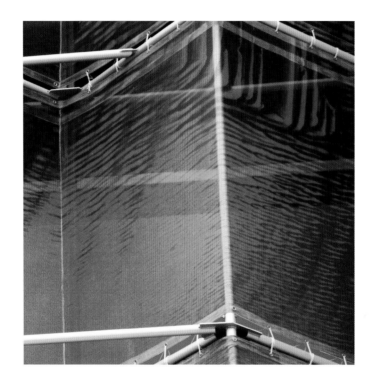

PARALLEL PARK DETAIL OF NORTH FACADE

ELDORADO LARTIGUED 2009 OIL ON PAPER, MONOTYPE 35 x 35 INCHES

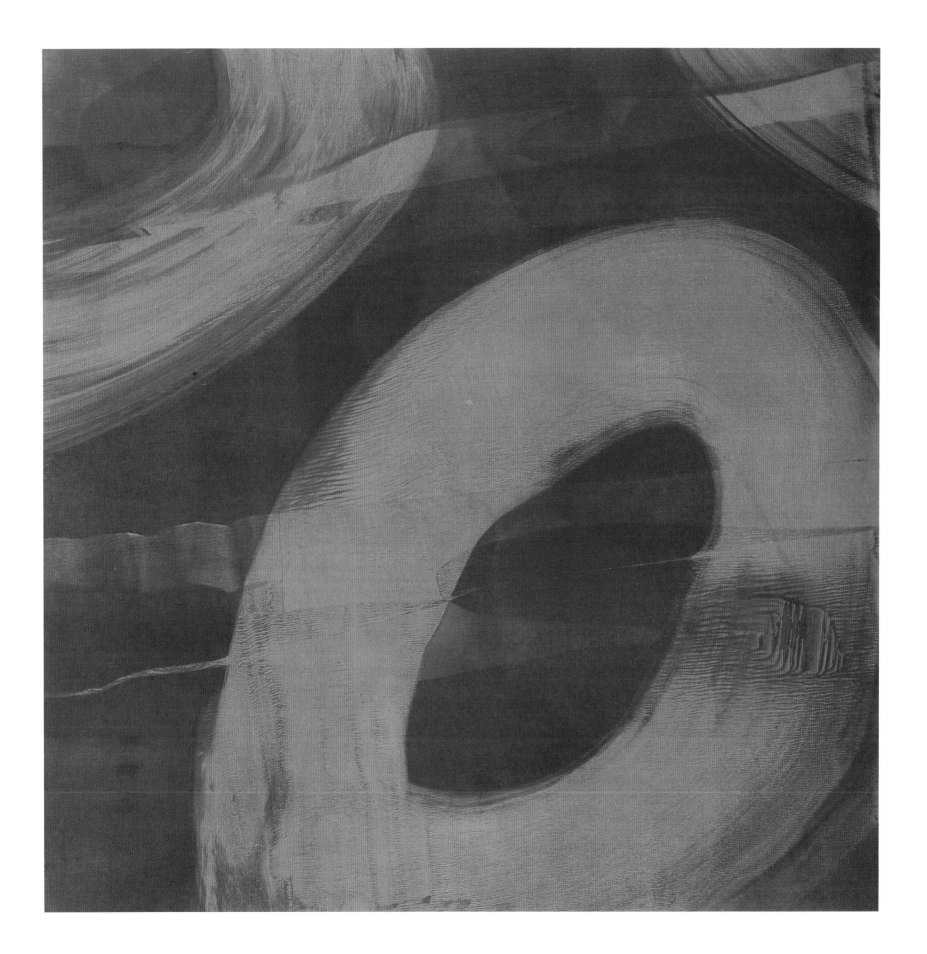

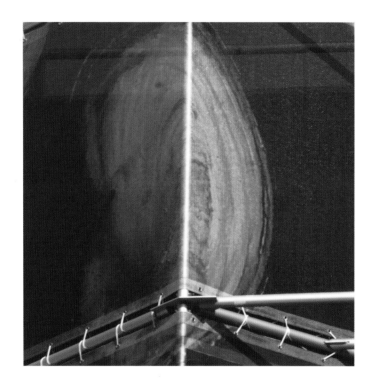

PARALLEL PARK DETAIL OF WEST FACADE

BEL AIR BREEZE 2009 OIL ON PAPER, MONOTYPE 35 x 35 INCHES

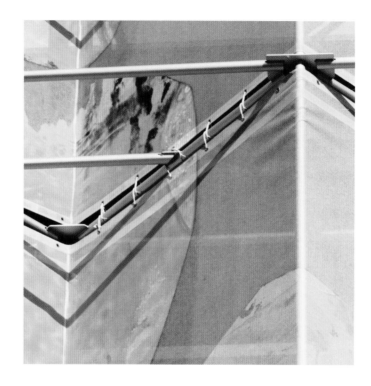

PARALLEL PARK DETAIL OF WEST FACADE

CAPRICE CAPRICE 2009 OIL ON PAPER, MONOTYPE 35 x 35 INCHES

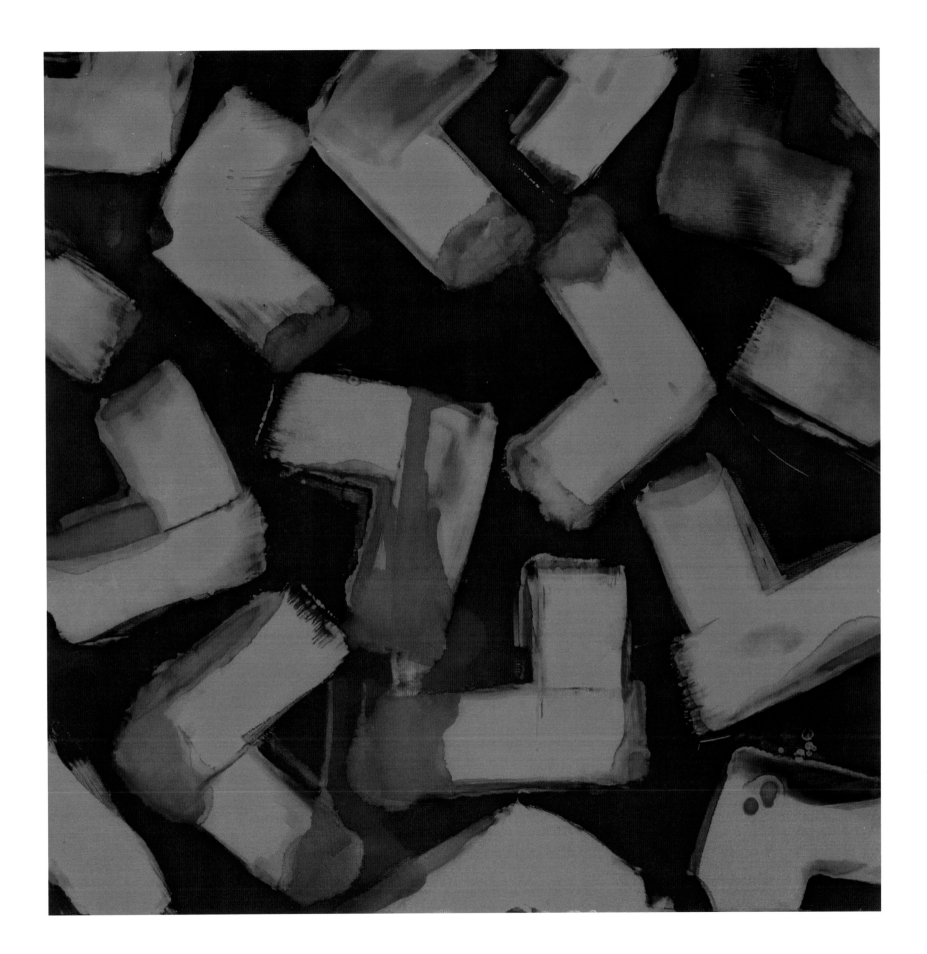

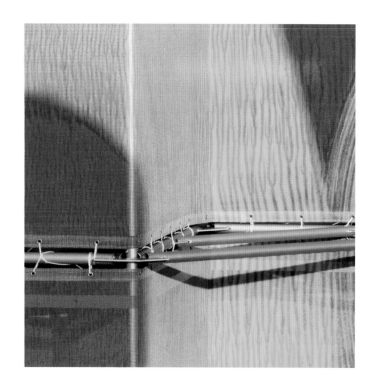

PARALLEL PARK DETAIL OF SOUTH FACADE

SOLSTICE 2009 OIL ON PAPER, MONOTYPE 35 x 35 INCHES, PRIVATE COLLECTION

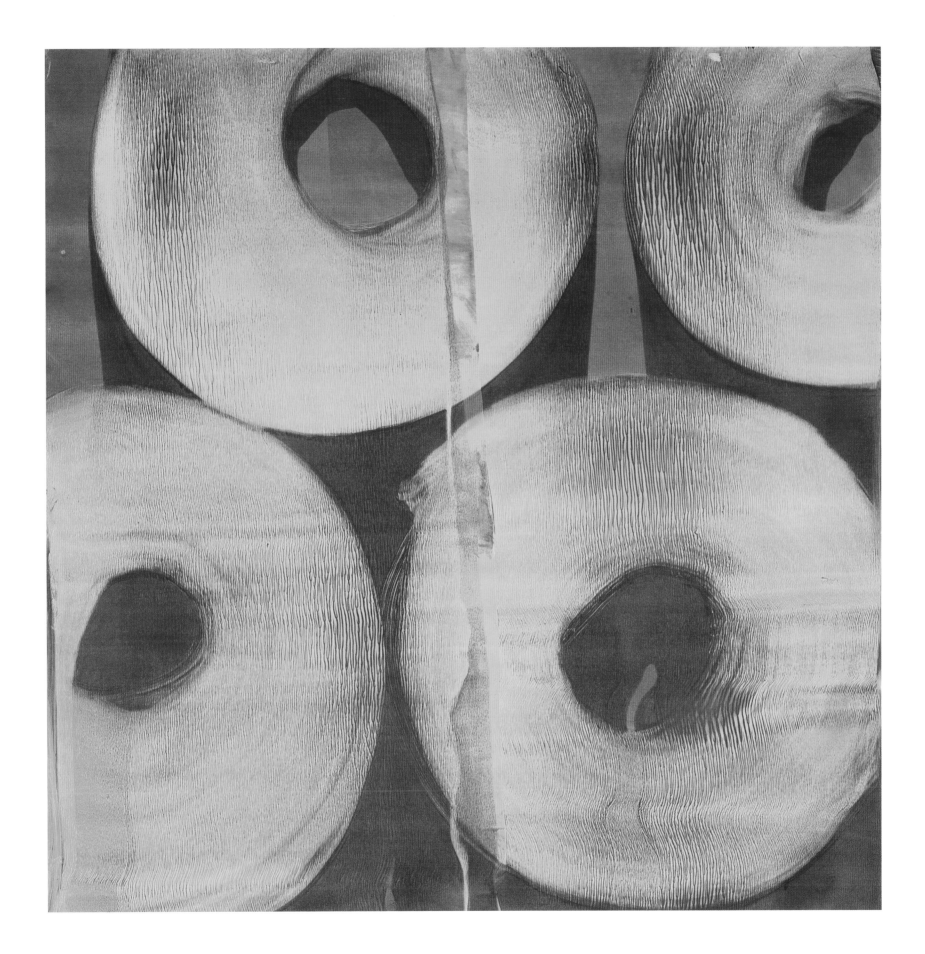

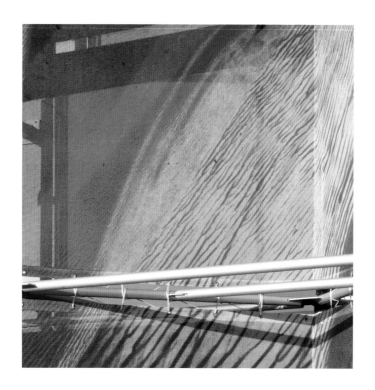

PARALLEL PARK DETAIL OF EAST FACADE

SEBRING 2009 OIL ON PAPER, MONOTYPE 35 x 35 INCHES

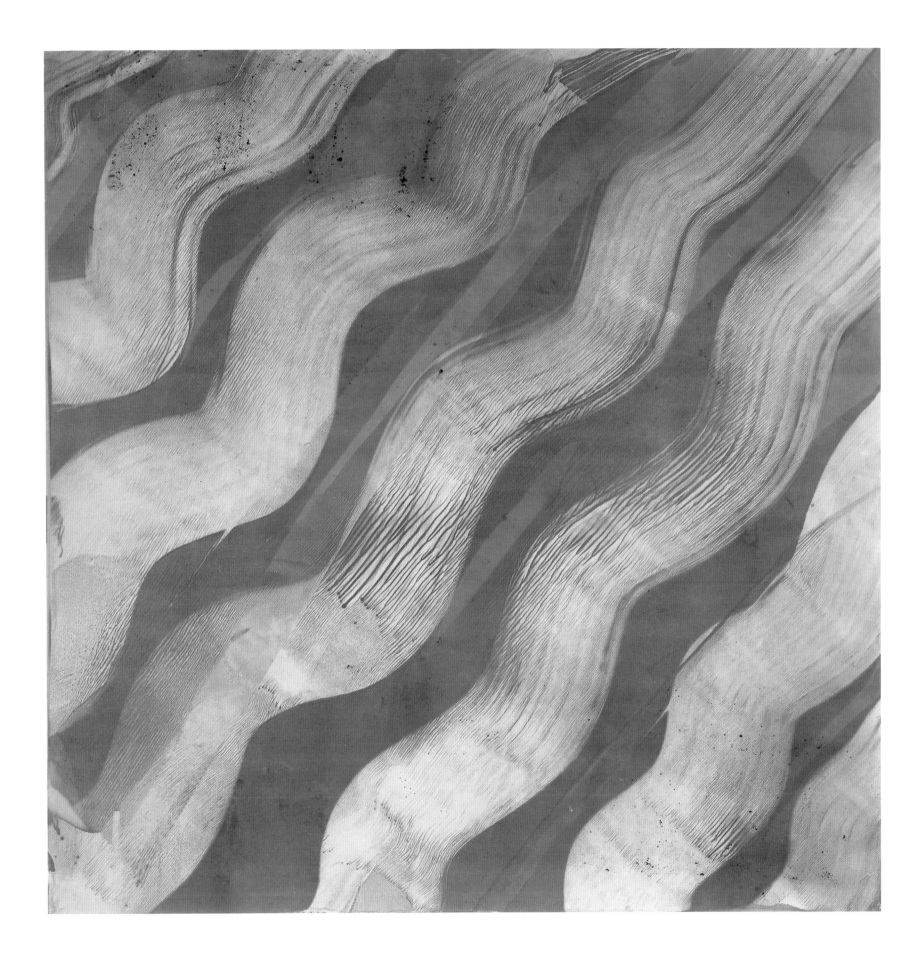

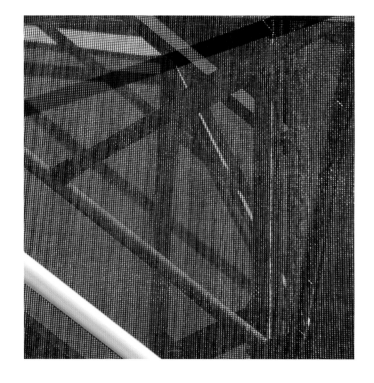

PARALLEL PARK DETAIL OF EAST FACADE

TORONADO TORQUE 2009 OIL ON PAPER, MONOTYPE 35 x 35 INCHES

(OVERLEAF) **MARYLYN DINTENFASS** EXHIBITION INSTALLATION, BOB RAUSCHENBERG GALLERY, FORT MYERS, FLORIDA, 2011

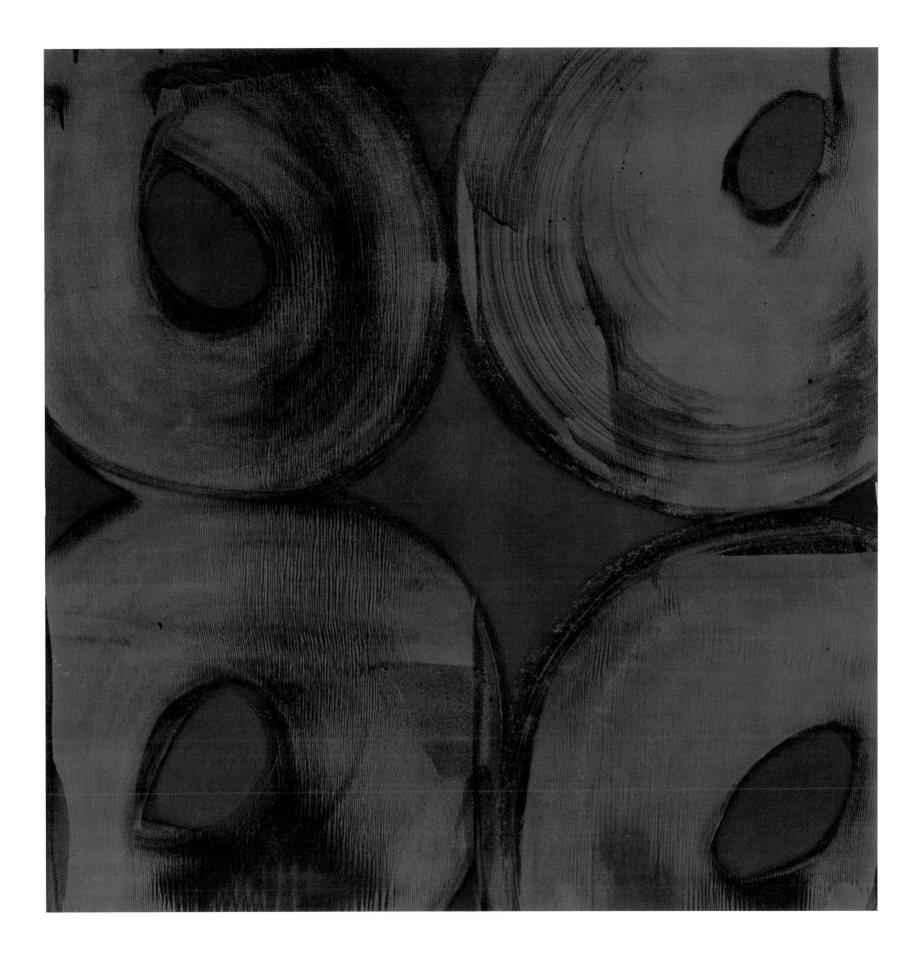

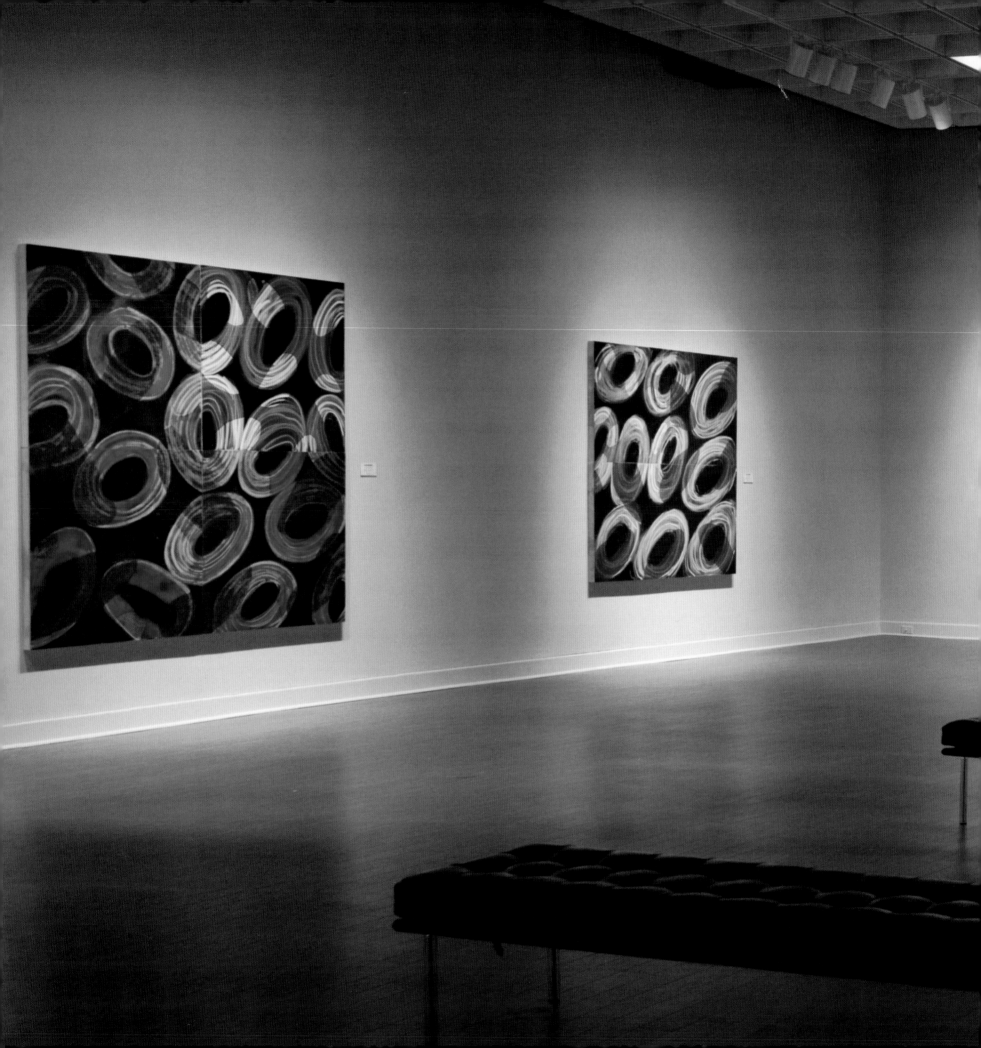

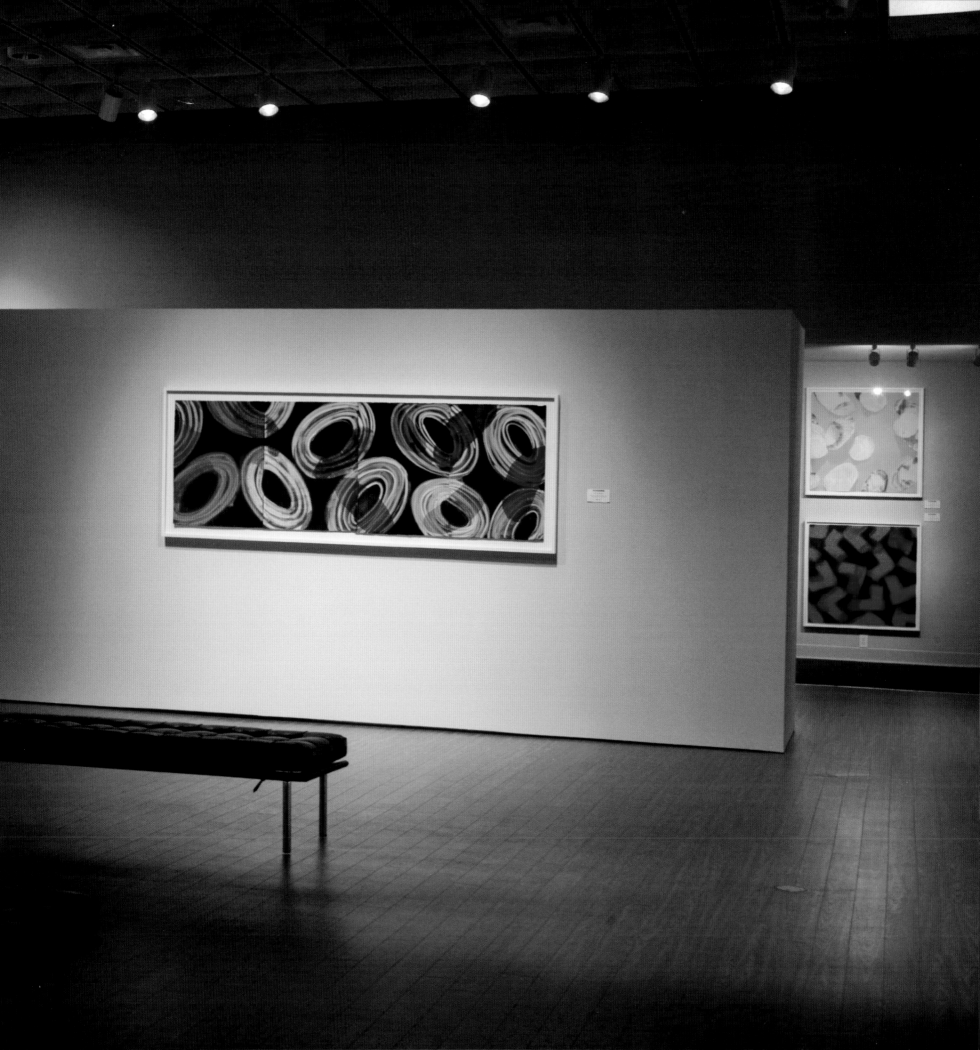

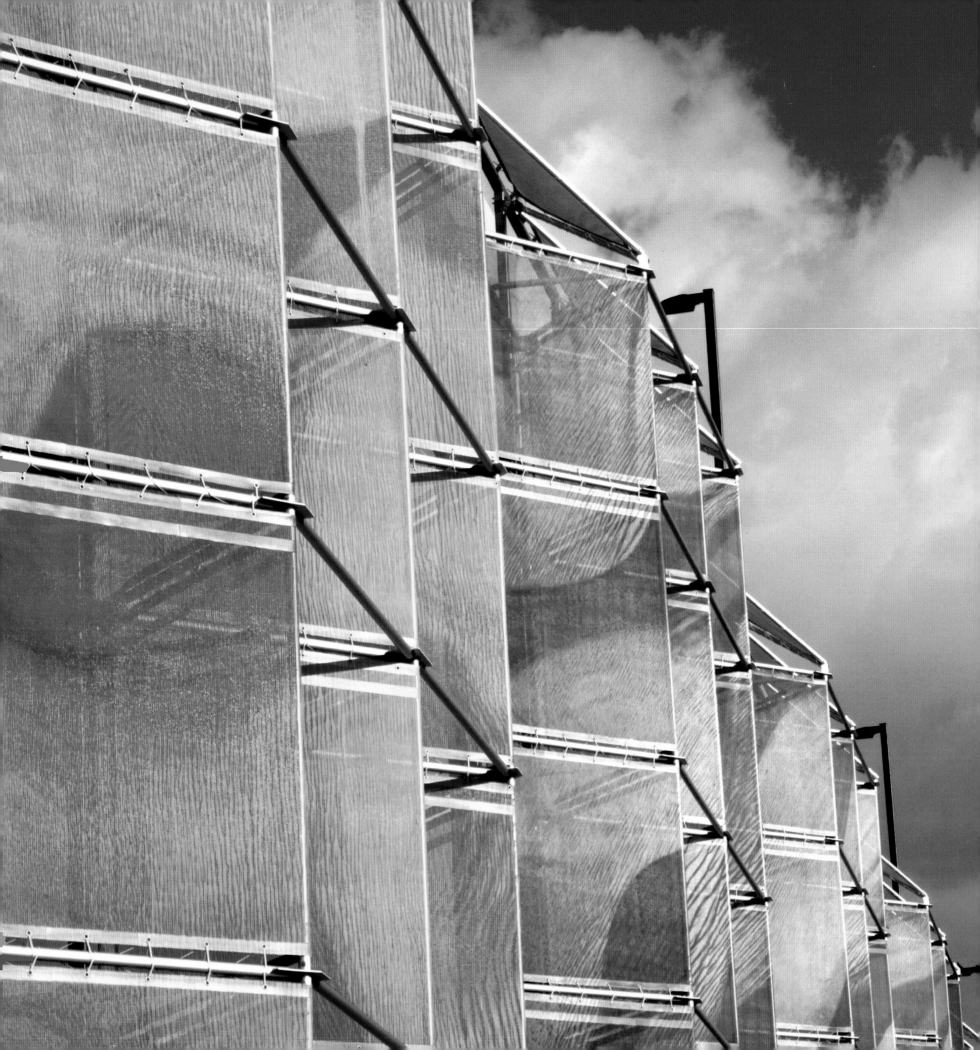

PARALLEL PARK INSTALLATION

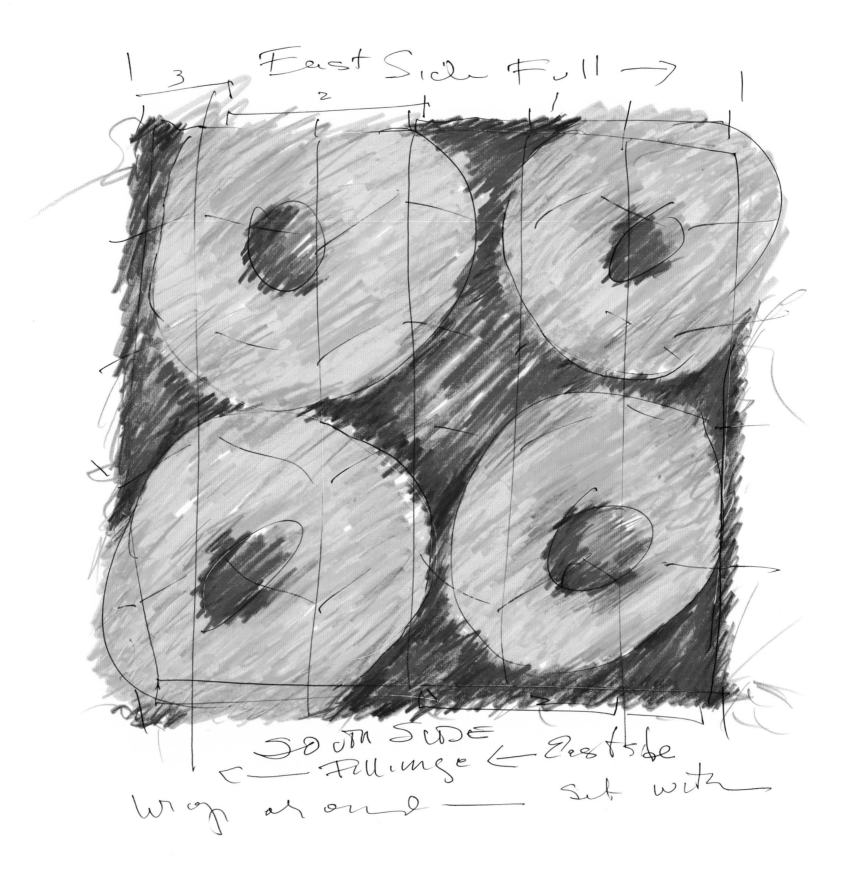

FROM PROPOSAL TO PARALLEL PARK:
THE CHALLENGES OF PUBLIC ART

BARBARA ANDERSON HILL

IN APRIL of 2009, as art consultant to the City of Fort Myers Public Art Program, I attended a meeting of the Public Art Committee. I listened as Kevin Williams of BSSW Architects presented an intriguing proposal for the new government parking garage that was then under construction, near the Lee County Justice Center. To comply with the city's public art ordinance, Lee County was required to provide artwork for this structure and Williams had a plan.

Williams proposed that the artwork would be monumental in scale: 33-foot-high panels mounted on exterior walls to completely surround the building. The architects had determined the overall scope of the project: the fabricator, printer and materials had been selected, and the framework to support the panels was already installed on the building. The next step was to commission an artist to create a 30,000-square-foot work of art that would be permanently installed on the structure.

This was an opportunity for Fort Myers to acquire a transformational, world-class, large-scale public artwork that would enliven the city's landscape and enrich the cultural experience of citizens and visitors. Fort Myers, having formed its public art program in 2004, was a newcomer to the public art arena. By comparison, older public art programs in the United States were reaching their fiftieth anniversaries, entrenched in a rich tradition of providing, in essence, "museums without walls" to enhance their communities. For Fort Myers' public art collection, a highly visible work of art by a distinguished artist could be a crowning achievement, a ground-breaking architectural landmark to put Fort Myers on the global public art map. Under Mayor Jerry Henderson, the Public Art Committee—chaired by Jeffrey Mudgett with Ava Roeder as vice chair, and including Stuart Brown, Wendy Chase, Patricia Idlette, Sharon McAllister, Gabrielle Oerter and William Taylor, with Jennifer Hobbic as staff liaison—readily embraced Williams' proposal.

The selection process was key to the success of the project. With the building's construction nearly complete, there was no time for an open call for artist's proposals. I suggested that the city, through its public art program, be responsible for the artist

Dintenfass, *Study for Parallel Park (Solstice)*, east facade, 2009. Colored pencils, litho crayon, ink and graphite on paper, 13 x 19 in.

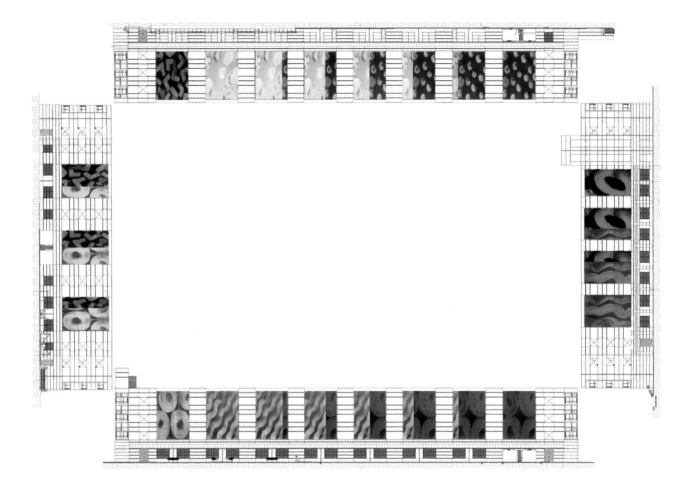

selection process and provide funds to cover the design fee for the county-owned building. The committee decided that abstract imagery would provide the greatest visual impact and that the selected artist would work with the county's project architect, printer and fabricator. This plan was approved, and the first-ever interagency collaboration to bring public art to Fort Myers commenced.

After developing the invitational call, the project management overview and the timeline, I sought out and contacted nationally recognized **artists** whose work would be appropriate for this site, while the committee and architect suggested three additional artists for consideration—giving us a final invitational short list of ten possibilities. **During this process** I first became aware of Marylyn Dintenfass' sensuous and colorful abstract work. Immediately, perhaps instinctively, I sensed that her work would translate perfectly at the massive scale required for this project.

To streamline the selection process, the committee visited the websites of the recommended artists, reviewed their work and qualifications and had opportunities to contact each artist directly. On June 9, 2009, the committee collectively reviewed and scored the artists, voting for three finalists, one of whom was Marylyn Dintenfass. On July 21, the finalists' proposals were reviewed. Dintenfass had submitted a site-specific proposal, entitled *Parallel Park*, that was exceptional. Her three-dimensional model showed how the work would appear on all four walls of the building: bold color, changing patterns and shapes unabashedly moved and shifted around the building in an accordion format that would provide visibility from all points of view. Her proposal narrative eloquently stated the ways in which her artwork not only corre-lated conceptually to the function of the building but enhanced it aesthetically. The iconography from her paintings, juxtaposed with the minimalist geometry of this massive structure, would be a tour de force, a merging of high art and public space.

The committee then voted to select Dintenfass' *Parallel Park* proposal. Dintenfass already had a distinguished record of completing more than twenty-five international commissions. She would create artwork for the building's exterior walls, expanding upon the primary concept that Williams had suggested. As Dintenfass originally defined in her proposal:

Parallel Park metaphorically expresses the spirit of the automobile. The circle shapes conjure tires, headlights, dashboard instrumentation and steering wheels; linear patterns are emblematic of roads, ramps, directional and parking designations. I have organized the four sides of the Lee County Justice Center

Plan and Perspective Views,
Dintenfass proposal for *Parallel Park*, 2009
Renderings, Aida Miron and Marylyn Dintenfass

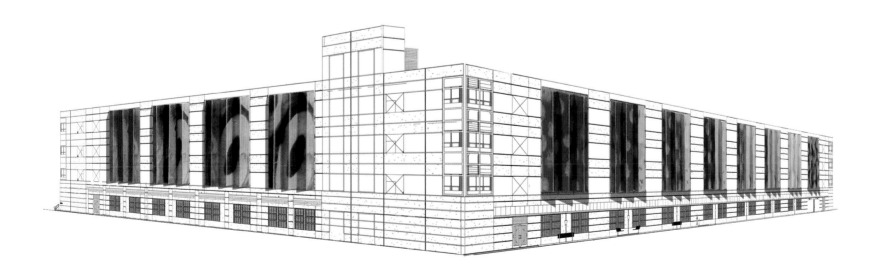

Parking Garage into a visual frieze or "book" of color, shape, pattern and scale to facilitate the viewers' imagination and visceral experience. In this instance I drew my inspiration from modern life experiences: ubiquitous automobiles, traffic patterns and the geometry of movement within the building itself. My desire is to transform the perimeter of the structure into a progression of changing images and colorful patterns—both key elements of my paintings and drawings. These images and patterns recall architectural friezes, mosaics and frescoes of the ancient, medieval and Renaissance artists, as well as works by early modern artists, such as the Synchronists and the Italian Futurists. It is my intent that *Parallel Park* will project a powerful signature identity.

This joint effort between the county and the city, the architect and the artist, to produce an extraordinary public artwork was now underway. With the artist based in New York, the printer in North Carolina and the fabricator in Orlando, everyone worked together to ensure that Dintenfass' aesthetic program was achieved.

The process was daunting. Every aspect of this project brought technical, logistical and financial challenges. Nevertheless, the collaborative spirit prevailed. At this

point Dintenfass' focus and attention to detail became apparent. She and I communicated almost daily, and as we worked together we built a wonderful friendship. She worked diligently, with a generosity of spirit undaunted by setbacks large and small. The project's complex, collaborative climate was not only energizing to all involved but essential to make this project soar.

A particular challenge was presented by the medium for the project. The Kevlar/fiberglass fabric panels had perforations of the open weave that allowed fifty percent of the surface area to remain open space. This made it imperative that the remaining surface had adequate ink saturation to produce the color intensity of Dintenfass' original work. Through a process of trial and error, Dintenfass and printer Jerry Banks, in Hickory, North Carolina, achieved the correct color saturation, at a much higher ink density than was originally thought needed. Then, to enhance archival properties and ensure durability over a long period of time, a protective coating to screen ultraviolet light was applied to the panels. After the printing was completed, another challenge arose: during installation, several panels were damaged and had to be reprinted and reinstalled. There were many additional challenges as well, but movement was always in the right direction, and once the installation was complete,

Dintenfass, *Study for Parallel Park (Bel Air Breeze, Caprice Caprice, and Electra Lux)*, west facade, 2009. Colored pencils, litho crayon, ink and graphite on paper, 13 x 38 in.

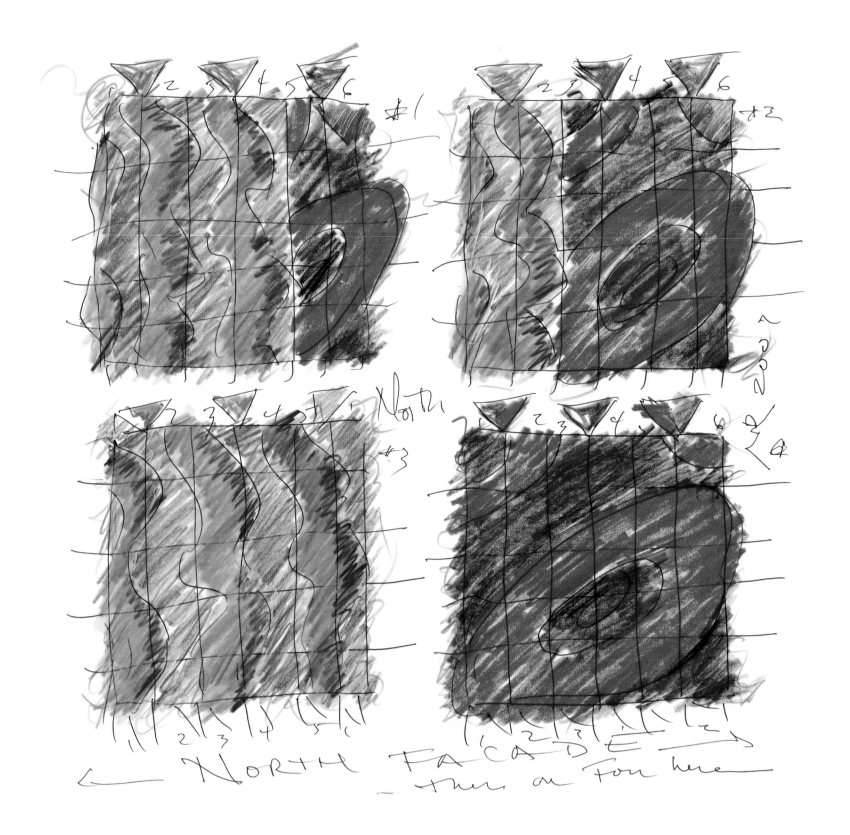

Parallel Park was perfect. It has already become a source of great civic pride and collective community identity that will continue for many years to come.

The Lee County Justice Center Parking Garage and the *Parallel Park* public artwork installation were completed in August 2010—a full year later than the originally scheduled completion date. The county and city celebrated the official dedication of the structure and the artwork with a ribbon-cutting ceremony on December 9, 2010. Those of us who were involved from the project's inception felt a palpable sense of relief combined with enormous pride. Through our efforts and our great good fortune in securing the services of an internationally recognized fine artist, a technically advanced, twenty-first-century public art project had been successfully completed.

The public's reaction to *Parallel Park* over the past few months is a testament to how the installation has affected perceptions and notions about Fort Myers itself. While some visitors assume the garage now holds a new art museum, others anticipate its invigoration of the local art scene, and still others see it as an essential indicator defining the cultural fabric of Fort Myers. *Parallel Park* has transformed the urban landscape of Fort Myers; and at a time when public art programs and budgets are being cut or eliminated, our achievement stands as an iconic example of how a successful public art project can be funded by public and private sources, and realized through an innovative collaborative process. This artwork was destined to be, and has already become, a significant landmark for southwest Florida.

Helen Lessick, co-juror of the projects included in the Americans for the Arts 2010 Public Art Year in Review, stated, "The best in contemporary public art uses public space and public language, municipal architecture, and vernacular sites for contemporary creative practice." I believe Marylyn Dintenfass' *Parallel Park* has not only met, but exceeded these criteria. She has expanded the very definition of painting in the context of public art.

BARBARA ANDERSON HILL was Art Consultant to the City of Fort Myers Public Art Program, 2006–2010. She has held key leadership positions at the Florida Gulf Coast Art Center, Belleair; John and Mabel Ringling Museum of Art, Sarasota; Edison-Ford Winter Estates Foundation, Fort Myers, and von Liebig Art Center, Naples, where she was founding executive director and curator. She currently serves on the board of the Florida Association of Public Art Professionals.

Dintenfass, *Study for Parallel Park (Fleetwood Would and Eldorado Lartigued)*, north facade, 2009 Colored pencils, litho crayon, ink and graphite on paper, 13 x 19 in.

PRODUCTION

MARYLYN DINTENFASS ARTIST

KEVIN WILLIAMS ARCHITECT

JERRY BANKS PRINTER

TOBEY SCHNEIDER BUILDER

MIKE MEECE PROJECT MANAGER

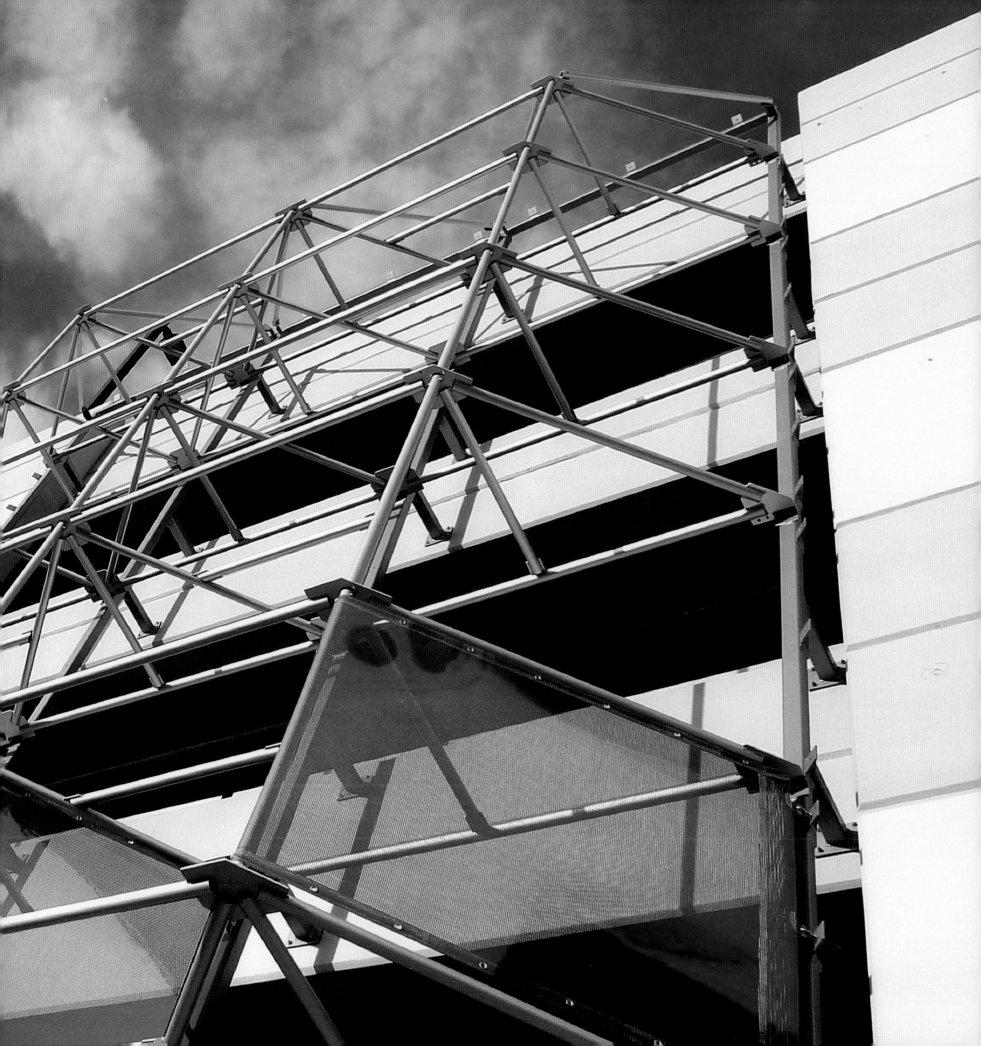

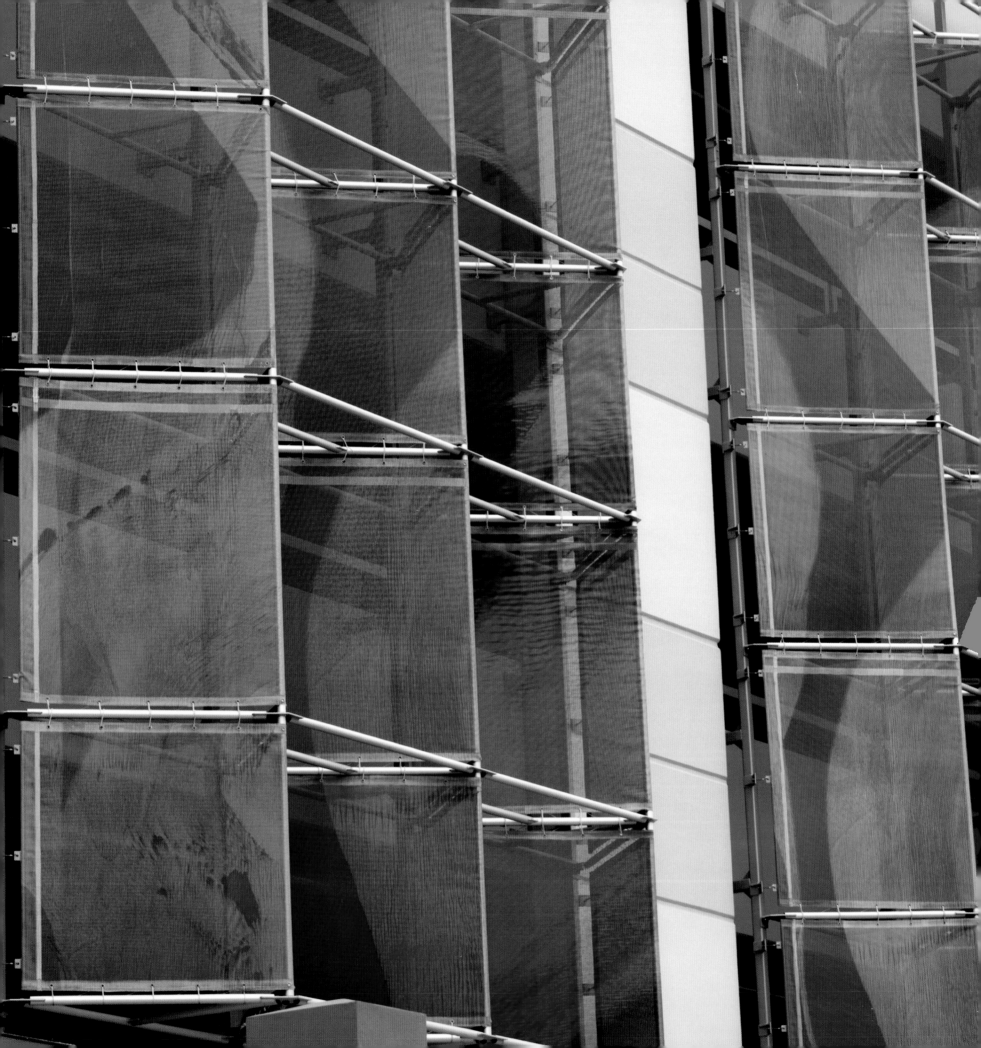

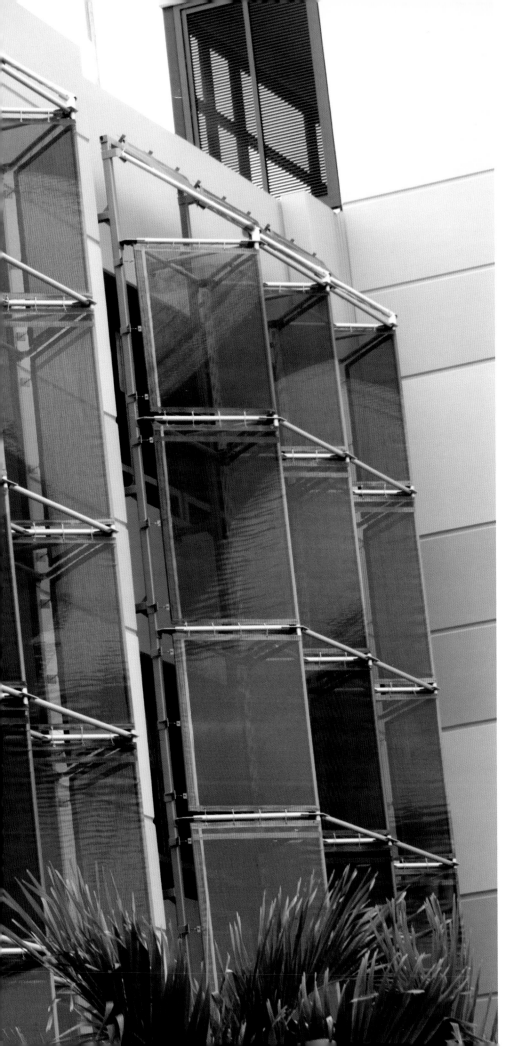

CONCEPT AND VISION Conceptually, the most crucial factor of this installation was how best to encompass all four facades of the parking garage. This provided an opportunity to express my narrative incrementally in time and space—like a short story—as viewers experience the art. Most importantly, there is no explicit beginning or ending to the cycle of imagery. The *story* unfolds like the chapters in a book, with eight delineated characters—or specific images in this case—provoking each other and progressing in twenty-three increments around the structure. As viewers randomly encounter the installation, they can also enter the visual story line at any point.

I wanted to create rhythm and a feeling of movement encircling the building. My desire was to create layered elements that simultaneously flow, overlap and intersect. This configuration reveals the imagery and yet also generates ambiguity, uncertainty and tension about which individual layers advance forward or retract from the viewers' sight as they move about.

While my artwork imparts a strong visual impact viewed from afar, it intentionally provides a rich visual payoff encountered nearby. For approaching pedestrians, either walking around or inside, the visual experience transforms with every shift in vantage point. This optical encounter becomes visceral and maybe intellectual, depending on the viewer.

—Dintenfass

NORTH FACADE

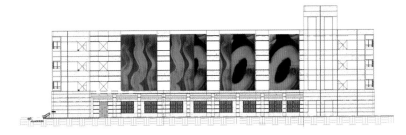

All facade renderings, Aida Miron and Marylyn Dintenfass, 2009

ARCHITECTURAL FRAMEWORK KEVIN WILLIAMS

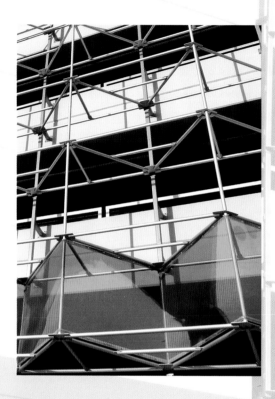

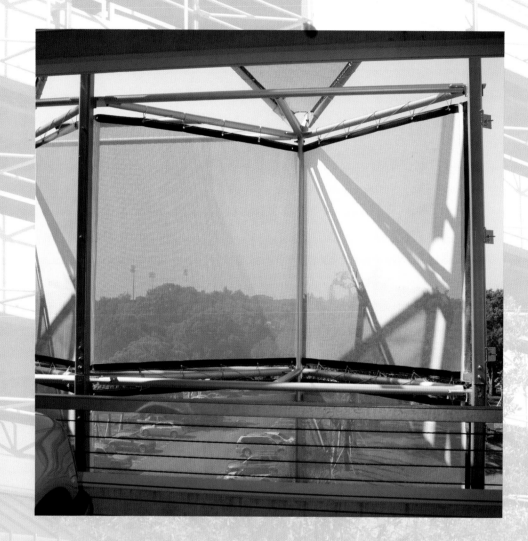

[We] went to the city of Fort Myers' Public Art Committee [PAC] for their ideas. The PAC said they would research throughout the country and select a group of artists to invite to participate in a juried review, where three finalists would be selected to submit site-specific proposals for the project.

Marylyn's approach embraced the design of the structure. She created artwork that is readable from far away, as you drive by, and also when walking close to the building. The changing perspective of the artwork creates multiple views from different angles, and her resolution was in keeping with what we wanted to accomplish from a design standpoint.

"The most elegant solutions, in my mind, are ones that solve problems, too."

Fort Myers has an ordinance that states a parking garage must screen vehicles from normal public sight, but it must be 50 percent open-air to prevent the build-up of carbon monoxide. Our biggest challenge was getting everybody on board. Convincing somebody that you're going to have 300 feet by 40 feet of artwork on the side of a building is a tough sell.... [But] as a large-scale Planned Urban Development project, incorporating public art is one of the provisions for zoning approval.

We looked for ways to take a different approach on how we could address the visual aspect of the parking garage, and screen [it] from the street.

I ran across the Kevlar fabric some years ago...in historic-preservation projects where they would scaffold over an old facade to restore it, and they would print the picture of the historic building on this material. That's what gave us the idea...we worked through the process of how we could structure it and reshape it for our project.

I've seen some large-scale uses of this fabric, which lean more toward advertisement...[but] none that have [such an] integrated design...and none as a commissioned public art piece.

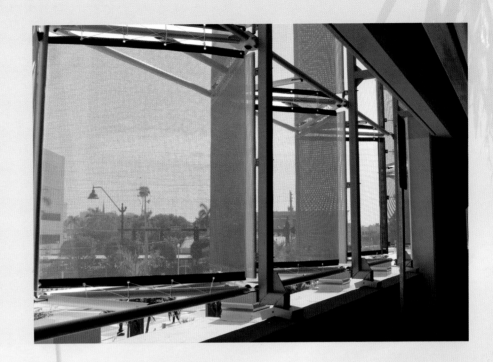

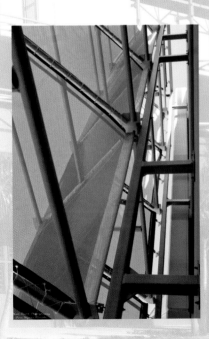
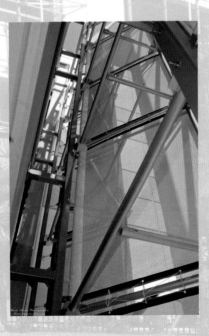
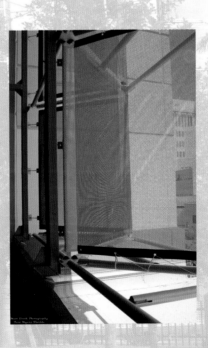
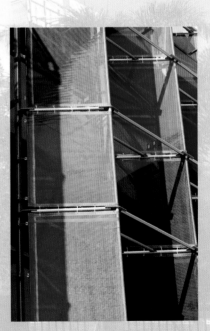

IMAGE AND COLOR Image selection is based on a configuration of gesture, shape and form, akin to the pieces of a puzzle. But it is color that always takes center stage. The hue and value of each image reverberate with the placement of the other colors to enhance their natural luminosity and to articulate the story line. This amplifies the viewer's experience of movement around the building. Of course, in doing so, one must take advantage of the hourly and seasonal transitions of the sun. Light is thus an integral act of movement across the imagery's surface.

Color is critical to all my work. The printer, Jerry Banks, was committed to capturing my vision through exact color representation. Collaboratively, we did several rounds of color matching and correcting directly on the press; we were thus able to compensate for the loss of 50 percent of the Kevlar material—due to the open weave—by increasing the amount of ink applied. This balanced the color's intensity and ensured faithful color hues while enhancing the installation's archival longevity.

It was challenging on many fronts to maintain the integrity of the original artwork as it was technically enlarged and manipulated through the digital printing process. In all, this intensified my great appreciation of the nuanced relationship between technology and art, and my respect for Jerry Banks' skills.

—Dintenfass

WEST FACADE

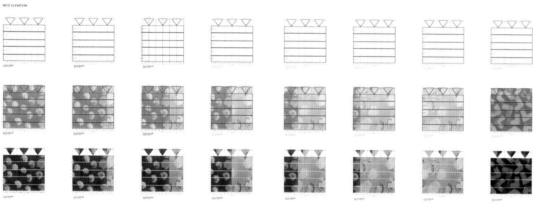

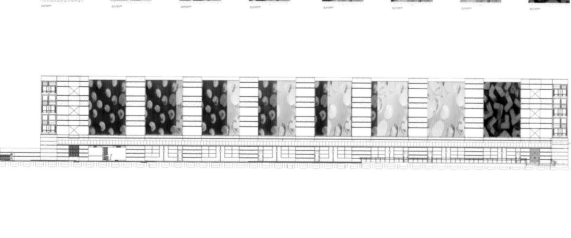

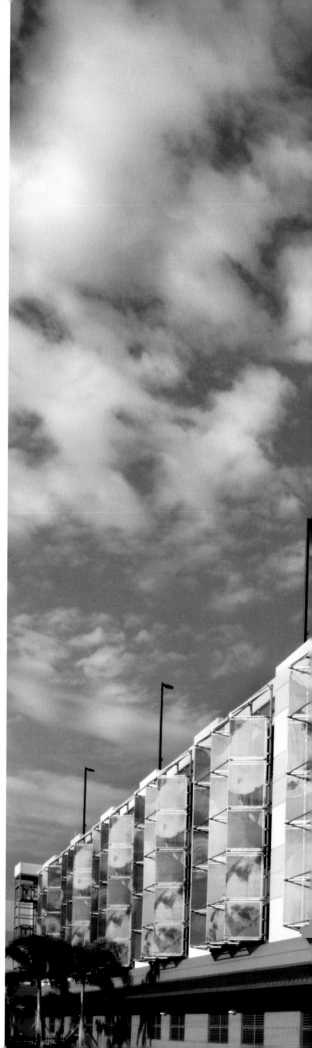

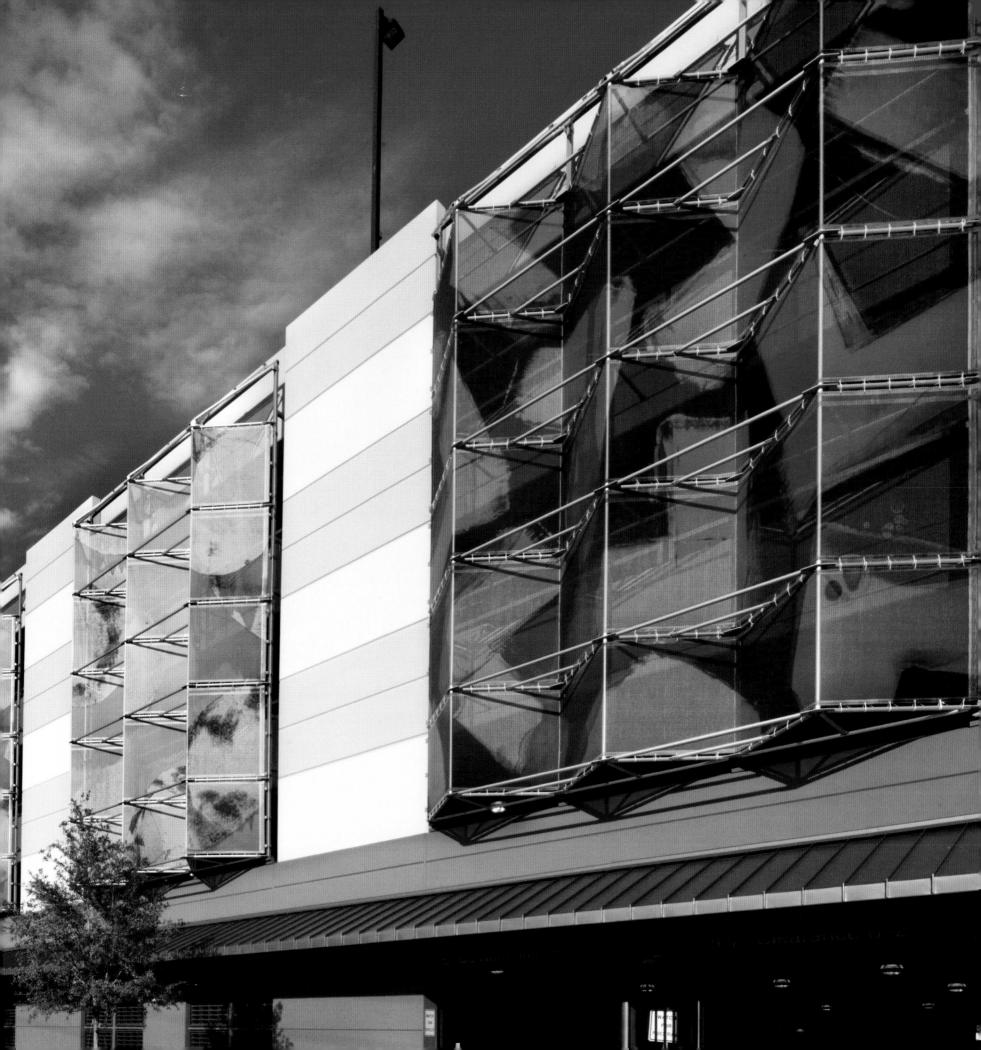

PRINTING PROCESS JERRY BANKS

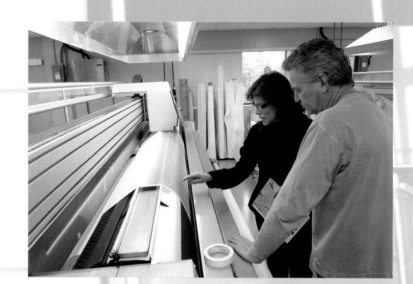

Most of what we do is vehicle wrapping for Nascar, furniture trailers, and tractor trailers. I have never worked on anything like this before. But other clients of mine, like Coca-Cola and Pepsi, are also very particular about their colors.

So first we looked at the images on the screen, to have Marylyn approve them. Then we cropped sections of the images from all the different prints, which we had Marylyn approve again. If one didn't work, we'd start to increase the 200-percent density to 300 percent. So we were laying down more ink.

With the Kevlar, the holes are so big—one-quarter inch—that in the printing, you are losing 50 percent of the color. We had to make special trays to catch all the ink that went through. The holes have a special purpose; the material is rated for 80-mph winds. We printed strips of Kevlar 50 inches wide as tests and had to hang them up on a wall at a distance to see what they would really look like.

"Very cool concept, very cool project. It makes you proud."

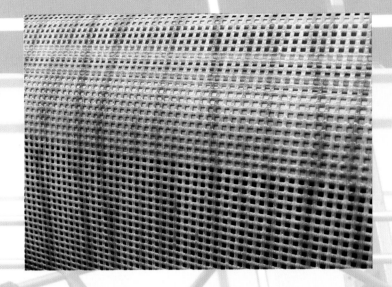

We were printing day and night for weeks to get the job done on time, one 160-foot roll at a time. We had to be there in case a printer had a hiccup. The closer you get the printer head to the material, the better the print. But sometimes the material isn't rolled on its spool tightly enough, and a ripple in the material can cause a "head strike" where the ink gets wiped off. Either my printer guy or myself would bring an air mattress into the shop. Every twenty to thirty minutes you'd get up to check it.

It makes you proud. You see it coming off the printer, and then to see the finished project is very satisfying! I hope she does another one. What makes me happy is listening to those machines run. To make Marylyn happy is very gratifying. She is very particular, like most artists! And when projects go well like that, it's great. Looking at original photos of the space, you think it's just a parking garage. And now look at it!

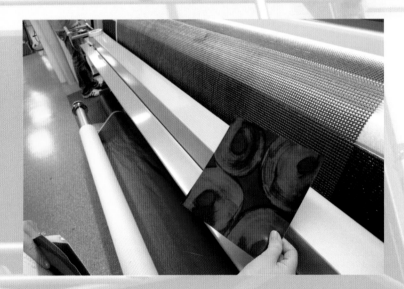

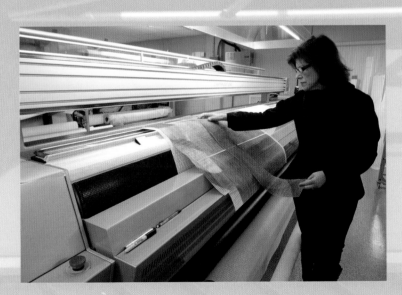

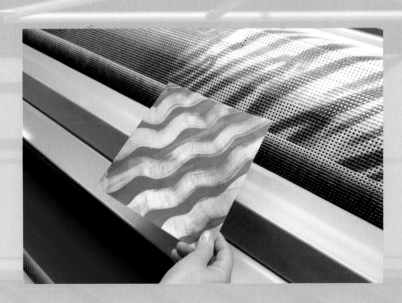

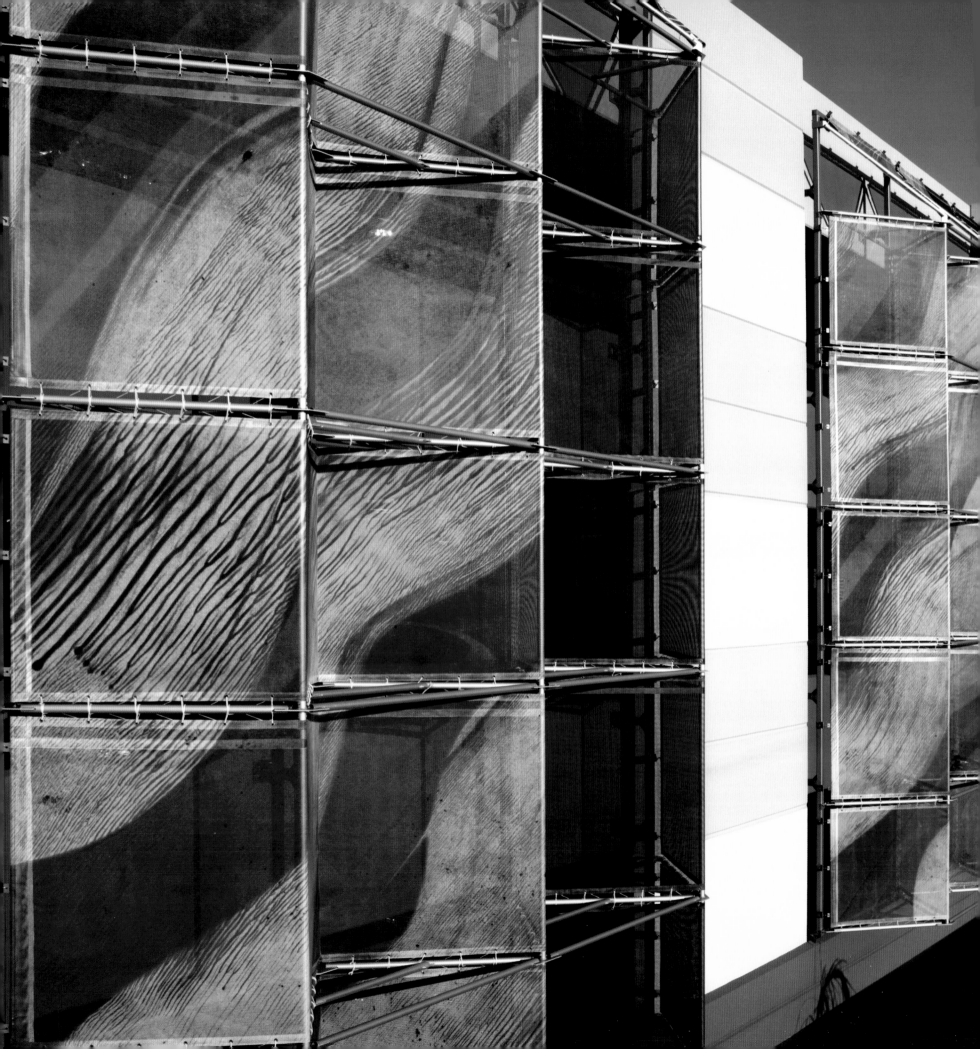

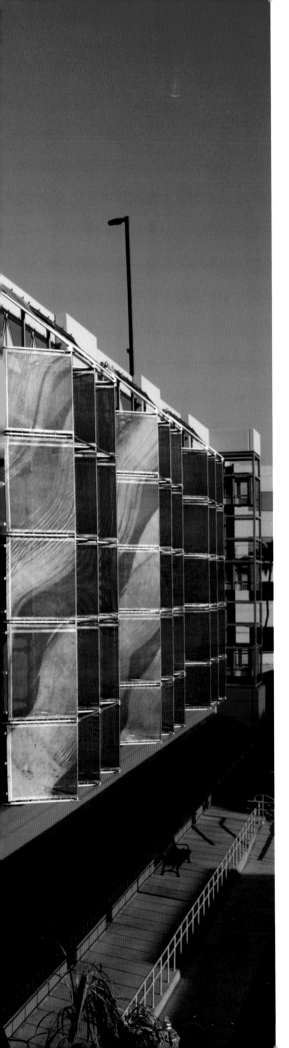

STRUCTURE AND SCALE Throughout history, it has been standard practice in art and architecture to use small units to construct large-scale works. It is the same in my work, going back to the beginning of my career. Sometimes my use of individual segments or grids to create a larger framework is done for practical or technical reasons, but always with an overarching plan that is purely aesthetic.

I find the technical, stylistic and aesthetic continuity of my work, over many years, amazingly reflected and summarized in *Parallel Park*. Years ago, I created work that focused on a structural aesthetic and an architectural integration as a creative resource. I continue to use the functional design of structure as a reference and as a basis from which to create my own narrative imagery. I continue to think of my paintings as objects as well as paintings, and I always look to have the utilitarian design of structure become an intrinsic part of the aesthetic statement—the art.

—Dintenfass

EAST FACADE

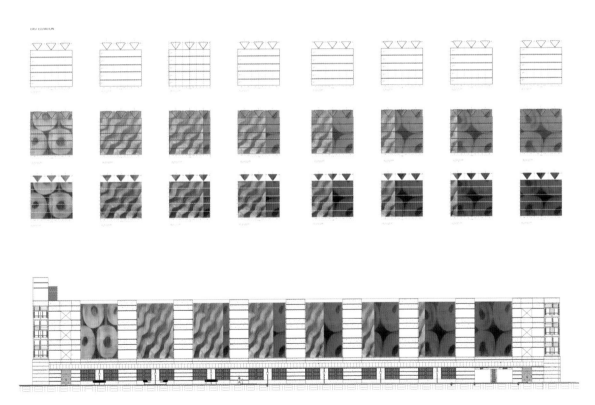

CONSTRUCTION STRATEGIES

TOBEY SCHNEIDER

The material acts almost like a flyswatter. It's got enough hold, it can breathe, and when we have big winds and hurricanes come in, it's not going to rip or tear.

The construction of the garage was a complicated affair. At the very least, 10,000 linear feet of aluminum tubing went into this project; the building is 250 feet by 140 feet; and the total square footage of the building is 220,000 feet. The building is five stories high (60 feet). And 30,000 square feet of fabric were used for the panels.

The challenge on this project was getting the artwork at the desired tint that it needed to get the different levels of color to show through on the fabric. When you have an original that is 36 by 36 inches, and you bring that up to 33 by 33 feet, it's a challenge to get that artwork depicted in the same way as the 36 by 36 inch piece of art.

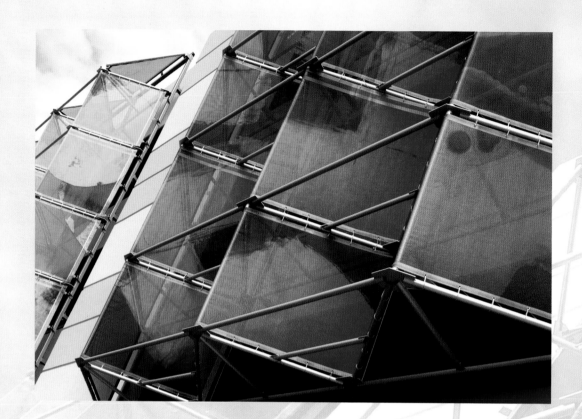

"The quality of the material can withstand hurricane-force winds."

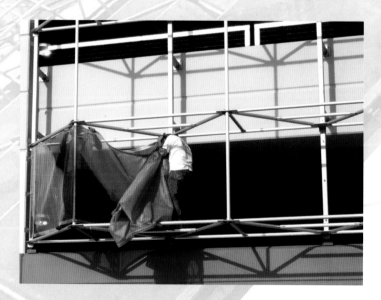

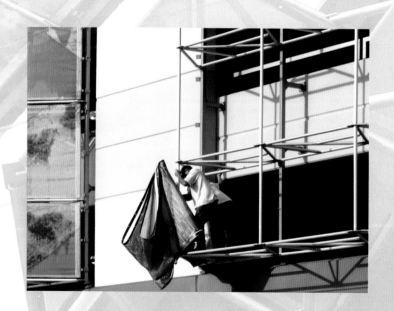

MIKE MEECE

Troubleshooting the color accuracy was difficult. The printer had to print up five sections again because the color was not what it needed to be in order to show the proper contrast. The panels had an archival coating that required a twenty-four hour application and drying period before they could be installed.

One of the most intriguing things about the entire framework for the fabric was the connections on the precast concrete. There were about 30,000 connections into the precast, and each one had to be inspected and approved by the precast manufacturing engineer.

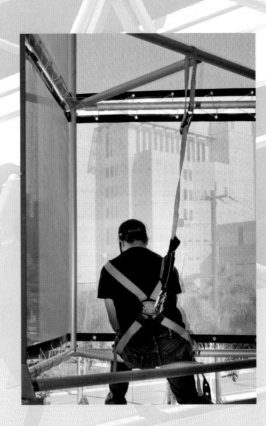

"I hear positive feedback on a daily basis."

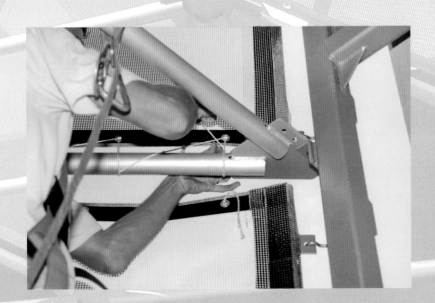
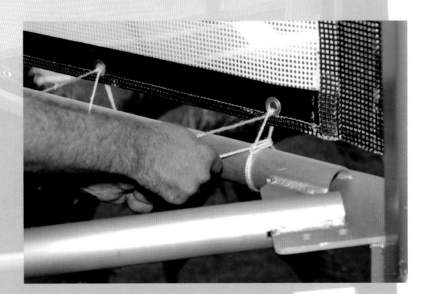

TRANSFORMATION *Parallel Park* has become a satisfying public art project for me through the integration of my long-standing affinity for the automobile with the sensory and cultural experience surrounding it. By uniting a civic building—an interactive public space—with my personal and artistic vision, a metamorphosis began, like alchemy. This marriage of personal imagery and public edifice has created something powerful and enduring that invigorates the city with the promise of renewal and regeneration.

My vision for *Parallel Park* incorporated utilitarian, practical public purposes [a parking garage] with a pure and expressive aesthetic [art]. It is an appealing idea that the act of entering your car, or driving your car into a garage, can become a dynamic or poetic moment. It is about transforming a mundane daily activity into an aesthetic experience. *Parallel Park* is about art, but with a potent subtext that this art can change our perspective, can change our environment and can change how we feel or think. Visual thought is my daily companion; it is who and what I am. *Parallel Park* is an assertion to others of the power of visual experience as a factor in daily life.

—Dintenfass

SOUTH FACADE

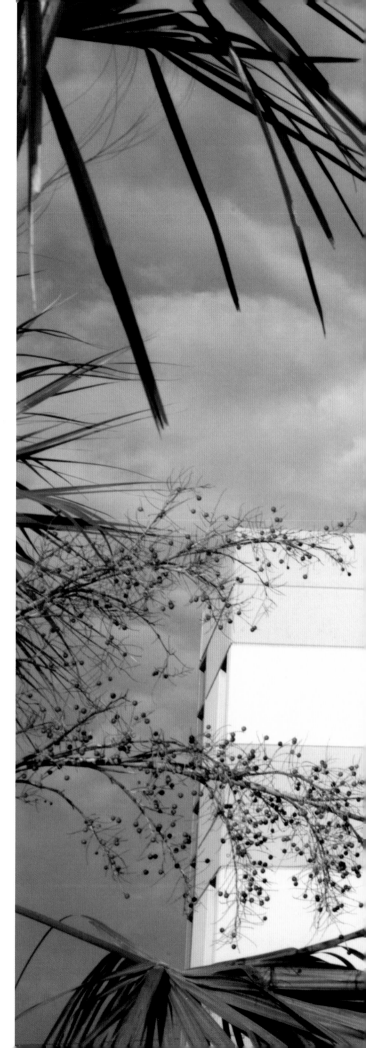

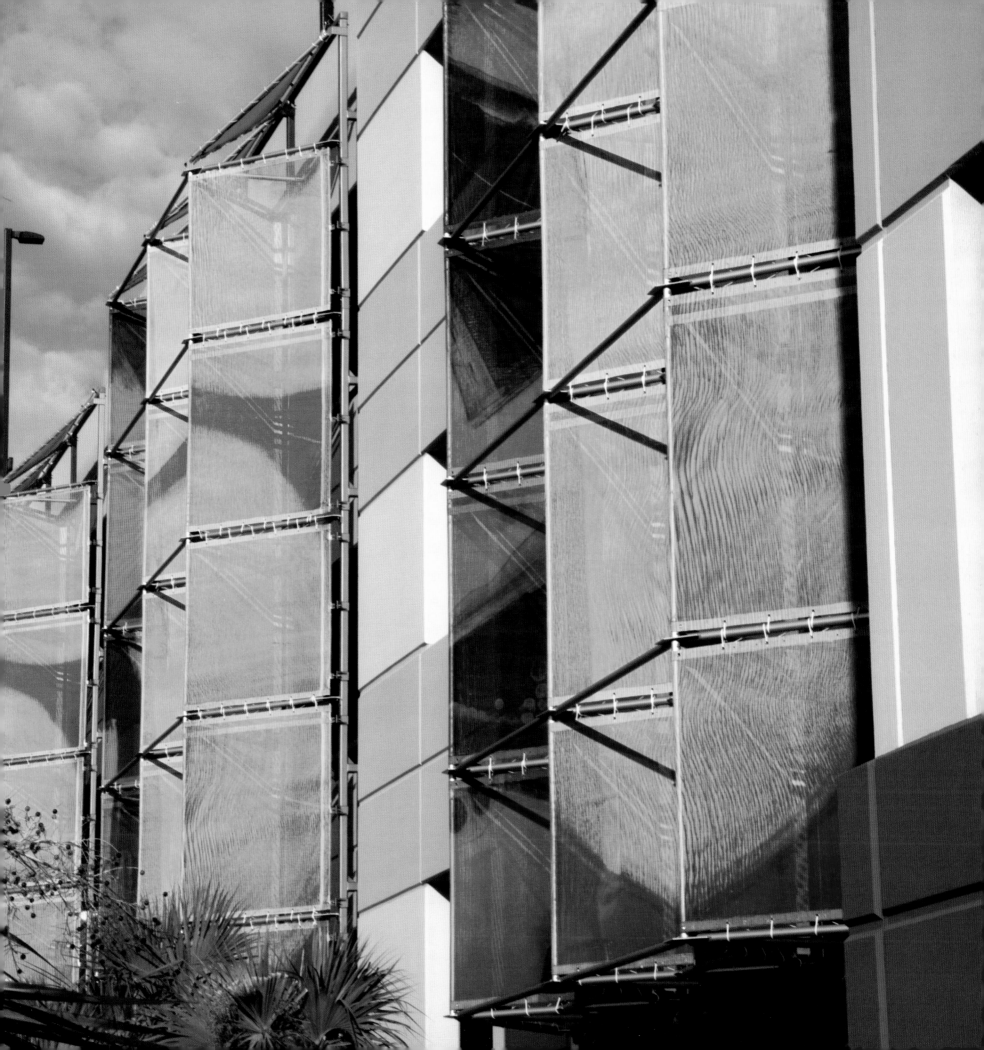

CITY TRANSFORMED

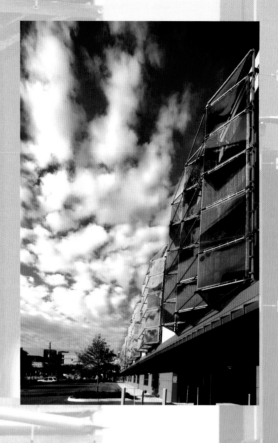

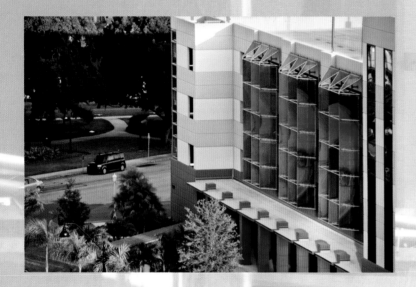

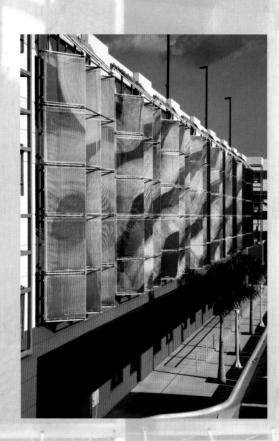

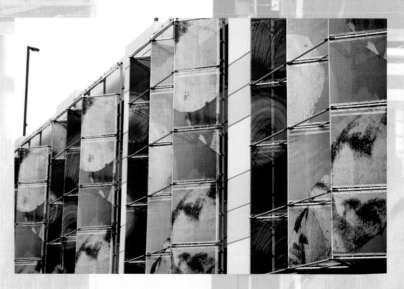

I hear positive feedback on a daily basis. We have an office down by the County Justice Center, and when I'm down there I hear comments on the parking garage and they're all positive. Most are referring to the artwork that's on the garage. I hear people say that the artwork makes the structure look like more than a parking garage, that it looks like a museum.

—Meece

> "The people driving by don't know it's a garage, they think it's a museum: the art museum of downtown Fort Myers."
>
> —Tobey Schneider

There's basically three ways to get to downtown from any interstate or major road. You have to pass the garage, and pass this art, to get into the lower downtown of Fort Myers. The transition gets you into thinking, "Okay, now we are in a place that has a lot more culture and diversity than other nearby places." The meshing of the art and the building, of how it looks on the structure, how it ties into the structure and the surrounding area, just tied in fabulously.

—Schneider

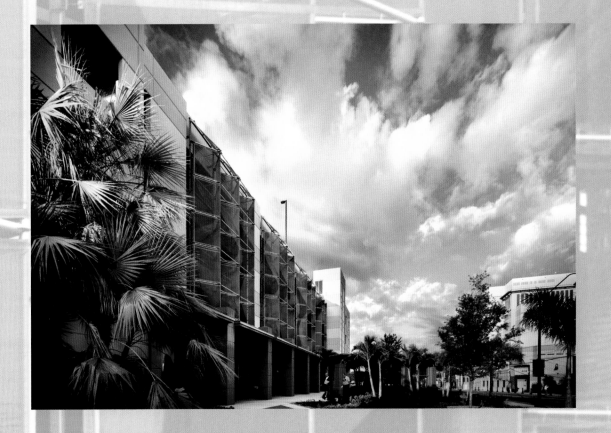

What's interesting about the building's placement is that it's on the western gateway or entrance to downtown. As you come from the main thoroughfare, it's one of the first structures that you come to. It gives a new gateway to the city of Fort Myers.

—Williams

(OVERLEAF) DINTENFASS, PERMANENT INSTALLATION, **PARALLEL PARK**, LEE COUNTY JUSTICE CENTER, FORT MYERS, FLORIDA, 2010

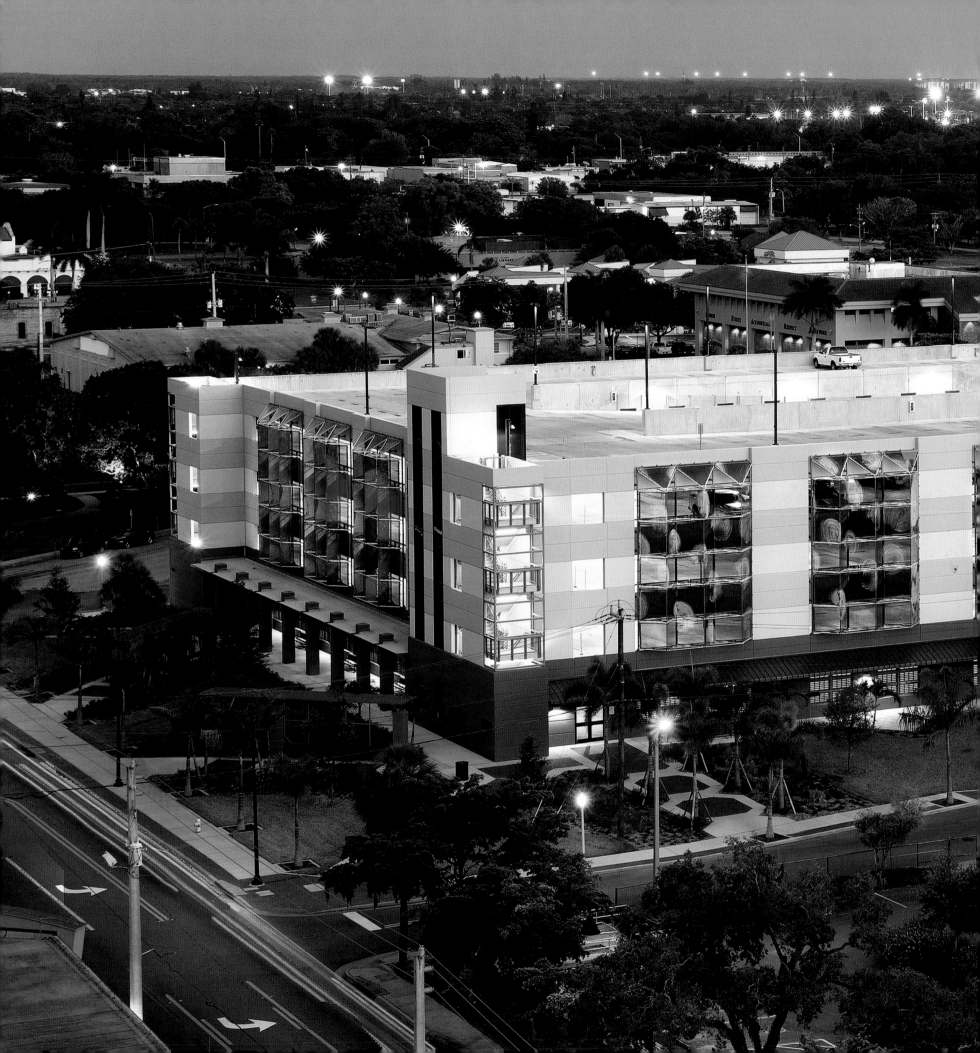

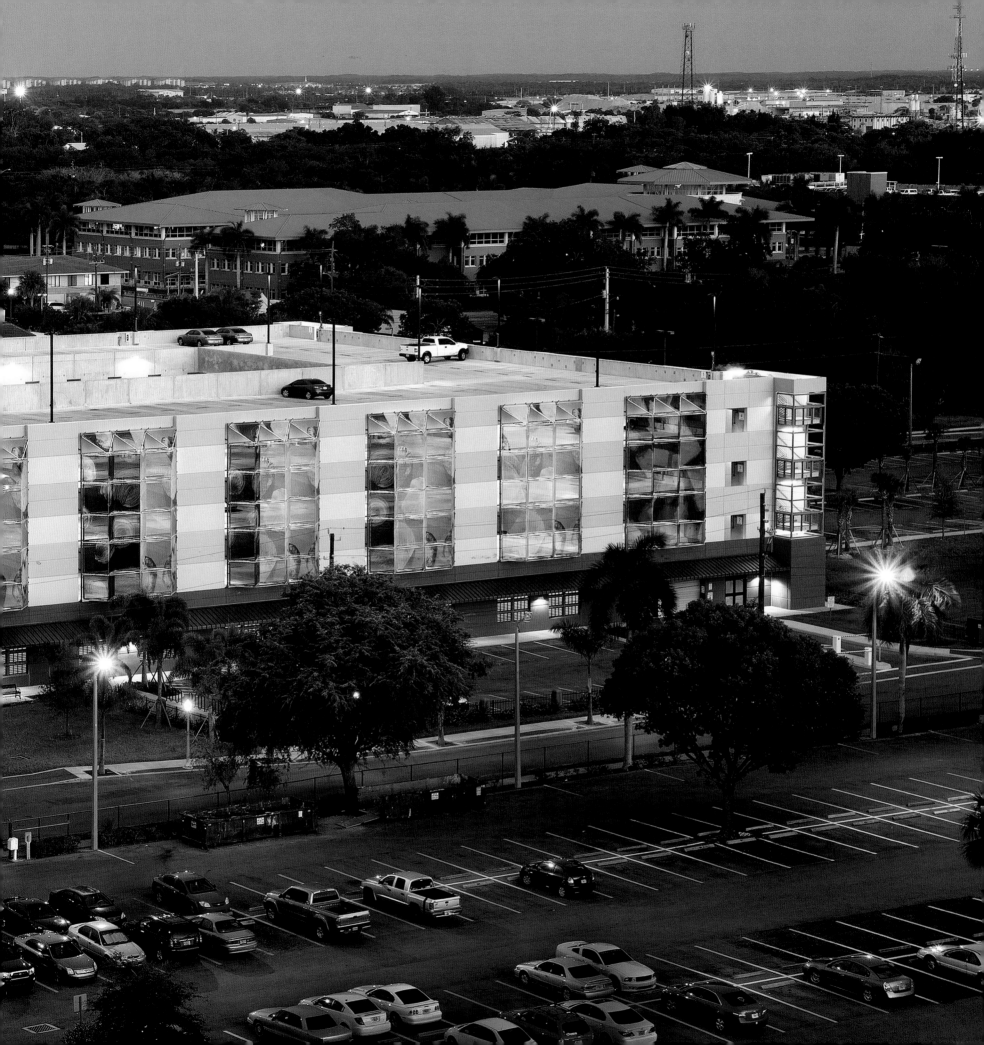

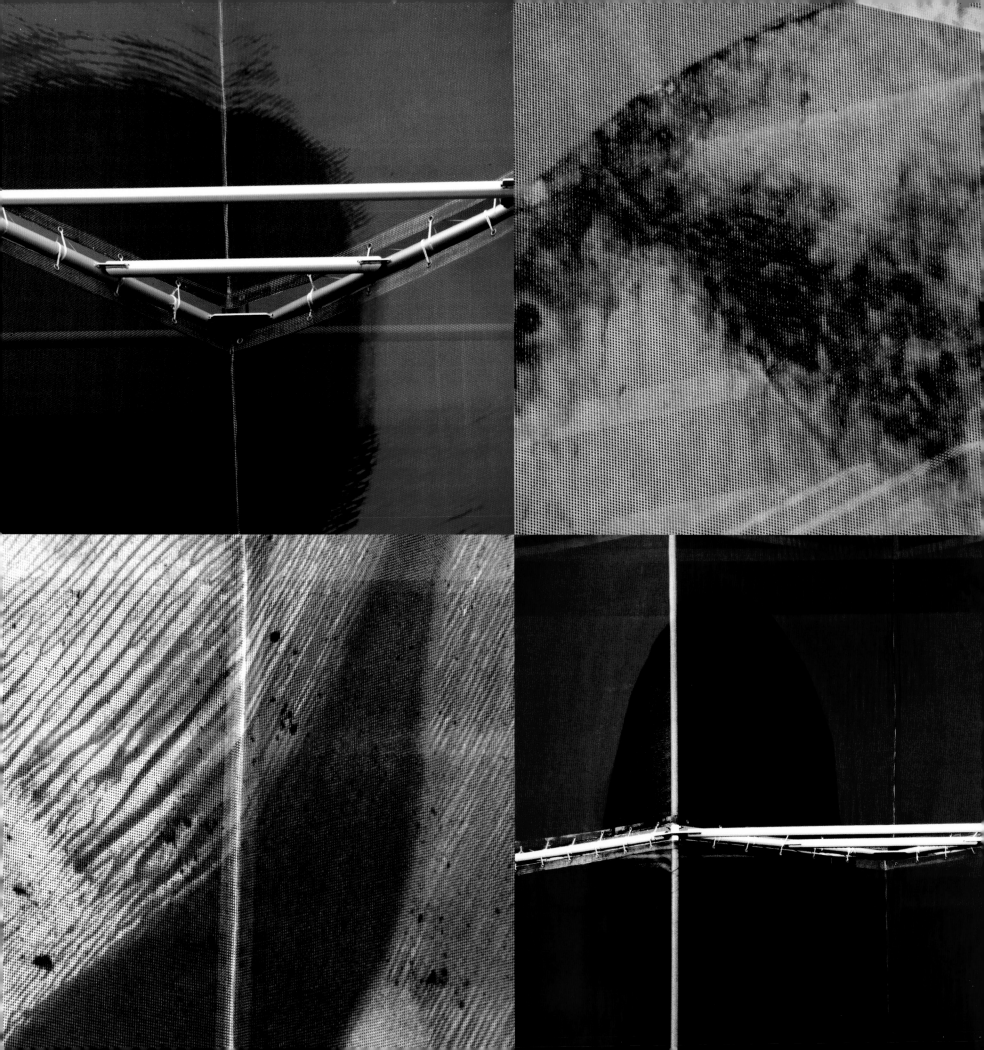

IT'S ABOUT TRANSFORMATION:
SCALE AS URBAN VISION

JENNIFER MCGREGOR INTERVIEWED BY JOHN DRISCOLL

JOHN What do you see as the principle points of interest in Marylyn Dintenfass' installation at the Lee County Justice Center Parking Garage in Fort Myers, Florida?

JENNIFER Well, there are a number of points one might address. One interesting aspect is the way Dintenfass responded to the commission by developing large-scale images for the building from the relatively small-scale pre-existing imagery of one of her monotype series. When you consider scale, this installation is enormous: composed of twenty-three panels, each 33 by 23 feet and extending over 30,000 square feet. Dintenfass' ability to translate her images to that monumental scale is particularly notable and points to her artistic versatility. A second impressive point is her ability to apply her concepts, to make her artistic vision work so effectively within the pre-established context of the architectural framework that Kevin Williams developed for screened panels on the building. What is also amazing is that she could adopt Kevin's plan and work freely with what was there in a really creative way, and to do it so quickly. . . . This is almost an ideal project for her.

JOHN Yes, it does seem ideal, and she has had such enthusiasm for it. Of course, she has significant prior experience with other large-scale projects, but in other respects this Fort Myers project is a direct outgrowth of current and earlier work.

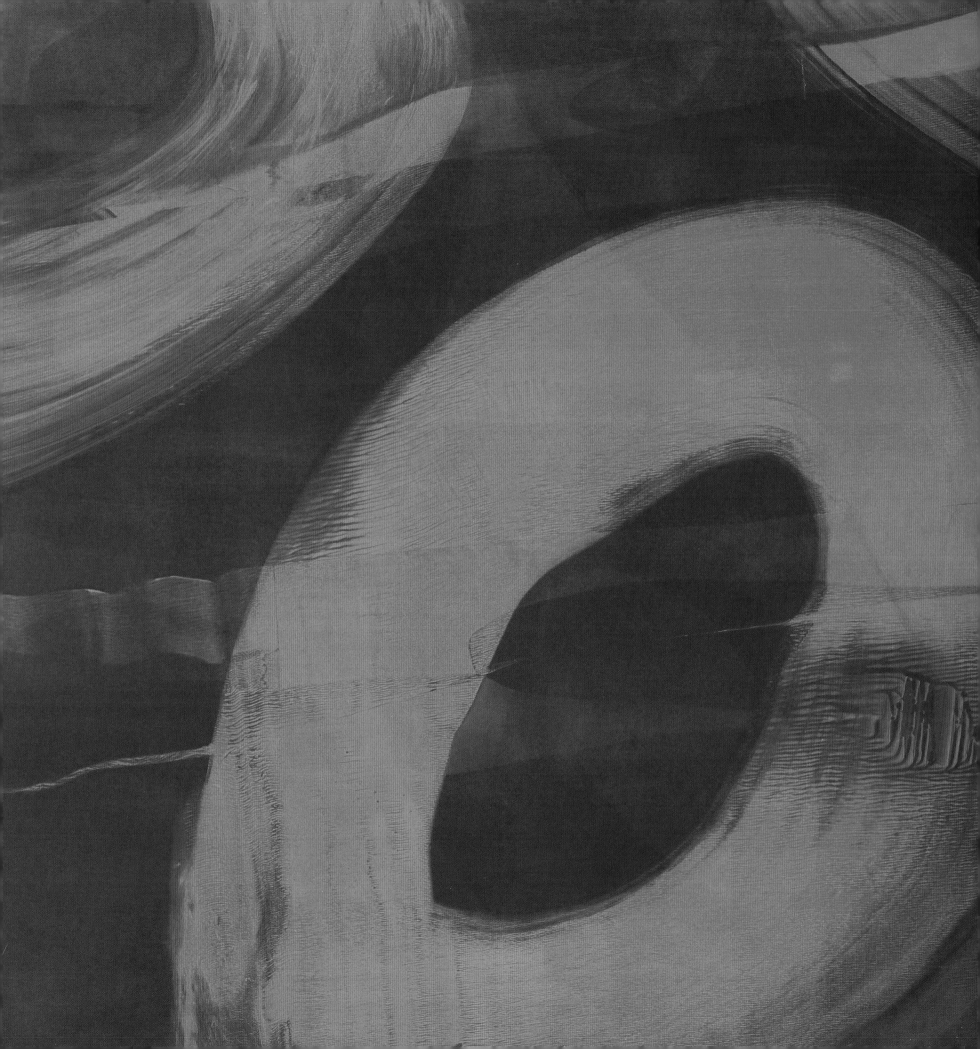

JENNIFER Indeed, it is interesting to see precursors in her work, her earlier commissions, many of which are physically three-dimensional. But this commission is dramatically three-dimensional, much more dynamic in dimensionality. There is a thread of this, which you can see, going right back to some of her earliest works.

JOHN Your comment reminds me that a few years ago Dintenfass was an invited finalist for a project at Bradley International Airport, near Hartford, in which she developed a plan for an installation that was over 300 feet long and composed of elements that came off the wall sometimes as much as six feet. She does like

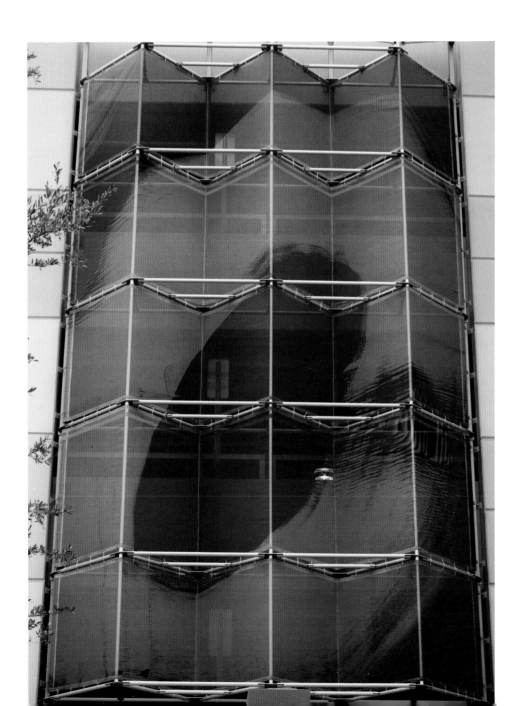

working three-dimensionally, and even in her paintings, with the transparent over-lapping color washes, she is striving for a deep three-dimensional appearance.

You made a point earlier about Dintenfass deriving the imagery for the Fort Myers project from a series of monotypes that she had done. I had not thought of this before, but it seems in most public art spaces an artist creates new imagery based on the specific needs of the entity or person offering the commission. In this instance, even though Dintenfass' imagery turned out to be site-specific, it came from imagery that already existed, imagery that was created to meet her own aesthetic considerations before she ever knew anything about the Fort Myers project.

JENNIFER Right. It does come from existing work. However, when you study the way that she laid it out, she didn't just take each square panel and put them right next to each other. It is really interesting to see the way she adapted her own imagery to create an entirely new rhythm, a sequential frieze-like cadence that you do not get from the original monotypes. She used the monotypes as a starting point, but the way that she decided to ultimately lay it out across the building was really responding to the site. It's about transformation, transforming not only her original art, but the building itself as well as the surrounding urban environment.

JOHN Over the past century, since the automobile became ubiquitous, there have been interesting and even dramatic examples of artists working with architects and designers to create structures that function as automotive-purpose-driven buildings and garages, which have an overriding aesthetic presence for both the public and for those who work inside the structure. Do you have any thoughts about Dintenfass' work in the context of that tradition?

JENNIFER Well, there is a tradition of architects and artists working together and, of course, parking garages are a new form, a 20th-century form, in the history of architecture. I am very interested to see that, as a building type, parking garages have offered new possibilities to artists from creative and aesthetic points of view. Parking garages do not tend to have the importance that a courthouse or some other civic or commercial structure might have. Architects, politicians, the public—no one gets particularly vested in the appearance of parking garages. Whenever possible, they are buried under other buildings, shunted off to the side, and people just hope they disappear. They almost never enhance or ornament any site. But this situation, it seems to me, does in fact create an opportunity for artists to have more freedom.

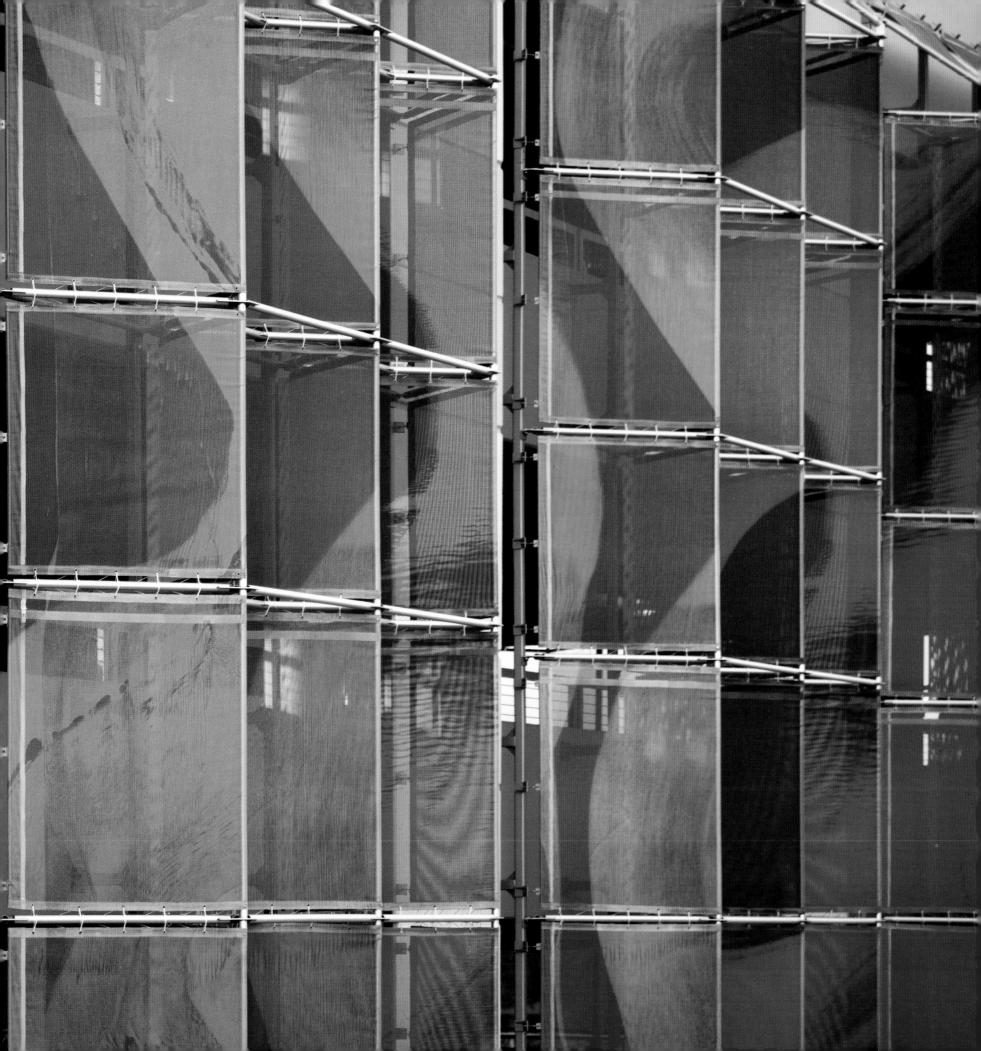

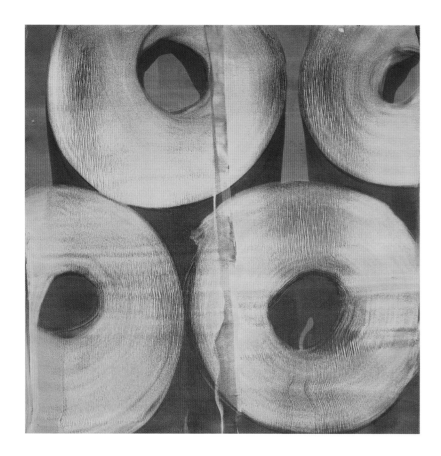
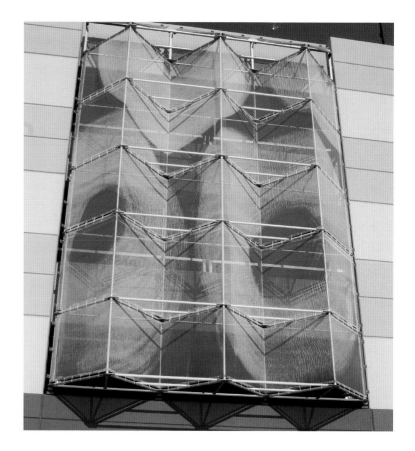

When you consider the size of parking garages and increased awareness of the impact they have on public environments, there is a real opportunity, a necessity really, to improve the form. Particularly when you look at the dramatic size of the Lee County Justice Center Parking Garage, and how Dintenfass' work transforms the structure—I mean, I can't imagine another type of building where architects would give over that much space, that much transformative authority to an artist.

JOHN You make an interesting point: architects naturally want their work, their message, their achievement to be the lasting imprint of their structures. Artwork associated with architecture is invariably an appendage to the architecture. In this instance, however, Kevin Williams, the architect, created a dramatic innovative opportunity for his building to be seen as a superstructure for art that would transform the entire urban environment of Fort Myers.

JENNIFER Yes, it is why I referred to Dintenfass' work earlier as "transformational," in terms of what it does for both the inherent structure of the building and the urban

environment of Fort Myers. It is an innovation because it is so complete for the whole building. It enhances the genre of parking garages in a way that is good for artists and very good for architects.

JOHN It is interesting—Dintenfass is now getting feedback that people who are driving into Fort Myers encounter the Lee County Justice Center Parking Garage and think it is an art museum.

JENNIFER That's so fabulous!

JOHN Well, yes. Parking garages tend to have a mundane utilitarian aspect that in current culture overrides all else. They seem to be a necessary evil and seldom add an edifying experience to anyone's day. And yet, there is an alternative history of the parking garage as automobile palace, with stained-glass windows, handmade tiles, chandeliers, and paintings—much like some of the grand old movie palaces of the past.

JENNIFER And when you consider how the car has transformed culture, how it was such a novel, brand new, and very exciting invention—the novelty and wonder of it seems lost, along with the brilliant aesthetic environments that were originally created for it. One thinks, for example, of the Michelin Building in London. Even today it is an experience to go to such buildings, to drive past them, or to take an automobile into them.

JOHN There must be other examples in contemporary architecture that are pertinent in terms of Dintenfass' work in Fort Myers.

JENNIFER Ned Kahn comes immediately to mind. He's an artist in Northern California doing brilliant work on a number of different buildings combining screening and transparency.

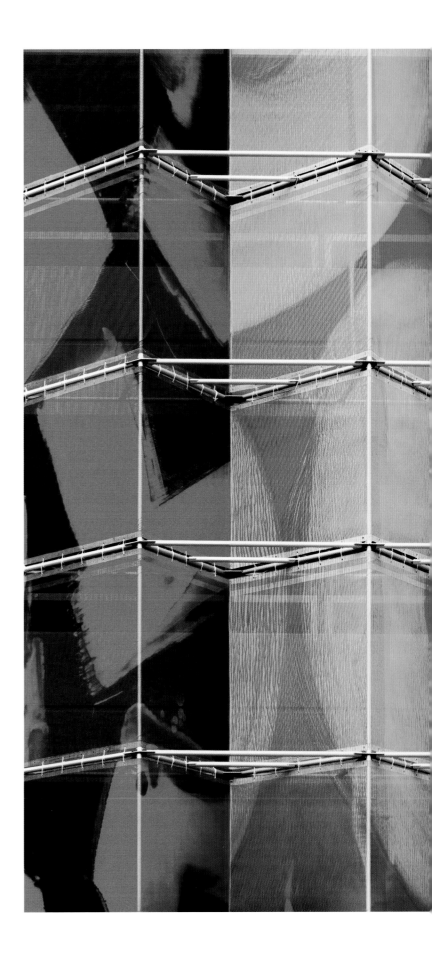

He uses discs that catch the sun, and the wind blows them a little bit. . . . It's an interesting way of covering a long architectural expanse using a kind of repetitive but edifying form. The scale of some of Kahn's projects is similar to this one of Dintenfass. I think it is the idea of screens, it is interesting to me, how new technologies and materials allow the kind of innovative imagery solutions that were not possible even just a few years ago. New possibilities for artists are created that were impossible even ten years ago. I was just involved in New York with the urban canvas design competition, which is seeking to enhance visual experiences in situations where scaffolding or temporary construction facades are placed. Even in these temporary situations there is an opportunity for artists to use innovative processes and material in new ways.

JOHN Talk a little more about what you see in the relationship between architect and artist.

JENNIFER It is important to know the audience and how they are going to experience the project. You can sometimes have very small-scale work that is extremely effective because it's intended to be intimate, a one-on-one experience. But in the Fort Myers project, much of the audience will experience the installation from the

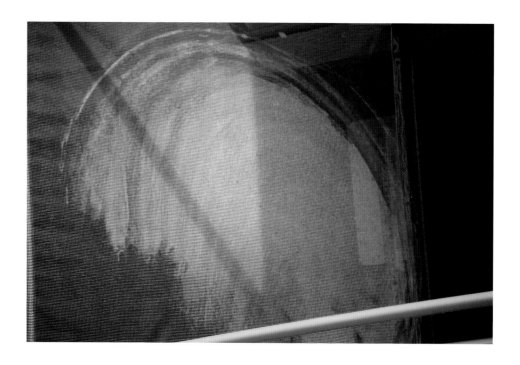

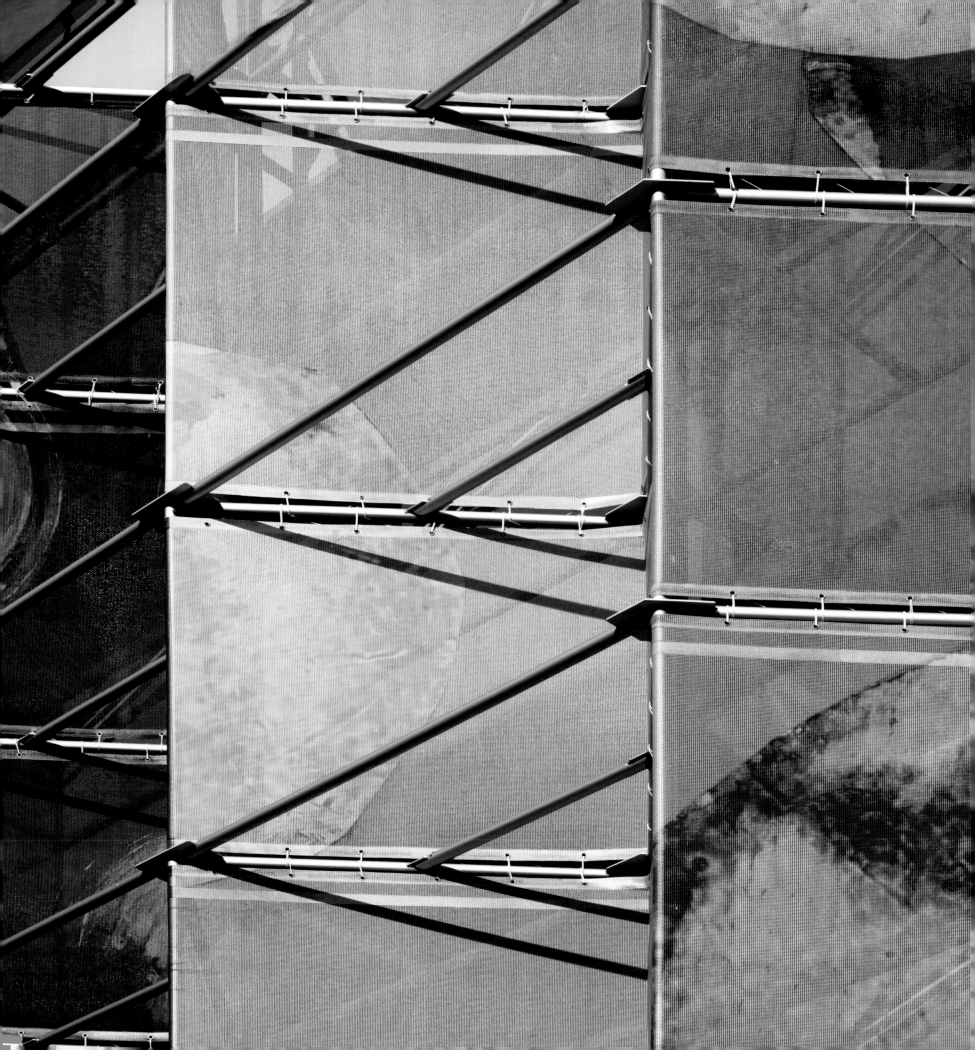

inside of a car, while others will walk by the site. With all the streets and sidewalks, not to mention surrounding buildings and views of the site from windows, there are many different ways to encounter this. So it is not only who the audience is, but how they will experience it. This project encompasses the entire building, on all four sides. The architect designed a system of louvered or triangular-shaped structures as part of his concept for the building—to support the artwork. I think it is one of the beauties of this project that the structural planning was already done and Dintenfass didn't have to solve any of those problems. She was free to really focus on how her imagery could be most effective.

JOHN You see this project as a matter of innovation.

JENNIFER Well, it certainly points the way for a very exciting direction for Dintenfass and for other artists. I know that Dintenfass considers herself a painter, printmaker, and sculptor. But people will see this and think, "Oh, wow, here's a painter but look at how much she can take on in terms of this whole building." So, it opens up new creative/expressive possibilities for artists, and how we think about what artists can do. It would be exciting to see this kind of solution applied to shopping centers, arenas, stadiums, and other public places that tend to be rather sterile and

uninteresting. I think there are exceptional and dynamic outgrowths that are possible, and this is very exciting.

It is also good that there is to be a book about this project. So many public art projects around the country are really wonderful and important but never have critical consideration or recognition beyond the immediate environment in which they are installed. The field needs more scholarly attention, more critical thought, and more literature.

This Fort Myers project is really exciting and innovative. I think Barbara Hill, the art consultant for the Fort Myers Public Art Committee, had a wonderful sense of what this project could be. Thinking of it in terms of an artistic statement, even a painterly statement, was inspired. It also feels like a natural progression for Dintenfass' work. It is so wonderful that she was invited to do this; she probably was not the first person they would have thought of, but the fact that it now seems so natural in every respect is probably the best testimony to Dintenfass' achievement.

JENNIFER MCGREGOR is Senior Curator and Director of Arts, Wave Hill, Bronx, New York. Formerly Director of the New York City Percent for Art Program from 1983–1990, in 1990 she founded McGregor Consulting to work nationally on planning and public art commissions. Her curatorial projects engage public dialogue with nature, culture and site, including the 2010 exhibition, *Remediate/Re-Vision: Public Artists Engaging the Environment*.

JOHN DRISCOLL, Ph.D., writes on John Kensett, Charles Sheeler, Marsden Hartley, Edwin Dickinson and Don Nice. He has held academic appointments at the Palmer Museum of Art, Yale, and New York University and has been the curator of, or contributor to, exhibitions at the Metropolitan Museum of Art, Los Angeles County Museum of Art, National Academy of Design and the National Gallery of Art. A member of the Visiting Committee, Department of Drawings and Prints at The Metropolitan Museum of Art, he is the Owner of Babcock Galleries, New York.

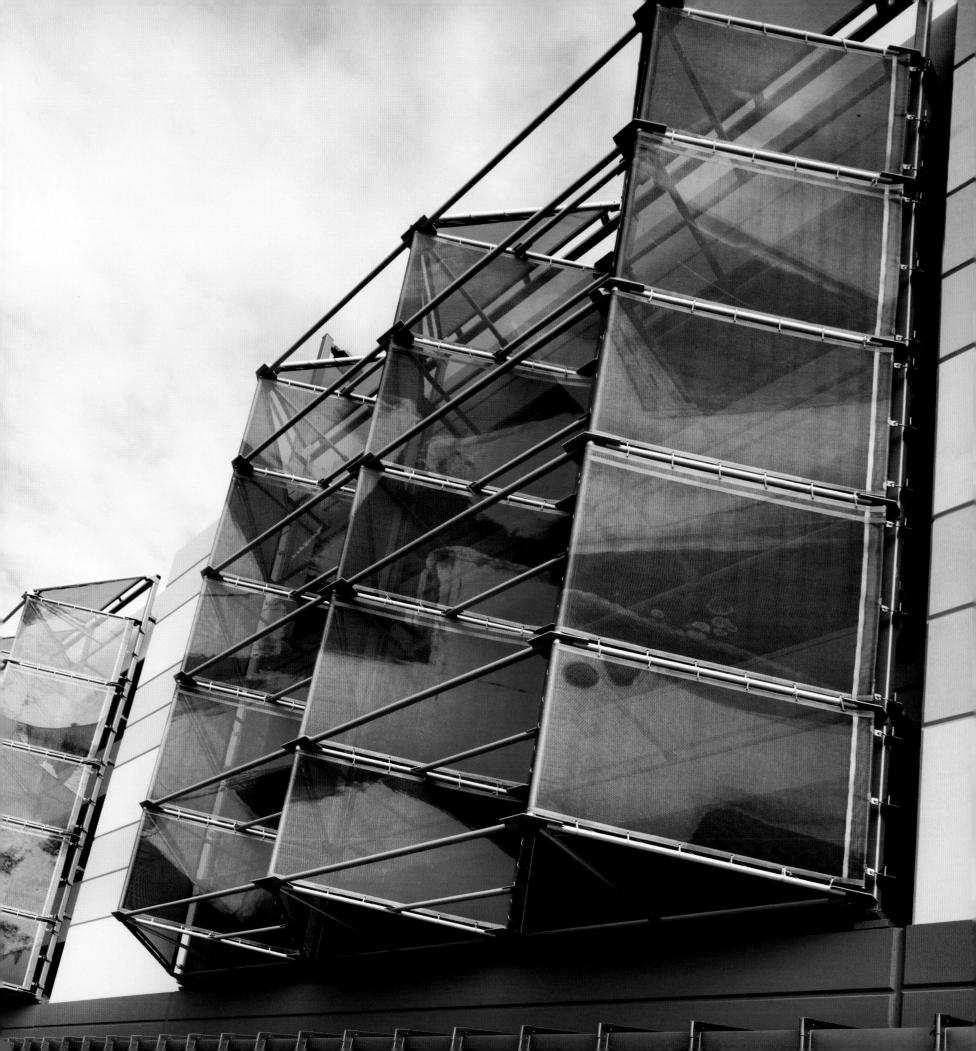

MARYLYN DINTENFASS

SELECTED SOLO EXHIBITIONS

2011
Bob Rauschenberg Gallery, Edison State College, Fort Myers, Florida,
 Marylyn Dintenfass

2010
Babcock Galleries, New York, *Marylyn Dintenfass: Parallel Park*

2009
Babcock Galleries, New York, *Marylyn Dintenfass: Good & Plenty Juicy*

2006
Greenville County Museum of Art, Greenville, South Carolina, *Marylyn
 Dintenfass Paintings* (exhibition catalogue)
Mississippi Museum of Art, Jackson, *Work in Progress: Marylyn Dintenfass*
 (exhibition catalogue)
Franklin Riehlman Fine Art, New York, *Marylyn Dintenfass: Recent Paintings*
Pelter Gallery, Greenville, South Carolina, *Marylyn Dintenfass: Works on Paper*

1994
Hamline University, Saint Paul, Minnesota, *Marylyn Dintenfass: Clay in Print*
 (exhibition catalogue)

1991
Terry Dintenfass Gallery, New York, *Paradigm Series* (exhibition catalogue)

1985
The Port Authority of New York and New Jersey, Bus Terminal, 42nd Street,
 New York, A.R.E.A. Project Site Installation, *Imprint Fresco*

1980
Katonah Museum of Art, Katonah, New York, *Tracks & Traces*

1979
Robert L. Kidd Galleries, Birmingham, Michigan, *Porcelain Progressions*

1978
Bell Gallery, Greenwich, Connecticut, *Porcelain Progressions*

1977
Schenectady Museum, Schenectady, New York, *Marylyn Dintenfass*

1976
Queens Museum of Art, Queens, New York, *Installation*

SELECTED PUBLIC COLLECTIONS

Ackland Art Museum, University of North Carolina, Chapel Hill

Art Museum of South Texas, Corpus Christi

Ben-Gurion University of the Negev, Be'er Sheva, Israel

Borough of Manhattan Community College, City University of New York

The Butler Institute of American Art, Youngstown, Ohio

Cheekwood Museum of Art, Nashville, Tennessee

The Cleveland Museum of Art, Cleveland, Ohio

Columbus Museum of Art, Columbus, Ohio

Danmarks Keramikmuseum, Grimmerhus, Middlefart, Denmark

Detroit Institute of Arts, Detroit, Michigan

Samuel Dorsky Museum of Art, State University of New York at New Paltz

Everson Museum of Art, Syracuse, New York

Fitchburg Art Museum, Fitchburg, Massachusetts

The Flint Institute of Arts, Flint, Michigan

Greenville County Museum of Art, Greenville, South Carolina

Kresge Art Museum, Michigan State University, East Lansing

Lee County Justice Center, Fort Myers, Florida

The Metropolitan Museum of Art, New York

Minneapolis Institute of Arts, Minneapolis, Minnesota

Mississippi Museum of Art, Jackson

Municipal City Hall, Be'er Sheva, Israel

Museo Internazionale delle Ceramiche, Faenza, Italy

Museum of Arts and Design, New York

The Museum of Fine Arts, Houston, Texas

New Orleans Museum of Art, New Orleans, Louisiana

Palmer Museum of Art, Pennsylvania State University, University Park

Smithsonian American Art Museum, Washington, DC

State of Connecticut Superior Courthouse, Enfield

Tajimi Middle School, Tajimi City, Gifu, Japan

Jane Voorhees Zimmerli Art Museum, Rutgers University,
 New Brunswick, New Jersey

Worcester Art Museum, Worcester, Massachusetts

SELECTED GROUP EXHIBITIONS

2010

Babcock Galleries, New York, *Color Conscious: Chuck Close,*
 Marylyn Dintenfass, Wolf Kahn, Andy Warhol
Castleton Project and Event Space, Castleton, New York, *The Castleton Twelve*

2009

Art Museum of South Texas, Corpus Christi, *New Acquisitions*

2008/9

Museum of Arts and Design, New York, *Inaugural Exhibition*

2007

Babcock Galleries, New York, *3 X 5: Chuck Close, Marylyn Dintenfass,*
 Alan Gussow, Don Nice, Andy Warhol
The Flint Institute of Arts, Flint, Michigan, *Recent Acquisitions of*
 Works on Paper
Hudson River Museum, Yonkers, New York, *I Want Candy: The Sweet Stuff*
 In American Art (exhibition catalogue). Traveled to Fresno Metropolitan
 Museum, Fresno, California, 2009; Contemporary Art Center of Virginia,
 Virginia Beach, 2010

2006

Samuel Dorsky Museum of Art, State University of New York at New Paltz,
 Museum, Mission and Meaning: Selections from the Collection
Detroit Institute of Arts, Detroit, Michigan, *Recent Acquisitions: Prints,*
 Drawings, Photographs
Mississippi Museum of Art, Jackson, *Art Adored: Icons from the Permanent*
 Collection
Paul Kasmin Gallery, New York, *Not Gay Art Now*. Curated by Jack Pierson
Chelsea Art Museum, New York, *City Arts* (benefit)

2005

Fitchburg Art Museum, Fitchburg, Massachusetts, *Collection Directions:*
 Acquisitions in the Twenty-first Century
Franklin Riehlman Fine Art, New York, *No Object*
Babcock Galleries, New York, *Barnet, Close, Dintenfass, Warhol*
Arkansas Arts Center, Little Rock, *2005 Collectors Show*

2004

New Orleans Museum of Art, New Orleans, Louisiana, *From Another*
 Dimension: Works on Paper by Sculptors. Curated by Daniel Piersol
Palmer Museum of Art, Pennsylvania State University, University Park,
 Works on Paper: Selections from the Permanent Collection
Samuel Dorsky Museum of Art, State University of New York at New Paltz,
 Out of the Vault: Recent Acquisitions
International Print Center, New York, *New Prints 2004.*
 Curated by Barry Walker
Babcock Galleries, New York, *Close, Dintenfass, Nice, Warhol: Master Prints*

2003

The Hunterdon Art Museum, Clinton, New Jersey, *47th National*
 Print Exhibition
Columbus College of Art and Design, Columbus, Ohio, *21st Century*
 Ceramics. Curated by Bill Hunt (exhibition catalogue)
Franklin Riehlman Fine Art, New York, *Gallery Works*

2002

Babcock Galleries, New York, *New York, Past and Present*

2000

Danmarks Keramikmuseum, Grimmerhus, Middlefart, Denmark,
 Recent Acquisitions

1997

Queens Library Gallery, Queens, New York, *Forms & Transformations:*
 Current Expressions in Ceramics, from Art to Industry. Curated by
 Judith S. Schwartz (exhibition catalogue)

1996

Jane Voorhees Zimmerli Art Museum, Rutgers University, New Brunswick,
 New Jersey, *Unique Impressions: Contemporary Monotypes and Monoprints*

1995/96

Rogaland Kunstsenter, Stavanger, Norway, *New York, New York: Clay.*
 Curated by Judith Schwartz (exhibition catalogue). Traveled to Hordaland
 Kunstsenter, Bergen; Nordenfjeldske Kunstindustrimuseum, Trondheim;
 Ostfold Kunstnersenter, Fredrikstad

1995

Click 3X, New York, *Anniversary Exhibition*
The Center for Book Arts, New York, *The International Library.* Curated by
 Helmut Löhr

1994

Shirley Fiterman Gallery, Borough of Manhattan Community College,
 City University of New York, *Selections from the Permanent Collection*
Silo Gallery, New Milford, Connecticut, *High on Tile*

1993

International Art Biennale, Be'er Sheva, Israel (exhibition catalogue)
Turkish Station Gallery, Be'er Sheva, Israel, *From the Factory*
Avraham Baron Art Gallery, Ben Gurion University of the Negev, Be'er
 Sheva, Israel, *Installations*
Associated American Artists Gallery, New York, *Monotypes/Monoprints*
 (exhibition catalogue)
Elsa Mott Gallery, New York, *Transcending Boundaries*

1992

Triplex Gallery, Borough of Manhattan Community College, City University of
 New York, *Selections from the BMCC Permanent Collection*
Paramount Center for the Arts, Peekskill, New York, *Art in Architecture*

1991

Museum Mensinghe, Roden, The Netherlands, *Internationale Keramiek
 Tentoonstelling*

1990

Kunsthalle Brandts Klaedefabric Museum, Odense, Denmark, *Clay Today*

1989

Katonah Museum of Art, Katonah, New York, *New Sculpture*
Nevada Museum of Art, Reno, *Visiting Artists*

1988

Tower Fine Arts Gallery, The College at Brockport, State University of
 New York, *Public Art: Making a Better Place to Live*

1987

45° Concorso Internazionale della Ceramica d'Arte, Faenza, Italy
 (exhibition catalogue)
National Archives of Canada, Montreal, *New York/Montreal: Grand Prix des
 Métiers d'Art—Banque d'Épargne*
School of Architecture, Syracuse University, Syracuse, New York, *Drawings,
 Sketches and Models: Ceramics in Architecture*
Wilson Art Gallery, Le Moyne College, Syracuse, New York,
 Empire State Selections
Gallery, Fashion Institute of Technology, State University of New York,
 New York, *Artists in Space*
The Gallery at Hastings-on-Hudson, New York, *Crossovers: Sculptured
 Painting/Painted Sculpture*

1986

First International Ceramic Exhibition, Mino, Japan (exhibition catalogue)
Robert L. Kidd Galleries, Birmingham, Michigan, *Major Concepts*
 (exhibition catalogue)

1985

Lever House, New York, *Art and the Environment*
Timothy Burns Gallery, St. Louis, Missouri, *Clay Murals and Tiles*

1984

Smithsonian Institution, National Museum of American Art (now Smithsonian
 American Art Museum), Renwick Gallery, Washington, DC, *Clay for
 Walls: Surface Reliefs by American Artists*. Curated by Raylene Decatur
 (exhibition catalogue)
Liberty Gallery, Louisville, Kentucky, *National Invitational, 1984*
 (exhibition catalogue)
Parsons, The New School for Design, New York, *Glazing in Watercolor and
 Porcelain* (faculty exhibition with Barbara Nechis)

1983

The Gallery at Hastings-on-Hudson, New York, *The Evolution of Seven Artists*

1982

Schenectady Museum of Art, Schenectady, New York, *Regional Works*
Interart Gallery, Women's Interart Center, New York, *Architectural Ceramics*
The Craftsman's Gallery, Scarsdale, New York, *The Art of Clay*

1981

Galerie Inge Donath, Troisdorf, West Germany, *International Works*
Bowdoin College Museum of Art, Brunswick, Maine, *Art in Craft Media*
 (exhibition catalogue). Traveled to William Benton Museum of Art,
 University of Connecticut, Storrs; Rose Art Museum, Brandeis University,
 Waltham, Massachusetts; Museum of Art, Rhode Island School of Design,
 Providence; Sterling and Francine Clark Art Institute, Williamstown,
 Massachusetts
Louis K. Meisel Gallery, New York, *Gallery Works*
Women in Design International Exhibition, San Francisco, California
 (exhibition catalogue)

1980

11th International Sculpture Conference, George Washington University,
 Washington, DC, *Architectural Ceramics*
Thorpe Intermedia Gallery, Sparkill, New York, *New York Clay Works*.
 Curated by Carl Rattner (exhibition catalogue)
31st New England Exhibition of Painting and Sculpture, Silvermine,
 Connecticut

1979
Herbert F. Johnson Museum of Art, Cornell University, Ithaca, New York, *Clay, Fiber, Metal*
Suzanne Gross Gallery, Philadelphia, Pennsylvania, *Art Ceramic*
Bridge Gallery, White Plains, New York, *Selections from the Visual Arts Affiliates of Westchester*

1978
The Bronx Museum of the Arts, Bronx, New York, *Women Artists*
The National Academy Museum Galleries, New York, *National Association of Women Artists*
Hudson River Museum, Yonkers, New York, *Hudson River Open*
Interart Gallery, Women's Interart Center, New York, *Raku Invitational*

1977
Pratt Institute, Brooklyn, New York, *Pratt Invitational*
Tyler Art Gallery, State University College at Oswego, New York, *Oswego Invitational* (exhibition catalogue)
Salmagundi Club, New York, *Knickerbocker Artists: 27th Annual Exhibition*
Lever House, New York, *Artist Craftsmen of New York*

1976
The Craftsman's Gallery, Scarsdale, New York, *Invitational 1976*

1975
University of Pennsylvania, Philadelphia, *Women's Cultural Trust*
Tweed Museum of Art, University of Minnesota, Duluth, *3rd Biennial International Exhibition* (exhibition catalogue)
National Craft Show, Rhinebeck, New York

1972
The College of New Rochelle, New York, *Anniversary Juried Exhibition*

1971
Mamaroneck Artists' Guild, Mamaroneck, New York, *Open Juried Show*

GRANTS/AWARDS

1993
International Art Biennale, Be'er Sheva, Israel

1990
Fellowship, The MacDowell Colony
International Symposium Residency Grant, Odense, Denmark

1988
Fellowship, The MacDowell Colony

1987
Individual Artist Fellowship, New York State Foundation for the Arts
45° Concorso Internazionale della Ceramica d'Arte, Faenza, Italy, Ravenna Prize

1986
First International Ceramic Exhibition, Mino, Japan, Silver Medal

1983
Women in Design International Exhibition, San Francisco, California, Outstanding Achievement Award

1982
National Endowment for the Arts Projects Grant, Architectural Ceramics, Women's Interart Center, New York

1980
31st New England Exhibition of Painting and Sculpture, Silvermine, Connecticut, Jurors Award

1978
National Endowment for the Arts Artist in Residence, Grant Artist Collaboration Program, Clayworks Studio, New York
Hudson River Open, Hudson River Museum, Yonkers, New York, Judges Award, Sculpture

SELECTED COMMISSIONS

2010
Lee County Justice Center, Fort Myers, Florida

1992
Edwards & Angell, New York

1990
Aetna Life Insurance Company, Hartford, Connecticut

1989
Ahavath Achim Synagogue, Atlanta, Georgia
American International Group, New York

1987
Crystal City Complex, Arlington, Virginia

1986
ADT Corporation, Waltham, Massachusetts
State of Connecticut Superior Court Complex, Enfield

1985
IBM, Atlanta, Georgia
Olympia & York, New York

1984
Baltimore Federal Financial Building, Baltimore, Maryland
Kaiser Permanente, Dallas, Texas

1983
IBM, San Jose, California

1982
Main Hurdman, Park Avenue Plaza, New York

1981
IBM, Charlotte, North Carolina
Main Hurdman, Park Avenue Plaza, New York
Thompson, Ventulett, Stainback & Associates, Atlanta, Georgia

1978
Benton & Bowles, Inc., New York

SELECTED CORPORATE COLLECTIONS

Astrolink, Bethesda, Maryland

Bayerische Landesbank, New York

Boston Consulting Group, New York

Freddie Mac Headquarters, McLean, Virginia

The Insurance Company of North America, Philadelphia, Pennsylvania

Latham & Watkins, New York

Mineral Technologies Inc., Chrysler Building, New York

J. P. Morgan, Los Angeles

National Reinsurance Corporation, Stamford, Connecticut

Pfizer Inc., New York

Charles E. Smith Company, Los Angeles

BIBLIOGRAPHY

Abott, Corine. "Psyching the Medium." *Detroit Birmingham Edition*, April 12, 1979.

Adkins, Roy. "The Fourth Quadrant." *Jackson* (Mississippi) *Free Press*, September 14, 2006.

"Artists at the MacDowell Colony." *Chronicles*, WBAC-TV, Boston, 1990.

"Arts Edition; Interview with Marylyn Dintenfass and Barbara Hill." Interview by Mike Kiniry, *Gulf Coast Live*, WGCU Public Radio, Fort Myers, FL, July 8, 2010.

"Building Vocal Space: Expressing Identity in the Radically Collaborative Workplace; Interview with Hani Asfour and Marylyn Dintenfass." Interview by Kate Ehrlich and Austin Henderson. *Interactions* 8 (January/February 2001): 23–29.

Barnes, Gordon A. "Judge's Statement." In *3rd Biennial International Exhibition*. Exh. cat. Duluth, MN: Tweed Museum of Art, 1975.

Bergér, Sandra Christine Q., et al. *Women in Design International Compendium* (San Francisco). Vol. 1. Exh. cat. Tiburon, CA: Women in Design International, 1982.

Boscherini, Giorgio, et al. *45° Concorso Internazionale della Ceramica d'Arte*. Exh. cat. Faenza, Italy, 1987.

Caldwell, John. Review of *New York Clay Works*, Thorpe Intermedia Gallery, Sparkill, NY. *New York Times*, October 19, 1980.

Castle, Frederick Ted. "The Clay Paintings of Marylyn Dintenfass." *Ceramics: Art and Perception*, no. 8 (1992): 7–9.

———. *Marylyn Dintenfass: Paradigm Series*. Exh. cat. New York: Terry Dintenfass Gallery, 1991.

Colby, Joy. "Progressions: Works in Porcelain." *Detroit News*, April 12, 1979.

Dantzic, Cynthia Maris. *100 New York Painters*. Atglen, PA: Schiffer, 2006.

Decatur, Raylene. *Clay for Walls: Surface Reliefs by American Artists*. Exh. cat. Washington, DC: Smithsonian Institution, National Museum of American Art, Renwick Gallery, 1984.

Dintenfass, Marylyn. "Working Large Scale: Portfolio." *Ceramics Monthly* 34, no. 5 (1986): 33–43.

Falk, Bill. "When Art Goes Aloft." *Suburbia Today*, May 1, 1983, 16–17, 20.

Finkelstein, Haim, ed. *Ceramics Biennale: Beer-Sheva, 1993.* Exh. cat. Be'er-Sheva, Israel: Avraham Baron Art Gallery, Ben Gurion University of the Negev, 1993.

Fiore, Linda, ed. *Artist-Craftsmen of New York Newsletter*, April 1983.

Flad, Mary, ed. *Architectural Craftworks: Conference Report.* Poughkeepsie, NY: Empire State Crafts Alliance, 1984.

Foighel, Hanne. "From the Desert to International Ceramics." *Berlingske Tidende* (Copenhagen), April 17, 1993.

"Fort Myers Downtown Garage to Host Installation by Marylyn Dintenfass." *Grandeur Magazine* (Fort Myers, FL), April 10, 2010, 54–55, http://www.news-press.com.

Freedman, Diana. "From Literal Subject to Poetic Self." *Artspeak* 5, no. 12 (1984).

Friedman, Ann. *Oswego Invitational.* Exh. cat. Oswego, NY: Tyler Art Gallery, State University College at Oswego, 1977.

Geibel, Victoria. "The Act of Engagement." *Metropolis*, July/August 1986, 32–36, 43, 46–47.

Grabowski, Beth, and Bill Fick. *Printmaking: A Complete Guide to Materials and Processes.* Upper Saddle River, NJ: Prentice Hall, 2009.

Hagani, Lisa R. *Monotypes/Monoprints.* Exh. cat. New York: Associated American Artists Gallery, 1993.

Hall, Barbara. "Open House at Artists' Workplace." *New York Times*, November 5, 1995.

Hefetz, Magdalena, and Yoheved Marx. "*First International Ceramics Biennale, Be'er Sheva, Israel, 1993.*" *New Ceramics/Neue Keramik* (Höhr-Grenzhausen, Germany), January 1994, 46–47.

Hirsch, Linda. "State Superior Court Building." *Hartford* (CT) *Courant*, October 24, 1986.

Hunt, Bill, ed. *21st Century Ceramics in the United States and Canada.* Exh. cat., Columbus College of Art and Design. Westerville, OH: The American Ceramic Society, 2003.

"Inside Travel & Tourism." WINK-TV (Fort Myers, FL), July 30, 2010.

Kato, Naoki, et al. "Brilliant Awarded Works in the First International Ceramics Competition '86 Mino." *Tono Shimpoh* (Tajimi City, Japan), October 31, 1986.

———. *First International Ceramic Exhibition '86, Mino, Japan.* Exh. cat. Tajimi City, Japan: Organizing Committee, International Ceramics Festival '86, Mino, Japan, 1986.

Katz, Ruth J. "Architectural Ceramics Show." *New York Times*, January 20, 1983.

———. "Ceramics Fires Artist's Eloquence." *New York Times*, August 2, 1981.

———. "Growth of Seven Artists Examined." *New York Times*, April 17, 1983.

Keller, Martha. "Marylyn Dintenfass." Reviews. *New Art Examiner* (Chicago), June 1979.

Kidd, Robert. *Major Concepts.* Exh. cat. Birmingham, MI: Robert L. Kidd Galleries, 1986.

Kingsley, April. "Marylyn Dintenfass." *American Ceramics* 2, no. 2 (1983): 16–21.

Laperrière, Rachel, et al. *1987 Grand Prix des Métiers d'Art—Banque d'Épargne.* Exh. cat. Montreal, 1987.

Levine, Angela. "Biennale of Clay." *Jerusalem Post Magazine*, April 23, 1993.

Lincoln, Joan. "Surprise! Your Hypothetical Wall Is for Real!!" *The Crafts Report: The Newsletter of Marketing, Management and Money for Crafts People* 8, no. 84 (1982).

Ling, Pei Chin. "Marylyn Dintenfass: Evocative Architectural Sculpture." *Ceramic Art* (Taipei), no. 16 (1997).

Marylyn Dintenfass Paintings. Exh. cat. Greenville, SC: Greenville County Museum of Art, 2006.

Mendelsohn, Meredith. "Marylyn Dintenfass: Babcock Galleries." Reviews: New York. *ARTnews* 108, no. 7 (Summer 2009): 124.

Nechis, Barbara. *Watercolor from the Heart: Techniques for Painting the Essence of Nature.* New York: Watson-Guptil Publications, 1993.

———. *Watercolor: The Creative Experience.* Westport, CT: North Light Publishers, 1979.

Nielsen, Teresa. "Symposium on Clay's Possibilities." *Danish Arts and Handicrafts* 3, no. 90 (1990): 14–20.

Parsley, Jacque, et al. *Porcelain 1984.* Exh. cat., National Invitational, 1984. Louisville, KY: Liberty Gallery, 1984.

Peterson, Susan. *Contemporary Ceramics.* New York: Watson-Guptill Publications, 2000.

———. *The Craft and Art of Clay.* 3rd ed. Woodstock, NY: Overlook Press, 2000.

———. *Working with Clay: An Introduction*. Woodstock, NY: Overlook Press, 1998.

Pettus, Gini L., et al. "Introduction to Collection Catalogue." IBM Contemporary Craft Art Collection, Field Engineering Education Center, Atlanta, 1984.

Piersol, Daniel. "From Another Dimension: Works on Paper by Sculptors." *Arts Quarterly* (New Orleans Museum of Art), April/May/June 2004.

Poet Lore (Bethesda, MD) 79, no. 1 (1984). Cover image: *Kite* by Marylyn Dintenfass.

Preston, Malcolm. "A Diverse Exhibition." *Newsday* (Melville, NY), January 19, 1982.

Rattner, Carl. *New York Clay Works*. Exh. cat. Sparkill, NY: Thorpe Intermedia Gallery, 1980.

Rex, Erica. "Molding Multimedia: One Artist's Approach to Teaching Kids Art." *Mac Home Journal* 5, no. 4 (1997): 64–65.

Riddle, Mason. *Marylyn Dintenfass: Clay in Print*. Exh. cat. Saint Paul, MN: Hamline University, 1994.

"The River District, Downtown Fort Myers: Art Installed on New Garage." *Happenings Arts & Entertainment Magazine* (Fort Myers, FL), July 2010.

Robinson, Joyce Henri. "Marylyn Dintenfass: The Art of the Sensual Grid." Exh. brochure, *Work in Progress: Marylyn Dintenfass*, Mississippi Museum of Art, Jackson, 2006.

———. *Work in Progress: Marylyn Dintenfass*. Exh. cat. Jackson: Mississippi Museum of Art, 2006.

Sandler, Irving. "Marylyn Dintenfass Interview." Filmed by Full Res Productions, New York, June 3, 2009, http://www.youtube.com/watch?v=_m1BKXEG-GO.

Scates, Deborah A. "Media Loft: Celebrating 10 Years of Art in the Making." *Westchester Artsnews* 15, no. 4 (1994).

Schlossman, Betty. "Clay, Fiber, Metal by Women Artists." *Art Journal* 37, no. 4 (Summer 1978): 330–32.

Schwartz, Judith S. Essay in *Forms and Transformations: Current Expressions in Ceramics, from Art to Industry*. Exh. cat. Queens, NY: Queens Library Gallery, 1997.

———. Essay in *New York, New York: Clay*. Exh. cat. Stavanger, Norway: Rogaland Kunstnersenter, 1995.

———. "Marylyn Dintenfass: Terry Dintenfass Gallery." *American Ceramics* 10, no. 1 (1992).

———. "New York Clay." *Ceramics Monthly*, May 1996, 47–50.

Scott, Martha B. "Silvermine's Annual." *Bridgeport* (CT) *Sunday Post*, June 15, 1980.

Sela, Mirit. "The Way to Be'er Sheva." *Kol Ha-ir* (Jerusalem), April 2, 1993.

Simone, Linda. "Big Spaces, Bright Lights: Lofty Solutions to Artists' Workspace." *Westchester Artsnews* 12, no. 5.

Speight, Charlotte F. *Hands in Clay: An Introduction to Ceramics*. 2nd ed. Mountain View, CA: Mayfield Publishing, 1989.

Speight, Charlotte F., and John Toki. *Hands in Clay: An Introduction to Ceramics*. 3rd ed. Mountain View, CA: Mayfield Publishing, 1995. Front and back cover illustrations: original artwork by Marylyn Dintenfass.

Staino, Patricia A. "The Changing Face of Education." *Westchester County Weekly* (White Plains, NY), April 27, 1995.

Stetson, Nancy. "Parallel Park: Modern Art Adorns Parking Garage Downtown." *Florida Weekly News* (Fort Myers), June 6, 2010.

Storr-Britz, Hildegard. *Internationale Keramik der Gegenwart/Contemporary International Ceramics*. Cologne: DuMont Buchverlag, 1980.

———. *Ornaments and Surfaces on Ceramics*. Dortmund: Verlagsanstalt Handwerk, 1977.

Van Buren, Greg. "Art in Architecture." *Valley Artists Association Newsletter* 1, no. 7 (1992).

Van Der Meulen, Henk. "'Clay Today'—Internationale kleikunst in Rodens koetshuis." *Leeuwarder* (The Netherlands) *Courant*, May 8, 1991.

Viant Annual Report, 1999. Boston, MA. Cover image: original artwork by Marylyn Dintenfass.

Walker, Barry. "New Prints 2004/Spring." *International Print Center New York Newsletter*, May 2004. Published in conjunction with the exhibition *New Prints 2004*, International Print Center New York.

Walton, Roberta S., ed. "Saga of Symbols Is Present in Ceramic Wall Construction." *Contract* (New York), February 1986, 118.

Watson, Katharine J., et al. *Art in Craft Media: The Haystack Tradition*. Exh. cat. Brunswick, ME: Bowdoin College Museum of Art, 1981.

Wei, Lilly. *Marylyn Dintenfass Paintings*. Manchester and New York: Hudson Hills Press, 2007.

Williams, Gerry. *Apprenticeship in Craft*. Goffstown, NH: Daniel Clark Books, 1981.

Williams, Roger. "2009: The Year in Ideas." *Florida Weekly News* (Fort Myers), August 2009.

Yelle, Richard, et al. "Marylyn Dintenfass." In *Clayworks*. New York: Clayworks Studio Workshop, 1979.

Zahorski, Carole. "She's Fired Up about Clay." *Suburban People*, April 26, 1987, 20.

Zakin, Richard. *Electric Kiln Ceramics: A Guide to Clays and Glazes*. 2nd ed. Radnor, PA: Chilton Book Company, 1994.

Zimmer, William. "Focus on Corporate Collectors." *New York Times*, February 20, 1983.

ACKNOWLEDGMENTS

My recent series of automobile themed paintings and monotypes, which comprised the January/February 2011 exhibition at the Bob Rauschenberg Gallery at Edison State College, were the genesis for the *Parallel Park* commission at the Lee County Justice Center in Fort Myers, Florida. The *Parallel Park* commission, and now this book, is the result of significant contributions by many colleagues and friends. Their expertise, hard work and dedication, goodwill, friendship, and support have been instrumental to the realization of both projects.

Aliza Edelman is a brilliant and articulate scholar and I am grateful for her wonderfully cogent and superb authorship of this book. Aliza has written beautifully of my current work with great insight, sensitivity and understanding about the continuity of my themes, images and their broader cultural associations. Jennifer McGregor, an authority on public art, also made an important contribution through her interview with John Driscoll, in which she discusses critical issues and contextualizes the Parallel Park commission in Fort Myers. Barbara Anderson Hill's fine and informative essay provides a clear overview of the city of Fort Myers Public Art Program and the Public Art Committee's commitment to engaging an artist, who I am pleased turned out to be me, for the Lee County Justice Center Commission. My sincere thanks also to Michele Cohen whose perceptive and beautifully written Introduction to this book touches on pertinent issues with poetic and significant insights. I would also like to give my appreciative thanks to Anne Bei, Publisher at Hard Press Editions, for championing the publication of this book and for responding personally with such enthusiasm to my work.

JoAnn Sieburg-Baker has brilliantly photographed my installations all over the United States for thirty years. I am always amazed with the ability, fluent intuition and vision that JoAnn brings to photographing my work in ways that capture what is important to me. I have also benefited from and deeply appreciate the talents of Amy Pyle at Light Blue Studio, who designed this book, and her husband, Tim Pyle, who expertly photographed many of the two-dimensional works illustrated on these pages, along with my long-time photographer, Howard Goodman. Thanks also to Alexis Medina, an excellent photographer whose friendship and sensitivity for my work I truly value.

The *Parallel Park* Commission for the Lee County Justice Center Parking Garage in Fort Myers, Florida was brought to my attention by Barbara Anderson Hill and to her I owe an unrivaled debt of gratitude. Barbara was the visionary, steadfast and brilliant driving force behind the City of Fort Myers Public Art Program selecting an artist for this project. Hill planned a national search and attracted great submissions from more than a dozen artists. She stewarded the entire process on behalf of the City of Fort Myers, its Public Art Committee, and Lee County. The Public Art Committee voted for my proposal, and from that point on Hill became my liaison marshalling resources and information and contributing immeasurably to my understanding of the process and moving everyone toward the successful completion of the commission.

In New York the superbly talented photographer Michael Vahrenwald produced the high quality 8 x 10 color transparencies and drum-scanning that allowed for the extraordinary enlargement of my imagery required by this commission. Also in New York, architect Aida Miron worked closely with me on the technical aspects of translating my imagery onto the building and how best to present my vision through designs and models.

I also wish to acknowledge project architect, Kevin Williams of BSSW Architects, who originally conceived, designed, and engineered the idea of having Kevlar tapestries be such an important part of the parking garage building. His concepts allowed the freedom to implement my own work in a way that was completely compatible with my original aesthetic concepts. Tobey Schneider, partner at Target Builders, is a hero! He was completely helpful and affirmative in every interaction. He went above and beyond the call to make this project a success, and to make my experience a cordial success. Mike Meece, foreman at Target Builders, was also a superstar with such a generous spirit. In Hickory, North Carolina, Jerry Banks, who printed the Kevlar panels with my images earned my respect and complete appreciation for his unflinching commitment to doing whatever needed to be done in order that my aesthetic concepts would be fully realized. I am, of course, grateful as well to the City of Fort Myers Public Art Commission, and each of its commissioners, who selected my work for this important commission. I also appreciate the enthusiastic interest and support of Mayor Randy Henderson, Jr.

Ron Bishop, Director of the Bob Rauschenberg Gallery at Edison State College in Fort Myers, championed the exhibition of my work there and worked closely with me, and the staff of Babcock Galleries, New York. His beautiful and sensitive installation of the paintings and monotypes, his goodwill and support created a congenial and successful atmosphere for getting things accomplished smoothly.

At Babcock Galleries I am, as always, grateful to Lyle Dawson, Tess Schwab, Alexandra Tagami and Sara Gilbert, all are devoted exponents of my work. In Philadelphia Mary Cason provided expert, expeditious, and excellent copy editing of this book. In my New York studio I wish to express my great appreciation to the multitalented and resourceful, Kris Hedley. My appreciation also goes to Sean Fader and Juliana Slutsky, for their expertise and creativity as well as Rio Alexander Hendrix, and Molly McKinley for their help and great attention to the inner workings of the studio. I have a special appreciation for master framer, David Rothman, who advises and perfectly fabricates to my designs and specifications. I also wish to express my sincere appreciation to Sergio Maia, who does the expert finish carpentry and joining of my work. Also, my gratitude to Daisy Arango, who with grace and ingenuity is always astute, anticipates my needs and wishes, and is a constant support. I treasure also Nina Delgado, whose good spirit, expertise, and advice is ever steadfast and right.

I wish also to add my ongoing appreciation to long-time friends and colleagues Ken Forman, a wonderful design expert and brainstorming partner; to the brilliant filmmaker Julia Mintz whose friendship and passion for documenting my career earn my eternal gratitude, and Amy Kisch whose wise and always pertinent counsel, knowledge, friendship and personal commitment to my work is so very much appreciated and valued.

Finally, I wish to thank John Driscoll, an ardent collector, wonderful scholar, and best friend, who is now my art dealer and my dear husband, for his enthusiastic professional support and always wise counsel. The creation of a work of art is a solitary task. But with so many kind and generous people, as those mentioned above, taking an interest, supporting, championing my efforts, I never feel alone: I feel gratified and inspired. I hope each of you will know and carry with you my deep appreciation.

MARYLYN DINTENFASS
New York, May 27, 2011

Opposite: [top row, left to right] 1. Tess Schwab, Lyle Dawson, Alexandra Tagami and Marylyn Dintenfass (MD) / JoAnn Sieburg-Baker and MD / Kevin Williams, Mayor Randy Henderson, Jr. and MD / Kris Hedley / 2. John Driscoll / Jessical Hill, MD and Barbara Hill / Aliza Edelman / Ron Bishop and MD / 3. Aida Miron / Daisy Arango / Mike Meece, Steve Adkins, MD and Tobey Schneider / Jerry Banks / 4. Mike Meece, MD and JoAnn Sieburg-Baker / Julia Mintz and MD / Rio Alexander Hendrix and Mollie McKinley / Jennifer McGregor

Published by Hard Press Editions
Stockbridge, Massachusetts
in association with
Hudson Hills Press LLC
3556 Main Street
Manchester, Vermont 05254

Distributed in the United States, its territories and possessions,
and Canada by National Book Network, Inc. Distributed outside
North America by Antique Collectors' Club, Ltd.

Publisher and Executive Director: Leslie Pell van Breen
Founding Publisher: Paul Anbinder

Book design: Amy Pyle, Light Blue Studio, Inc.

Photography: Lead photographer and photo editor: JoAnn Sieburg-Baker
 Photos copyright © 2010 JoAnn Sieburg-Baker except as noted:
Noel Allum, p. 25
Matt Booth, p. 100, 101, 108, 109
Howard Goodman, front and back cover, p. 12, 15, 18, 19, 20,
 53–67, 69, 71, 73, 75, 77, 79, 80, 81, 83
Alexis Medina, pp. 84–85
John O'Donnell, p. 24
Timothy Pyle, Light Blue Studio, Inc., p. 2, 4, 6, 10, 16,
 21, 22, 23, 34, 37, 39, 41, 42, 45, 46, 49, 51, 88, 92–94
Nick Saraco, p. 19 (right), pp. 32–33

Printed and bound in China by Regent Publishing Services, Hong Kong

Library of Congress Cataloguing-in-Publication Data

Edelman, Aliza (Aliza R.)
 Marylyn Dintenfass Parallel Park / Aliza Edelman ;
 with contributions by Michele Cohen . . . [et al.]. — 1st ed.
 p. cm.
 Includes bibliographical references.

ISBN 978-1-55595-346-1
 1. Dintenfass, Marylyn. Parallel Park. 2. Site-specific
 installations (Art)—Florida—Fort Myers. I. Dintenfass, Marylyn.
 II. Cohen, Michele, 1958– III. Title.

N6537.D533A73 2011
709.04'074—dc23

Kevin Williams, BSSW Architects, Fort Myers, Florida, www.bsswarchitects.com

Tobey Schneider, Target Builders, Fort Myers, Florida, www.targetbuilders.com

Jerry Banks, Hyperformance Graphics, Hickory, North Carolina,
www.hpghickorync.com

MARYLYN DINTENFASS is represented by Babcock Galleries in New York.

Babcock Galleries
724 Fifth Avenue
New York, NY 10019
+1.212.767.1852
info@babcockgalleries.com
www.babcockgalleries.com

**MARYLYN DINTENFASS
SOLO EXHIBITION**
January 7–February 19, 2011
Bob Rauschenberg Gallery
Edison State College
Fort Myers, Florida